Contents

Foreword

I first encountered Glacier National Park as so many do: from the east. Fresh out of the Army, I was on my way to take a park ranger job when I spied the snow-shine of Glacier's mountains from the prairies. Their dominance grew the closer I drove. As I climbed up – then through them—on the Going-to-the-Sun Road, I was overwhelmed. Little did I know then how this place would change my life.

Larry Len Peterson writes about a landscape that is, and has always been, an inspiration to all that encounter it. Yes, he writes about people, but people that, in turn, try to tell the story of a place. It's a magical landscape that causes creative juices to flow. It was magical to the Indians who lived there. It inspired George Bird Grinnell to return again and again to experience and try to grasp it. He wrote of its feel and how it touched the senses and described it as the "Crown of the Continent." It's a landscape that moved two countries to designate two national parks.

And it certainly moved me. That first park ranger job was just for the summer, but led me in a new direction. It began a career in the National Park Service that led me to Alaska and Yellowstone, the Great Smokies and Mammoth Cave, and full circle back to Glacier. But more importantly, Glacier inspired me to pick up again a paintbrush that as a teenager (with other interests) I had laid aside. Having Bull Head Lodge with all its history down the lake from my ranger station didn't hurt. And seeing the art of Charlie Russell, John Fery, and Winold Reiss at every turn were reminders that others had done something more with their inspiration. Seeing them reminded me that I, too, had once been so inspired. So I began again, first with sketches done on solitary backcountry patrol and later with paint when dark came early on crystal cold nights.

As with many artists, I am aware of the light. The incredible morning light of Glacier that casts giant shadows of mountains one on another or slices though the crisp morning air to sparkle the dew. The light I'm convinced causes the fragrance from the awakening pores of larch and fir or the heavy wet smell of mist and west-side fog. And the sunsets – the sunsets that last for hours and glow late into the north – not the west – remind you: this is a special place.

How many Russell paintings of plains and mountains were painted in the long summer light of Bull Head Lodge? How many Glacier sunsets found their way into Fery's paintings? How much of the Chief Mountain's spirit impressed John Clarke's mind to guide his hands? While the landscape inspires creative genius in artists, the

creative ability of this place has inspired nations to create not just Waterton Lakes and Glacier National Park, but the world's first international peace park. And when that, too, wasn't enough, the imprimatur of "world heritage site" by UNESCO marked this landscape as special to all humankind.

What is it about these special places saved by people so that others may experience them? When you look at the Waterton-Glacier landscape on a satellite image you can immediately pick it out. It's the backbone of white with finger lakes and valleys both east and west. It is totally different from the mountains north and south. Scientists can explain it: how the Pacific plate "overthrust" the North American plate as one big piece, without folding and breaking. How glaciation carved the U-shaped valleys. That as the hydrologic apex of North America the waters flow to three oceans, giving new meaning to "continental divide." But I like the Blackfeet word. It is "Mistakis"– the "Backbone of the World" in the Pikuni language, and it is the Place where most sacred things begin and continue to be sustained.

How did they know?

Shortly after I became superintendent of Glacier National Park, I got a hush-hush call from Washington headquarters. Could we put together a trip for high-level foreign diplomats to enable them to see the "peace park?" Of course, I answered. But the trip never materialized. It seems the idea of the peace park was one option for disputed lands in the Middle East. But assassins ended the lives of the principals involved and the terror of the moment overwhelmed the debate of an idea that disputed territories could be symbols of peace. A landscape belonging to "every-man" rather than the "right" man was too difficult to grasp.

What would have happened if they had come? If they had been awed by the majesty as others before them? If they had been moved by the same spirit felt by the Pikuni, Salish, and Kootenai? If they could have seen the spectacular landscape that inspired so many before? Could it have changed the world with which we are confronted today?

Could it still?

Such is the power of this place. In these pages you will read Larry Len Peterson's description of people inspired by a landscape that has inspired many to great things. But the power of the landscape to inspire is not over.

It has just begun.

David Mihalic
Superintendent of Yosemite National Park
October 2001

Introduction

In time, our memories fade often replaced with fond recollections of a place based less on reality than wishful thinking. Revisiting childhood vacation spots can be disappointing, but that's not the case when it comes to Glacier National Park. My mind can never pluck and hold the scenic majesty of this wonderland. Every visit is as new and exciting as the first.

My dad's hardware store in northeastern Montana was only one block from the train station where the Empire Builder stopped on its journey from the east to Glacier country. When the train whistled its arrival, I often ran down to the train station to peer through the windows to see what people from the big city looked like. Early on, I thought they had picked the orange and black colors of the train after our high school colors. Eventually, I figured that one out, but it did nothing to dampen my enthusiasm the first time I had the chance to head west on the train to the Park. Collectors are born, not made, and I am a collector. I collected Great Northern Railway memorabilia from menus to mountain goat masks that came in handy at Halloween. Other trips were by car traveling down Highway 2 that sliced through the amber, rolling plains of northern Montana. It was thrilling to see how quickly my world changed from horizontal and brown to vertical and green as we approached Browning.

The years went by. More trips were taken. This time with my own children and friends. Once you enter the Park not much has changed over the last hundred years. The magnificent lodges and the Going-to-the-Sun road are reminders of a grand past and seem like part of the natural order there now. Hiking and horse trails still lead to magnificent vistas, and the lodge lobbies are still as inviting as ever. Fortunately, Louis Hill, head of the Great Northern Railway, saw to it that the lodges and chalets enhanced the lure of the Park. It's comforting to know that the mountains, streams, lakes, and waterfalls will never be further commercially developed; thanks to George Bird Grinnell, the father of Glacier National Park, who lobbied for years for Park status.

Charlie Russell is every Montana boy's hero. Enormously talented, yet self effacing, Russell was drawn to Glacier spending every summer for the last twenty years of his life at Bull Head Lodge on Lake McDonald. While researching his life for *Charles M. Russell, Legacy*, a book I wrote for the Russell Museum in Great Falls, I came to appreciate Glacier even more through learning about the numerous authors, photographers, and painters that visited him at Bull Head Lodge. This led to studying other artists that left their mark on the Park. Its fascinating how so many of them crossed paths and how passionate they were for Glacier. The story of Glacier is told best through their works. Perhaps no other Park has attracted such national and international talent.

Whether it was growing up next to the Fort Peck Indian Reservation or being drawn to the compelling, tragic story of the native Americans,

I have always found the art of Glacier more appealling when it involves Indian subjects. Maybe, they are the connection to a passing way of life that all of us nostalgics long for. Whatever reason, the power and majesty of the Kootenai, Flathead, and especially the Blackfeet are no better demonstrated than by the artists of Glacier National Park.

I hope that after you read this book and enjoy the images, that you won't have to rely just on your memory in the future to recall the grandeur that is Glacier. Indeed, all the artists answered the "Call" in their own unique way. By doing so they gave the gift of art to generations to come. Unfortunately, it is beyond the scope of this book to mention every artist that visited Glacier. They are just too numerous. I apologize if I have left out one of your favorites. Nonetheless, the artists profiled provide a window to the past in a way that will never be equaled again. As long as there is the place we call Glacier National Park, there will be new artists eager to follow in the footsteps of these great Americans.

Larry Len Peterson

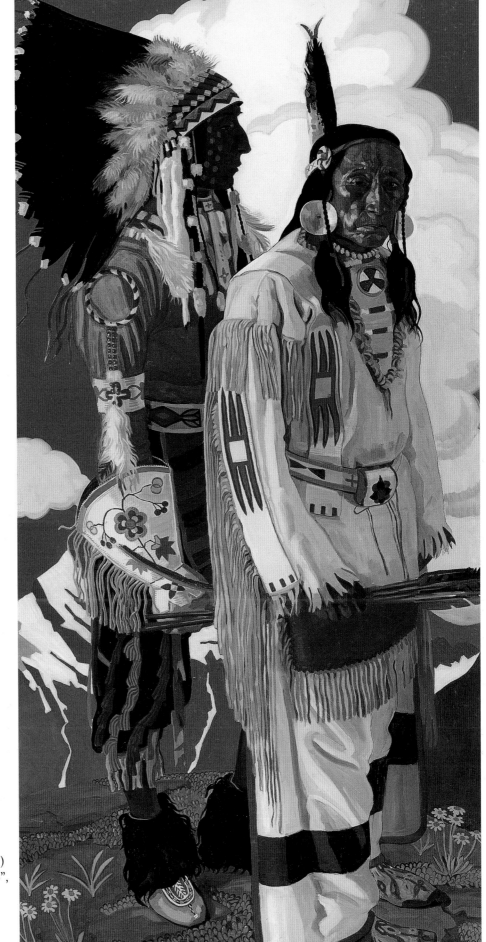

Many White Horses and Eagle Calf (1927)
by Winold Reiss, oil on canvas 80" x 36",
CAA

Acknowledgments

Traveling down Highway 2 from northeastern Montana, I first saw Glacier National Park from the back seat of my parents' Impala station wagon. The sudden rise of the blue Rockies from the straw-colored plains was a shock to a young boy's eyes. I wish my parents were still alive so I could thank them for making Glacier country such a lasting and wonderful place for me. I've tried to do the same for my family and hopefully, my daughters will do likewise for their children.

Many answered my "call." The research trail was met at every stop with enthusiastic individuals who went out of their way to assist so that the first book on the artists of Glacier could become a reality. Some had private art collections, some owned galleries, and others worked for institutions. Without their help, there would be no book.

Without a doubt, my soul mate on this publication is Stuart Johnson who helped edit the text. From the beginning his enthusiasm and support have been unwavering. Stuart and his family spend every summer in Kalispell within view of the Park. His staff at Settlers West in Tucson,

Arizona was tremendous. Michael Salkowski assisted Stuart with the editing and did a fine job as usual. Carol Lowry again did a stellar job with the graphic design. Her ability to give an art book the right look is uncanny.

Kirby Lambert, curator at the Montana Historical Society, gave me the idea for the book after I read his 1996 article, "The Lure of the Parks," that appeared in *Montana: The Magazine of Western History*. Glacier National Park was well represented, and the illustrations in the article really sparked the fire. Throughout the project, he helped me at every step. His coworkers, Susan Near and Martha Kohl, and the rest of the staff at the Society were invaluable. Deirdre Shaw at the Glacier National Park archive, West Glacier, provided me with research material and photos on many of the artists. Eileen McCormack at the James Jerome Hill Reference Library in St. Paul, Minnesota shared several wonderful images of the Hill family with me. Stephen Mark at Crater Lake National Park helped with Fred Kizer, as did the Oregon Historical Society. The staff at the Charles M. Russell Museum, one of my favorite places, came to my aid on several occasions.

William Healey, the foremost collector of the art of John Fery, let me pick the cream of the crop to reproduce. He has always been a big help on past projects. Bill King at the Bozeman Trail Gallery in Sheridan, Wyoming lent some rare examples of Joe De Yong's landscapes. Mike Overby at the Coeur d' Alene Galleries in Idaho provided several images, including one by Lone Wolf. Jeff Cornell at Two Medicine Gallery in Whitefish, Montana shared his fabulous collection of Great Northern Railway promotional brochures. While some artists were often not credited, their work was bright and beautiful. Joyce Clarke Turvey, John Clarke's daughter, is keeping her father's art alive from her gallery at East Glacier. She provided many images of him working on his woodcarvings. John Howard at John Howard Fine Arts, Inc. in Missoula provided images and biographical information, and went the extra mile for me. What else would you expect from a fellow University of Oregon Duck? Mitchell Brown at Mitchell Brown Fine Arts, Inc. in Santa Fe, New Mexico shared several rare Maynard Dixon oils of Glacier. Thomas Minckler at the Thomas Minckler Gallery in Billings shares my love of books, art, and George Bird Grinnell. He

also provided rare photos and biographical information for the book. Thomas Nygard at Thomas Nygard Galleries in Bozeman shared numerous images by Winold Reiss, Maynard Dixon, and Joseph Sharp. I would especially like to thank Curtis Tierney for selecting the pieces. Paul Masa in Kalispell and Steve Rose at the Biltmore Gallery in Scottsdale also provided important pieces. Sally Hatfield who still lives in her grandfather's home (Frank Bird Linderman) on Flathead Lake shared rare photos.

A very special thanks to the Van Kirke Nelson family—Kirke, Helen, and Doug— who live in Kalispell and play in Glacier National Park. Kirke has collected Glacier material for decades and graciously sent me crates full of goodies to photograph on numerous occasions. As all who know them have discovered, they love to show off the wonders of the Park. I will never forget the time we hiked to Granite Chalet. My knees have never been the same. The Nelson's Glacier Gallery in Kalispell is a wonderful place to learn more about Glacier and its artists. Linda Engh-Grady, who works there, was most helpful in securing images of several paintings.

Past publications laid the foundation for this one. Unfortunately, all can't be listed, but several need special recognition. The Glacier Natural History Association (West Glacier, Montana 59936) has published numerous outstanding books and brochures on Glacier. Four of the most important are: *Through The Years in Glacier National Park* by Donald Robinson (1960) and reprinted many times, *Man In Glacier* by C. W. Buchholtz (1976), *Place Names Of Glacier/Waterton National Parks* by Jack Holterman (1985), and *Stars Over Montana: Men Who Made Glacier Natioanl Park History* by Warren L. Hanna (1988). No one loved Glacier more than Hanna, and his book chronicles the lives of the men who "played vital roles in the creation of the Park as we know it today." Other important publications are: *Grinnell's Glacier: George Bird Grinnell and Glacier National Park* by Gerald Deittert (1992), *James J. Hill: Empire Builder of the Northwest* by Michael Malone (1996), and *Glacier's Historic Hotels & Chalets: View with a Room* by Ray Djuff and Chris Morrison (2001). Christiane Diehl-Taylor in her important article, "Passengers, Profits and Prestige: The Glacier Park Hotel Company, 1914-1929," in *Montana: The Magazine of Western History* (1997) first showed the importance of Glacier to Louis Hill in terms of prestige since the Hotel Company never was a profitable endeavor. An ongoing tribute to artists who painted in Montana is published quarterly in *The Big Sky Journal* by University of Montana professor, Dan Flores. It is a must read. Also, thanks to all the authors who have written books on the individual artists.

Others who have answered my call are: Bob Amon, Jim Bennett, Jim Combs, Brian Dippie, Bob Drummond, Pat Fuchs, Harold Grover, Peter Hassrick, Kevin Lawson, Ron Lerner, John Murphy, Bob Rasmussen, Ginger Renner, Steve Schmidt, Neil Snyder, Dave Solberg, Rick Stewart, the Timmermans (Craig, Gary, and Joel), Bill Ward, Clif White, and Jack Zuber.

Visits to Glacier are made most special when accompanied by my family. Love and thanks to LeAnne, my enduring wife who is so supportive of my time at the computer and camera. To my children, Lara and Haley, keep going back to Glacier all your lives. To Beau and Lexy, thanks for keeping my feet warm while working on the project.

While this book focuses on the past artists, I would like to thank all of those that continue to paint Glacier. Three of my favorites are Joe Abbrescia from Kalispell, Tom English from Great Falls, and Charlie Fritz from Billings. I enjoy their work every day on the walls of my office and home.

And finally a special thanks to David Mihalic who I first got to know when he was the superintendent of Glacier National Park. His leadership and love for the Park is contagious. He combines that passion with one for painting which he started when he was a teenager. This makes him ideal to reflect on the importance of Glacier. His foreword is a treasure. I was fortunate to accompany him and others several years ago on the Superintendent's Walk from Lake McDonald to the Prince of Wales. While I thought for sure I would be eaten by a Grizzly, it never happened, but I came away from the hike with a deeper appreciation for Dave's wit, humility, and kindness. I hope in his busy life being the Superintendent of Yosemite National Park he finds time to keep painting. I know Jeri, his wife, will make sure he does. Dave's comments reflect the feelings of all artists who have answered the "Call" of Glacier, "I paint the parks and in doing so I strive to capture that spark that makes the viewer want to treasure those beautiful places forever. Without the parks—to paint or visit or dream about—our world, and ourselves, would be less than complete." Hopefully, your lives will be more complete after you read this book.

Larry Len Peterson
Black Butte Ranch
Sisters, Oregon
October 2001

Notes & Abbreviations

Dimensions of artwork are given height before width. Only artists who worked in the Park before 1930 are profiled. Perhaps some future work will explore the lives of the hundreds of deserving artists who have followed.

The abbreviations below indicate that multiple illustrations were used courtesy of one of the following collections:

BHC	Bill Healey Collection, Jackson, Wyoming
BSC	Big Sky Collection, Larry and LeAnne Peterson
BTG	Bill King, Bozeman Trail Gallery, Sheridan, Wyoming
CAA	Coeur d'Alene Art Auction
CAG	Mike and Lisa Overby, Coeur d'Alene Galleries, Idaho
CMR	Charles M. Russell Museum, Great Falls, Montana
FGR	Fred and Ginger Renner Collection, Paradise Valley, Arizona
GNP	Glacier National Park Archives/Glacier Natural History Association
JCC	Jeff Cornell, Two Medicine Gallery, Whitefish, Montana
JCT	Joyce Clarke Turvey, East Glacier, Montana
JFC	Jim and Fran Combs Collection, Great Falls, Montana
JHA	John Howard Fine Arts, Missoula, Montana
JHL	James Jerome Hill Library, St. Paul, Minnesota
MBA	Mitchell Brown Fine Arts, Inc., Santa Fe, New Mexico
MHS	Montana Historical Society, Helena
MSJ	Melody and Stuart Johnson Collection, Kalispell, Montana
TEC	Trails End Collection, Van Kirke and Helen Nelson, Kalispell, Montana
TMG	Thomas Minckler Gallery, Billings, Montana
TNG	Thomas Nygard Gallery, Bozeman, Montana

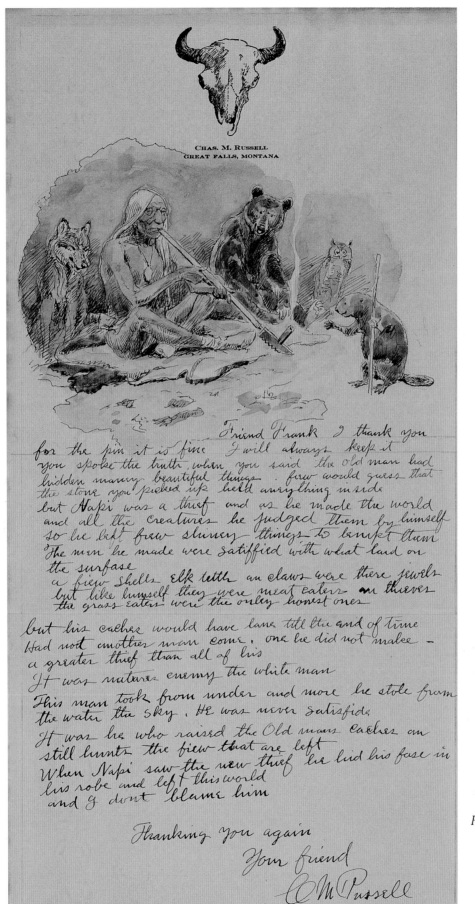

CHAS. M. RUSSELL
GREAT FALLS, MONTANA

Friend Frank I thank you
for the pin it is fine I will always keep it
you spoke the truth when you said the old man had
hidden many beautiful things . few would guess that
the stone you picked up held anything inside
but Napi was a thief and as he made the world
and all the creatures he judged them by himself
so he left few shiney things to tempt them
The men he made were satisfied with what laid on
the surface
 a few shells elk teeth an claws were there jewels
 but like himself they were meat eaters on thieves
 the grass eaters were the only honest ones

but his caches would have lane till the end of time
Had not another man come . one he did not make —
a greater thief than all of his
It was natures enemy the white man
This man took from under and more he stole from
the water the sky . He was never satisfide
It was he who raised the Old mans caches an
still hunts the few that are left
When Napi saw the new thief he hid his fase in
his robe and left this world
and I dont blame him

Thanking you again
 Your friend
 C M Russell

Friend Frank [Frank Linderman] by Charles M. Russell,
illustrated letter, 1914, TEC

Sign Talkers

The Authors

Do not lounge in the cities! There is room and health in the country, away from the crowds of idlers and imbeciles. Go west, before you are fitted for no life but that of the factory.

Horace Greeley's words, published in the *New York Tribune*, reflected the country's mood as the last great surge of migration moved across the western prairies. During the years immediately following the Civil War, encroaching civilization began to threaten our most prized and irreplaceable natural settings prompting enlightened individuals to rally to the land's defense. As early as 1833, frontier artist George Catlin proposed conserving a large portion of the Great Plains for wildlife and native inhabitants. Clearly, there were millions of acres deemed worthy of preservation. In 1864, Congress formally placed Yosemite Valley under the watchful eye of California, thus providing a model for the concept of publicly-used wilderness parks. Through the lobbying efforts of David Folsom, photographer William Henry Jackson, artist Thomas Moran, and others, Yellowstone National Park was established on March 1, 1872, thus protecting its wondrous geysers and boiling pools.

To the northwest, in a remote corner of Montana, a craggy, snow-capped mountain range, largely unexplored and virtually unknown, awaited recognition. Today we identify this rugged paradise as Glacier National Park, but at the turn of the century, most learned of the distant expanse only through books and magazines. Literary descriptions were enhanced by the imagery of skilled painters and photographers, opening all eyes to the splendor of Glacier's land and the nobility of its native people.

It was a diverse group of authors that rallied the cause. Wealthy and highly educated easterners like George Bird Grinnell and Walter McClintock understood the nostalgic affinity most Americans shared for Montana's passing frontier. Their stories, real and imagined, told fundamental truths about its indigenous people — Blackfeet, Kootenai, Flathead, and other nomadic bands who passed through the region to hunt buffalo or to raid enemies. Others, like James Willard Schultz and Frank Bird Linderman, rugged men who spent much of their lives in the territory, knew its people and could truly be called Montanans.

Once Glacier National Park was dedicated in 1910, "celebrity" authors came from the East, and their summer adventures were published as a means to entice vacationers to the area. Prominent writers like Mary Roberts Rinehart and Agnes Laut shared their fascination of the Park with a national audience. Some were paid by Louis Hill to extol the joys of Glacier, as he kept an eye on the interests of the Great Northern Railway, building imposing

log guest lodges and waiting for the tourists to arrive. Ballyhooed in countless books and periodicals, the natural beauty of Glacier attracted authors, photographers, and painters. Their work significantly advanced the preservation of what may confidently be called America's most beautiful mountain region. The story of Glacier National Park would be incomplete without celebrating the contributions of these dedicated individuals.

George Bird Grinnell (1849-1938)

It must have been a bittersweet moment for George Bird Grinnell, father of Glacier National Park, when he arrived at Many Glacier Hotel on July 11, 1926. How times had changed. The prior season saw park visitation surge past 40,000. This would be Grinnell's last trip to Glacier. He was no longer a young man, but at seventy-six, he still looked forward to hiking the mountain named after him. George and Elizabeth Grinnell went unnoticed in the lobby until Morton Elrod, a biology professor from the University of Montana and summer nature guide, recognized the couple. It had been years since the friends had seen each other, and after greetings, conversation turned to days gone by.

In the morning, Elrod, Grinnell, and a party of hikers trekked to his favorite haunts at Grinnell Lake and Grinnell Glacier. Since his first visit in 1887, the ice had receded almost 100 feet, and Grinnell sadly predicted, "All these glaciers are receding rapidly and after a time will disappear."

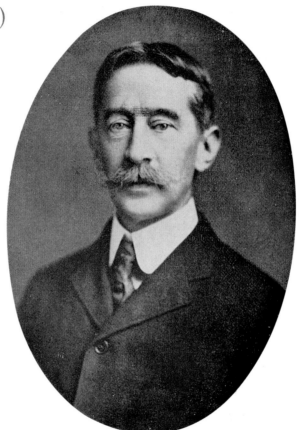

George Bird Grinnell
The father of Glacier National Park, GNP

The lifelong contribution of George Bird Grinnell toward the establishment of Glacier National Park cannot be understated.

Born on September 20, 1849 in Brooklyn, Grinnell spent his early years growing up on the former estate of naturalist John James Audubon. Here, he developed an interest in ornithology while peering from Audubon's very window. As he grew older, Grinnell suffered from neurasthenia, a trendy malady common among men of the upper class. Characterized by headaches and sleeplessness, neurasthenia was attributed to excessive study and nervous strain. Grinnell's treatment, though probably not prescribed by any physician, was to explore the American West.

His frontier adventures began in 1870. After completing undergraduate work at Yale, he accompanied Othniel C. Marsh, a renowned paleontologist, on a fossil-collecting expedition. During six months of travel, Grinnell found himself irresistibly drawn to everything the West had to offer, including Native Americans. When he returned two years later, he joined a large group of Pawnee gathered to hunt buffalo. From this

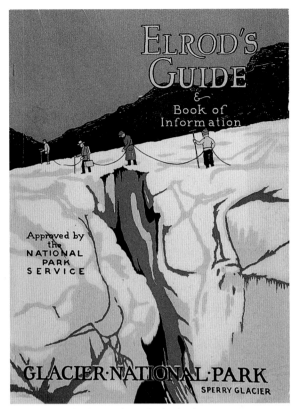

Elrod's Guide & Book of Information
by Morton Elrod, 1930, BSC

initial contact, Grinnell viewed Native People as instructors. In one article in *Forest and Stream* titled "What We May Learn from the Indian," he described how they protected the game on which they survived by practicing proven methods of conservation in hunting.

Grinnell returned to the Black Hills in 1874 to catalog the birds and mammals of the region for Colonel William Ludlow, Chief Engineer for the Department of Dakota Territory. While on this trip, he met Lieutenant Colonel George Armstrong Custer, and became friends with the

famous scout, "Lonesome" Charley Reynolds as they tried to defend gold seekers from the Sioux. Grinnell's assessment of the area was completed as he traveled toward Fort Abraham Lincoln.

Impressed by his efforts, Ludlow asked Grinnell to join an expedition through Montana Territory the following year, focusing on the country around Yellowstone National Park. The party traveled by boat from Bismarck to the Judith Mountains, on to Fort Ellis (near Bozeman), and finally down through Yellowstone country. Grinnell was shocked when he witnessed the senseless slaughter of wildlife and stated this in his official report to Ludlow:

It may not be out of place here to call your attention to the terrible destruction of large game, for the hides alone, which is constantly going on in those portions of Montana and Wyoming through which we passed. Buffalo, elk, mule-deer and antelope are being slaughtered by thousands each year, without regard to age or sex, and at all seasons. Of the vast majority of animals killed, the hide is only taken. ... The Territories referred to have game laws but, of course, they are imperfect and cannot, in the present country, be enforced. ... It is certain that, unless in some way the destruction of these animals can be checked, the large game so abundant in some localities will ere long be exterminated.

Due to his growing reputation as a sportsman who enjoyed hunting but loathed the wanton killing of wildlife, *Forest and Stream* hired Grinnell as its natural history editor in the spring of 1876. For $10 a week, he wrote book reviews and several pages of copy while still working on his Doctorate in osteology and vertebrate paleontology at Yale and assisting Professor Marsh at the Peabody Museum in New Haven. Bound by his commitments, Grinnell was forced to turn down an invitation to accompany the troops on what was to be Custer's fateful campaign against the Sioux in Montana Territory. Years later, Grinnell recalled:

Had I gone with Custer I should have in all probability been mixed up in the Custer battle, for I should have been either with Custer's command, or with that of Reno, and would have been right on the ground when the Seventh Cavalry was wiped out. Very likely I should have been with Reno's command as Charley Reynolds and I were close friends and commonly rode together.

From his earliest days at *Forest and Stream*, Grinnell bought stock in the company. By 1880 he owned almost one third of the magazine and eventually became its president and editor. The business proved lucrative, and in 1883, he was able to purchase 1,100 acres in the Shirley Basin in Wyoming Territory. His ranch investment

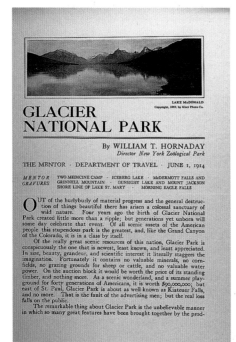

William T. Hornaday in his Bronx Zoo office, BSC

eventually failed, hastened by the harsh winter of 1886-87 that destroyed much of the livestock on the northern plains.

In 1883, Theodore Roosevelt, another consummate outdoorsman, went west to live the life of a sportsman and cowboy. His experiences inspired him to write such classic tales as *Hunting Trips of a Ranch Man*, and the four-volume *The Winning of the West*. In 1885, Roosevelt called on Grinnell at *Forest and Stream* to discuss one of Grinnell's reviews. Years later, Grinnell noted the significance of this occasion in his introduction to the twenty-volume *Works of Theodore Roosevelt*:

… after we had discussed the book … we passed on the broader subject of hunting in the West. … My account of big-game destruction much impressed Roosevelt, and gave him his first direct and detailed information about this slaughter of elk, deer, antelope, and mountain-sheep. No doubt it had some influence in making him the ardent game protector that he later became, just as my own experiences had started me along the same road.

It was this incidental meeting that brought together two of the Boone and Crockett Club founders. For years Grinnell championed the formation of a private organization to protect the rapidly changing West. In May 1884, he wrote in *Forest and Stream* about the need for an "association of men bound together by their interest in game and fish, to take active charge of all matters pertaining to the enactment and carrying out of laws on the subject." Limited to one hundred members, the Boone and Crockett Club was established in 1887. Its members shared an enthusiasm for big game hunting while loathing the disastrous effects both market hunters and settlers had on the indigineous wildlife population. At the founding dinner held at Theodore Roosevelt's home, distinguished guests included novelist Owen Wister, painter Albert Bierstadt, General William Sherman, and William Hornaday, superintendent of the National Zoological Park in Washington.

Championing Grinnell's values, the club's goals were to: 1) promote manly sport with the rifle, 2) promote travel and exploration in the wild, 3) work for the preservation of the large game of this country and assist in enforcing the existing laws, 4) promote inquiry into, and record observations on the habitats and natural history of the various wild animals, and 5) bring about among the members the interchange of opinions and ideas on hunting, travel and exploration, various kinds of hunting rifles, and conservation of the habitat of game animals. From its inception, Grinnell remained the group's most influential member. He embodied the principles the club stood for, wrote most of the Boone and Crockett book series on hunting and conservation, and advocated as one of its objectives to explore the only "wild and unknown … portions of the country" that still existed — including the St. Mary region in northwestern Montana.

Grinnell's interest in this area was peaked after reading James Willard Schultz's poignant description in a *Forest and Stream* article entitled "To Chief Mountain." Grinnell wrote Schultz and asked if he would guide him on a hunt, and by September of 1885, the two were together in St. Mary country. It was on this trip that Grinnell named the river flowing into St. Mary Lake, the Swiftcurrent River. As the men reached a mountain ridge overlooking the valley, heavy clouds moved in. They began their descent in

The Great Game for the Rulership of the World by Charles M. Russell in *How the Buffalo Lost His Crown* by John H. Beacom, 1894, BSC

falling snow. Grinnell's enthusiasm was not diminished:

An artist's palette, splashed with all the hues of his color box, would not have shown more varied contrasts. The rocks were of all shades, from pale gray, through green and pink, to dark red, purple and black, and against them stood out the pale foliage of the willows, the bright gold of the aspens and cottonwoods, the vivid red of the mountain maples and ash, and the black of the pines. In the valley were…lakes, turbid or darkly blue, somber evergreens; on the mountain side foaming cascades, with their white whirling mist wreathes, gray blue ice masses, and fields of gleaming snow. Over all

arched a leaden sky, whose shadows might dull, but could never efface, the bewildering beauty of this mass of color.

Glacier's spectacular scenery captivated Grinnell. Two years later, Lieutenant John H. Beacom, a career officer from Fort Shaw near Great Falls, joined Grinnell and Schultz to further explore the Swiftcurrent chain of lakes. At their base camp below Swiftcurrent Falls, Beacom named a towering mountain in front of them Apikuni, Shultz's Blackfoot name. The party went on to explore the area and named a glacier, lake and mountain after Grinnell. Likewise, Grinnell bestowed friends' names on surrounding peaks: Mount Wilbur for an associate at *Forest*

and Stream, Mount Allen for Cornelia Seward Allen, granddaughter of Lincoln's Secretary of State, and Mount Gould for a friend from Santa Barbara.

In 1889, Grinnell wrote his first book on Indian life, *Pawnee Hero Stories and Folk-Tales with Notes on the Origin, Customs, and Character of the Pawnee People.* It received critical and popular acclaim. Encouraged by the public's acceptance of a work on Native Americans, Grinnell urged his friend Schultz to write a book on the Blackfeet. Though Schultz had written an article, "Life Among the Blackfeet," for *Forest and Stream*, he preferred someone else write the first major book about these people. Schultz sincerely believed Grinnell should be the author and provided him with insightful notes. Grinnell appreciated Schultz's contribution, stating "... he is entitled to great credit, for it is most unusual to find any one living the rough life beyond the frontier, and mingling in daily intercourse with Indians, who has the intelligence to study their traditions, history, and customs, and the industry to reduce his observations to writing."

Grinnell wanted to finish mapping the St. Mary and Swiftcurrent regions and further explore the glacier above Upper St. Mary Lake. In 1891, on his sixth trip to the St. Mary area, Grinnell brought along William H. Seward, Jr. and Henry L. Stimson, fellow classmates from Yale. Schultz

Blackfoot Lodge Tales: The Story of a Prairie People by George Bird Grinnell, 1892, BSC

was the party's guide, and asked Billy Jackson, an Indian scout who fought alongside Reno at the Little Big Horn, to join the group. As expected, Grinnell named mountains in honor of his friends Stimson, Jackson, and Charles E. Reynolds, managing editor of *Forest and Stream*. After the trip, Grinnell stayed on at the Blackfeet Reservation gathering information for his upcoming book.

Published in 1892 by Charles Scribner's Sons, *Blackfoot Lodge Tales: The Story of a Prairie People*, stands as one of the most remarkable works ever published on Native People of Montana. It proved inspirational for other great authors of the period including James Willard Schultz, Walter McClintock, Frank Bird Linderman and John Beacom. Grinnell's sincere empathy for the plight of all American Indians was in direct opposition to the popular doctrine of manifest destiny where nature and "nature's people" were but minor irritants to the spread of progress. His words, written over one hundred years ago, mirror a more present day attitude:

The most shameful chapter of American history is that in which is recorded the account of dealings with the Indians. The story of our government's intercourse with this race is an unbroken narrative of injustice, fraud, and robbery. Our people have disregarded honesty and truth whenever they have come in contact with the Indian, and he has had no rights because he has never had the power to enforce any.

... Within two years, I have been present on a reservation where government commissioners, by means of threats, by bribes given to chiefs, and by casting fraudulently the votes of absentees, succeeded after months of effort in securing votes enough to warrant them in asserting that a tribe of Indians, entirely wild and totally

ignorant of farming, had consented to sell their lands, and to settle down each upon 160 acres of the most utterly arid and barren land to be found on the North American continent. The fraud perpetrated on this tribe was as gross as could be practiced by one set of men upon another.

Americans are a conscientious people, yet they take no interest in these frauds. ... I believe, in fact that practically no one has any personal knowledge of the Indian race. The few who are acquainted with them are neither writers nor public speakers, and for the most part would find it easier to break a horse than to write a letter. ...

I give the Blackfoot stories as they have been told to me by the Indians themselves, not elaborating nor adding to them. In all cases except one they were written down as they fell from the lips of the storyteller These are Indians' stories, pictures of Indian life drawn by Indian artists, and showing this life from the Indian' point of view

The Indian is a man, not very different from his white brother, except that he is undeveloped. In his natural state he is kind and affectionate in his family, is hospitable, honest and straightforward with his fellows, a true friend For his friend he will die, if need be

The Indian is intensely religious. No people pray more earnestly nor more frequently. This is especially true of all Indians of the Plains.

Using information provided by Blackfeet elders, Grinnell's masterpiece explored native religion, tribal origins, the role of medicine men, and the influence of war and warriors on their culture. A nation caught up in the nostalgia of the Old West was captivated by the stories. Despite its widespread popularity, first editions are rare; however, *Blackfoot Lodge Tales: The Story of a Prairie People* has been reprinted several times by the University of Nebraska Press.

Grinnell had not forgotten his main concern and wrote the editor of *Century Magazine* to see if he would publish an article on the St. Mary country. "The scenery ... is wonderfully grand; the mountains high and remarkably bold. ... Some day it will be a great resort for travelers. ... The mountains ... lie within the boundary of one of the proposed forest reserves, and some day I hope may be set aside as a National Park. ..." The article titled "The Crown of the Continent" remained unseen for nine years until there was a groundswell of support for Glacier's inclusion in the National Park System. Grinnell's commentary was not the first regarding Park status for Glacier. Lieutenant John Van Orsdale's letter, published by the *Fort Benton River Press* in 1883, preceded it:

I sincerely hope that publicity now being given to that portion of Montana will result in drawing attention to the scenery which surpasses anything in Montana or adjacent territories. A great benefit would result to Montana if this section could be set aside as a National Park.

Complicating the idea of protecting Glacier was the continuing increase of mining interest around the St. Mary country. With prospectors searching for gold, silver, and copper, a troubled Grinnell wrote a friend in 1885, "Paradise may soon be invaded by mines." Some authorities called for the Blackfeet to sell the mountains, hoping this would alleviate friction between the tribe and its white neighbors. The Blackfeet were indeed skeptical. Eight years earlier they had signed a treaty giving most of northern Montana to the Federal government for ten paltry annual payments of $150,000, only to have the money squandered away by reservation agents. The Indian leaders asked Grinnell and Charles E. Conrad, a Kalispell banker, to negotiate on their behalf.

A concerned Grinnell wrote the Blackfeet agent that the tribe "will be in serious need of further aid.... Indians are not competent to meet white men in business... ." Offered a position on the commission to study the problem, he declined stating, "The only motive that can influence me in this matter is the good of the Indians, and no

other consideration can enter into my view of the case. I had hoped that it might be practicable to set off the mountain part of the Piegan reservation as a national park, or a forest reserve, but if minerals actually exist there … there is of course no hope that my plan can be carried out."

Grinnell was a fighter, and at this impasse he sought the support of James J. Hill, arguably the most powerful man on the northern plains. Little did Grinnell know that it would be Hill's son, Louis, who would passionately embrace the concept of Glacier National Park. By means of introduction, he wrote to F.J. Whitney of the Great Northern Railroad, sharing his vision of:

… a public park and pleasure resort, somewhat in the nature of Yellowstone National Park, or the Banff National Park on the Canadian Pacific. I presume you are familiar with the St. Mary's Lakes. I am sure that Mr. Hill [president of the Great Northern Railroad] is, for I remember a year or two ago having quite a long talk with him on this subject. The matter is one of great interest to me and to other men in the east, and it should be of interest to intelligent persons of Montana.

Grinnell returned to Montana, stopping at the new Blackfeet agency at Willow Creek, where dozens of Indian friends met him with questions. He endeavored to "explain the bad things and praise the good" with mixed results. The Blackfeet believed that because prospectors illegally occupied part of the reservation, the forced sale of their land was inevitable. With the passing of the Indian Appropriations Act of March 2, 1895, Grinnell reluctantly agreed to be a member of the commission authorized to negotiate the selling price of the land in question. Later that year, the commissioners met the Blackfeet and after considerable bickering over land values, Chief White Calf accepted the offer of $1.5 million with certain conditions:

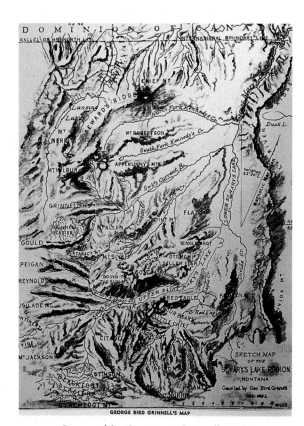

Crown of the Continent, Grinnell's 1892 map, published September 1901 in *Century* magazine, BSC

Chief Mountain is my head. Now my head is cut off. The mountains have been my last refuge. We have been driven here and now we are settled …. I want the timber because in the future my children will need it. I also want the grazing land. I would like to hunt and fish in the mountains …. I shake hands with you because we have come to an agreement, but if you come for any more land we will have to send you away.

While Grinnell was successful in coaxing the Blackfeet to sign the treaty, he remained troubled. Although he negotiated an agreement that had the best chance of Congressional approval, he sadly wrote, "It grieved me to think of that beautiful country being defaced by civilization and improvements so called, but there seemed no way to avoid facing conditions which existed." Unfortunately, Grinnell's participation in the treaty tainted his legacy with the Blackfeet, who like other Native Peoples, once again experienced an unceasing pattern of losing ownership of their land to whites.

Although the next several years saw Grinnell and his allies keeping pressure on the government to designate Glacier a national park, not all of Grinnell's attention was being focused on Montana. Another love appeared in his life. Grinnell's conservation articles caught the eye of a twenty-four year old photographer, Elizabeth

George Bird Grinnell and his wife, Elizabeth visit
Grinnell Glacier for the last time, 1926, GNP

Curtis Williams. That spring, Elizabeth accompanied him to Oklahoma Territory, where she took photos for a book he was planning on the history of the Southern Cheyenne. After a whirlwind courtship, the two were married in New York City in late summer. Like an eager child, Grinnell could hardly wait to take his new bride to the St. Mary country, and by the summer of 1900, the young couple were climbing Chief

Mountain. Grinnell was impressed with how quickly his new bride took to hiking, "The women climbed with extraordinary pluck and facility."

With oil speculators now in the region, Grinnell stepped up his call for political pressure in a 1905 *Forest and Stream* editorial:

> *Still another country—practically without inhabitants—yet marvelous in its wonderful beauty and grandeur—is that known as the St. Mary's country.... It is a region of marvelous lakes, towering peaks, vast glaciers and deep, narrow fiords. Few people know these wonderful mountains, yet no one who goes there but comes away filled with enthusiasm for their wild and singular beauty.*

James J. and Louis Hill now gave their full sponsorship to the idea of Glacier National Park, urging Montana Senator Thomas Hill to "Go for it." Feeling pressure from many directions, Senator Carter, along with Senator Joseph Dixon and Representative Charles Pray, introduced legislation to organize the Park in December of 1907. As in everything political, passage was hardly guaranteed as Congress studied, debated, and amended the original bill. Grinnell recruited conservationist Gifford Pinchot and other influential members of the Boone and Crockett Club to get involved. He targeted Congress in a *Forest and Stream* article:

> *I have been trying to get Senator Carter to introduce this bill for a good many years, and at last he has done it. I want now, if I can, to arouse in his mind sufficient interest in his own bill to get him to push it to a vote A generation hence it will be as great a resort as is the Yellowstone Park.*

There were setbacks. The House and Senate passed a slightly different versions of the bill, and it seemed compromise was impossible. Congress recessed without passage. Then, the Canadian government entered the fray by announcing its proposal to designate land directly north of Glacier for a National Park. Optimistically, Grinnell wrote:

> *No doubt it will be reintroduced in the next Congress, and will finally be enacted. ... It is gratifying to see the readiness with which Canada appears disposed to co-operate with the United States in the work of conserving the natural things of this continent. Two such good neighbors may wisely work together for so good an object.*

Third time was the charm. After more arm twisting by Grinnell, the Glacier National Park Bill was signed by President William Howard Taft on May 10, 1910. Grinnell received congratulatory letters from both Congressman Pray and Senator Carter. Grinnell's challenging mission had at last

succeeded. In 1929 Grinnell recalled, "Important men in control of the Great Northern Railway were made to see the possibilities of the region, and after nearly twenty years of effort, a bill setting aside the park was passed."

In 1911 Grinnell sold *Forest and Stream* in order to focus on studying and writing about Native American culture. His prolific book-writing career includes classics like *Blackfeet Indian Stories* (1913), *Wolf Hunters* (1914), *The Fighting Cheyenne* (1915), *The Cheyenne Indians* (1923), *When Buffalo Ran* (1923) and *By Cheyenne Campfires* (1926). Understanding the importance of his younger readership, some of his most well received books were written for children: *Jack Among the Indians*; *Jack, the Young Cowboy*; *Jack in the Rockies*; *Jack, the Young Explorer*; *Jack, the Young Canoeman*; and *Jack, the Young Trapper.*

Grinnell's busy schedule did not prevent him from returning to Glacier National Park almost every summer, although he was somewhat distraught by the large crowds and persistent development by the Great Northern Railway. When he and Elizabeth visited, they stayed in the comfort of the newly-completed Many Glacier Hotel, built in the very shadow of Mount Grinnell. In 1914, he told a friend, "… I continue to visit it even though it has been made a national park and is now more or less full of tourists."

Public recognition of Grinnell's lifelong contributions came in 1925 when he, Gifford Pinchot, and teacher Martha Berry each received the Theodore Roosevelt Distinguished Service Medal. President Calvin Coolidge praised Grinnell:

Mr. Grinnell, I am struck by the fact that this year I have the pleasure of presenting these Roosevelt medals to three pioneers. You and Miss Berry and Governor Pinchot have all been trailblazers. In the case of Miss Berry and Mr. Pinchot, however, it is true only in a figurative sense.

But you were with General Custer in the Black Hills and with Colonel Ludlow in the Yellowstone. You lived among the Indians; you became a member of the Blackfoot tribe. Your studies of their language and customs are authoritative. Few have done as much as you, none has done more to preserve vast areas of picturesque wilderness for the eyes of posterity in the simple majesty in which you and your fellow pioneers, first beheld them.

In Yellowstone you prevented exploitation, and therefore the destruction, of the natural beauty. The Glacier National Park is peculiarly your monument.

As editor for thirty-five years of a journal devoted to outdoor life, you have done a noteworthy

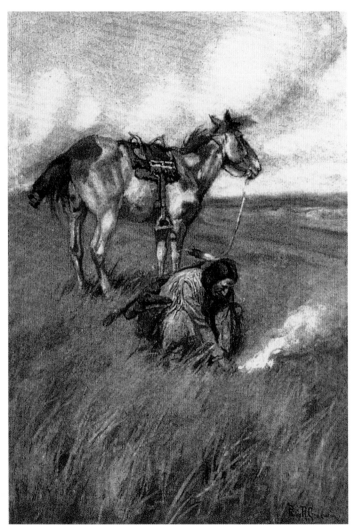

"*Then came a puff of smoke and the prairie afire,*" frontispiece by Philip R. Goodwin in *The Wolf Hunter* by George Bird Grinnel, 1914, BSC

service in bringing to the men and women of a hurried and harried age the relaxation and revitalization which come from contact with nature. I am glad to have a part in the public recognition that your self-effacing and effective life has won.

Although 1926 was the last time Grinnell visited Glacier National Park, his advancing years did not slow him down. He remained active on the Board of Directors for the American Game Protective Association, and served as president of both the National Parks Association and the Boone and Crockett Club. Grinnell expressed both sadness and optimism in a letter to a friend:

Most of us began as ardent hunters, but later our viewpoint changed.

To look back on wild life, as it was half a century ago is saddening, but the change of sentiment in recent years brings cheer. Many of us now recognize that we are trustees of this wild life for a coming generation.

Within the term of the life of one man, species that formerly swarmed here in the wild state have disappeared. The natural inhabitants of the soil have been killed or crowded out, and man occupies the places where they once roamed, and fed and bred. Their homes are gone. We have cut down our forests, cleaned up our fields,

drained our swamps and plowed up our lake beds. Yet a new era has begun, and more and more people demand that refuges be set aside where the wild creatures may live and man may not encroach on them. This, as I see it, is the question of the day.

Following a heart attack in 1929, Grinnell was weakened both physically and mentally, and his activities were greatly curtailed. He died on April 11, 1938 at the age of eighty-nine. The *New York Herald Tribune* praised him:

The passing of Dr. Grinnell cuts a strong strand in the remnants of the thinning cable that still links America with the age of its frontier.... His happy and penetrating gifts as a naturalist gave George Bird Grinnell his peculiar foresight with reference to the fate of natural resources.... He could visualize and work toward the everlasting sanctuaries of the Yellowstone and Glacier National Parks.... His outstanding characteristic was that of never-failing dignity, which was doubtless parcel of all the rest. To meet his eye, feel his iron handclasp or hear his calm and thrifty words—even when he was a man in his ninth decade—was to conclude that here was the noblest Roman of them all.

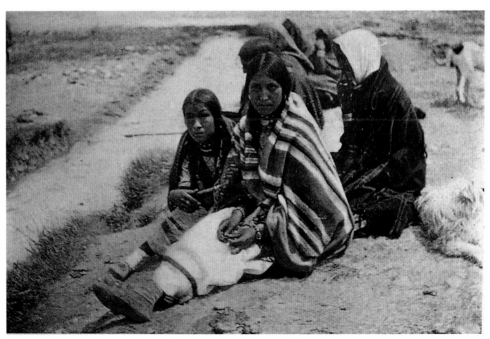

Photograph taken by George Bird Grinnell for *My Life as an Indian* by James Willard Schultz, 1907, TEC

James Willard Schultz (1859-1947)

James Willard Schultz was born in Boonville, New York in 1859. As a youth he developed a passion for the outdoors, spending much of his time hunting and camping in the Adirondacks. In the summer following his junior year at the Peekskill Military Academy on the Hudson River, Schultz traveled to St. Louis to visit his uncle, Benjamin Stickney. Spending his days on the waterfront, he eagerly listened to tales of adventure spun by riverboat crews returning from the West. Fascinated by their stories of Montana's wilderness, Schultz booked passage and headed up the Missouri for Fort Benton.

Shortly after he arrived, Schultz met Joseph Kipp, an early settler of the region and well-known prospector, trader, army scout, and rancher. Kipp took the young easterner under his wing, prompting Schultz to later write, "He was more than a brother to me. To him I owed the happiest years of my life." While spending the next several years with Kipp and his Blackfeet in-laws, Schultz kept details of his experiences in Montana. Chief Running Crane gave him the name Apikuni, meaning "Far-Off Spotted Robe." Kipp's wife, Double Strike Woman, arranged Schultz's

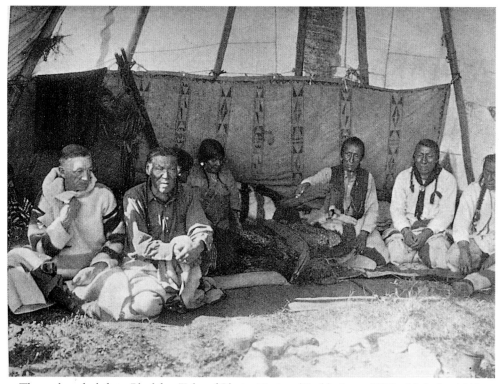

The author, far left, in *Blackfeet Tales of Glacier National Park* by James Willard Schultz, 1916, BSC

marriage to fifteen-year-old Fine Shield Woman who bore his first son, Hart Merriam, on February 18, 1882. Hart later became an important regional artist, using his Blackfoot name, Lone Wolf to sign his paintings. Schultz witnessed the last days of freedom for these nomadic people, brought about in part by the white mans' total destruction of the once vast buffalo herds.

From his earliest days as a hunting guide, Schultz was known as a gifted storyteller. In the late summer of 1888, he guided a group from Troy, New York through the Cut Bank and St. Mary country. Their experiences resulted in an adventure book, *Sport Among the Rockies*. Schultz claimed the stories were greatly exaggerated, though they made for brisk sales. On another occasion, the celebrated eastern writer, Emerson Hough, hired Schultz to guide a hunting trip along the west side of the Rockies. That fall, with Schultz guiding them, Hough and his wife explored the valleys of Two Medicine and Swiftcurrent, and the St. Mary Lakes. Shortly after the sudden death of Fine Shield Woman from heart disease, Schultz agreed to take Ralph Pulitzer, the son of the famous journalist Joseph Pulitzer, on a hunting trip where they illegally shot four bighorn rams. When local game officials discovered the offense, Pulitzer was heavily fined. Schultz, always a bit of a maverick, panicked and fled the state.

Drifting, he spent time in Arizona where he wrote *My Life as an Indian*. Using the pen name, W. B. Anderson, the book was first serialized in *Forest and Stream* as "In the Lodges of the Blackfeet." In 1907, it was published as a book and illustrated with photographs taken by Grinnell. In an editorial note Grinnell praised his friend:

In this account of his long residence with the Blackfeet, Mr. Schultz has given us a remarkable

story It is a true history and not romance, yet abounds in romantic incident. In its absolute truthfulness lies its value

The book has extraordinary interest as a human document. It is a study of human nature in red. The author has penetrated the veil of racial indifference and misunderstanding and has got close to the heart of the people about whom he writes.

Schultz settled in California and worked for the *Los Angeles Times* as literary editor. Still, he grieved for Fine Shield Woman, and despite the success of

his first book and a new job, his personal existence was miserable. Lonely and looking for companionship, Schultz placed a personal ad in *Heart and Hand*. One respondent was Celia Belle Hawkins, and in 1907 the two were married. His popularity continued to increase, and in 1914, Schultz made the decision to return to Montana. With his new prominence, he was somewhat of a celebrity. He began a controversial campaign to give Blackfeet names to Glacier Park sites. Grinnell, among others, was not amused and commented "... the white tourists cannot handle such names as Siksikakwan." He found his friend's efforts "comic and sad":

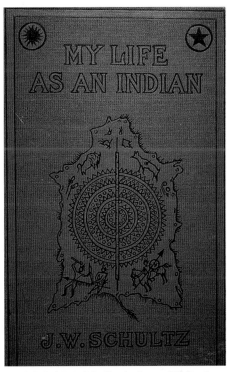

My Life as an Indian by James Willard Schultz, cover, 1907, TEC

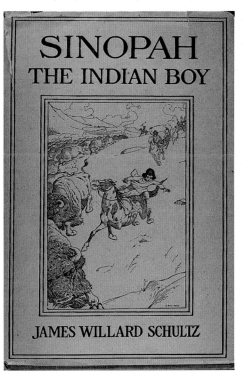

Sinopah: The Indian Boy by James Willard Schultz, dust jacket, 1913, TEC

Schultz, it seems, has the privilege of naming, or renaming, the mountains, lakes, peaks, etc., in the park. I have seen a partial list of names, and they include those of his friends; old coffee coolers who used to lie around Ft. Benton or Ft. Conrad — regular scrubs — not one old time, respcted chief in the bunch.

Louis Hill invited Schultz to stay in the Park as his guest. In an effort to bring further national attention to the area, Schultz engaged some of his Blackfeet friends to visit important sites in Glacier. Photographer Roland Reed accompanied the party and shot dramatic images of the Blackfeet amidst spectacular settings. Schultz used Reed's photographs to illustrate the resulting book, *Blackfeet Tales of Glacier National Park.* Chronicling Native legends, the book was dedicated in 1916 to Schultz's patron, Louis Hill. Schultz wrote, "True friend to my Blackfeet people, and the one who has done more than any other individual, or any organization, to make the wonders of Glacier National Park accessible to the American people."

Each summer, beginning in 1915, Schultz and his wife were brought by the Great Northern Railway from Southern California and given lodging in the Park. In return, Schultz penned additional memoirs such as *Friends of My Life as an Indian* (1922), and *Signposts of Adventure* (1926). The couple's last trip together in 1927 proved ruinous to an unhappy marriage when Celia found Schultz attending an Indian ceremony with Jessica Donaldson, a professor of English at Montana State College. By 1930 they divorced, and in 1932 Schultz married Donaldson, who was twenty-eight years younger. Together, they wrote *The Sun God's Children.* With the onset of the Depression, the couple moved often searching for work. In the

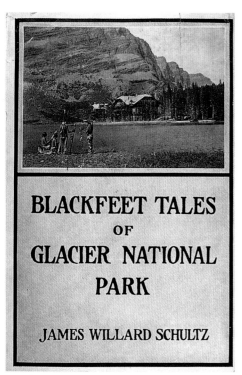

Blackfeet Tales of Glacier National Park by James Willard Schultz, dust jacket, 1916, TEC

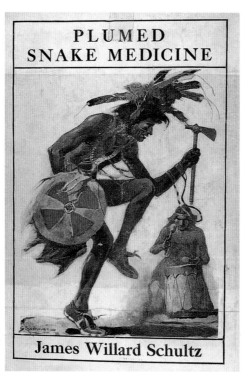

Plumed Snake Medicine by James Willard Schultz, dust jacket, 1924, TEC

Signposts of Adventure by James Willard Schultz, dust jacket, 1926, JCC

Signposts of Adventure by James Willard Schultz, cover, 1926, TEC

mid-1930's, they lived on the Blackfeet Reservation. Schultz was seventy-five, in failing health, and no longer able to write. They later moved to the Wind River Reservation in Wyoming where Schultz suffered a fatal heart attack on June 11, 1947. His son, Lone Wolf, designed a grave marker for his father who was buried next to his Blackfeet friends in Browning, Montana. Jessica shared her husband's love of Native People and dedicated the rest of her life working for the benefit of Native Americans. After her death in 1976, she was bestowed an honorary degree in letters by Montana State University.

Although Schultz had little formal education, he proved to be a prolific writer, often finishing two or three books a year. It is estimated that since 1911, over 2 million copies of his books have been printed, with *My Life As An Indian* accounting for nearly 500,000 of the total number. In addition to the 37 books published in his lifetime, four other manuscripts were published posthumously by the University of Oklahoma Press: *Blackfeet and Buffalo* (1962), *Floating on the Missouri* (1979), *Why Gone Those Times?* (1974), and *Many Stranger Characters* (1982).

One of Schultz's greatest accomplishments was his leadership of The Indian Welfare League, an organization that struggled to attain full citizenship for all Native Americans.

Schultz writings remain popular today. The James Willard Schultz Society, founded in 1976, publishes a quarterly and holds its conventions in Glacier National Park. Schultz brought to the American people compelling narratives of the Blackfeet, written with the compassion and understanding that could only come from his own experiences living with these noble people.

Walter McClintock (1870-1949)

Walter McClintock was born in 1870 in Pittsburgh, Pennsylvania. His education at the private Shadyside Academy, which his father helped found, was followed by graduation from Yale in 1891. Five years later, President Grover Cleveland selected a group of conservation-minded individuals to travel to northwestern Montana for the purpose of establishing a national policy on land preservation. Included were Gifford Pinchot, chief of the U.S. Forest Service; forester Henry S. Graves, who later became the Dean of the School of Forestry at Yale; and McClintock.

Billy Jackson, who was one quarter Blackfeet, and Jack Monroe led the group. Afterwards, McClintock returned with Jackson to the annual Sun Dance ceremony gathering. There he met Chiefs White Calf, Running Crane, Little Plume and Little Dog — all traditional Blackfeet leaders. After the Sun Dance, he returned to Jackson's cabin in East Glacier, and stayed until autumn, often visiting his new friends at the nearby Blackfeet camps. Such experiences forever changed McClintock's life. He became so well respected that Mad Wolf ceremonially adopted

him, and Chief White Calf later bestowed on him an Indian name, stating, "This is the white weasel, one of the sacred animals in our beaver bundle. We name you 'A-pe-ech-e-ken' (White-Weasel-Moccasin), because your color is light (his hair was blond) and your eyes are blue. We pray this name may bring you long life and good luck." Their friendship was mutually beneficial. Mad Wolf knew McClintock would help in dealing with the white man, in turn, through copious notes and photographs, he was able to document a vanishing way of life.

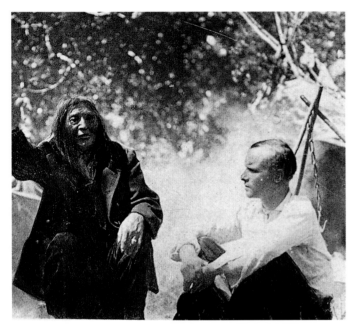

Walter McClintock, right, in *Southwest Museum Leaflets*, 1937, TEC

The Old North Trail by Walter McClintock, cover, 1910, BSC

An astute observer, McClintock put together a series of lectures on the Blackfeet, enhanced by lanternslides of his beautiful photographs. He presented them to enthusiastic American and European audiences, stopping at the Berlin Society of Anthropology, Ethnology and History at the Imperial Museum; the Royal Institute in London, Oxford, and Cambridge; and the Royal Society in Dublin. In 1907, Theodore Roosevelt warmly welcomed McClintock to the East Room of the White House, where he was introduced to cabinet members, Supreme Court judges, and diplomats from around the world.

McClintock's books on the Blackfeet left an enduring legacy. *The Old North Trail*, or *Life, Legends and Religion of the Blackfeet Indians,* published in 1910, is a landmark study into the center of the Blackfeet world. Its 539 pages explored their ceremonial customs and spiritual beliefs, McClintock's adoption into the tribe, and current issues facing the Blackfeet. McClintock sounded optimistic when he wrote:

Under the passing of the old conditions and the coming in of the new policy, the younger generation of Blackfeet is already responding, and manifesting a capacity for improvement. They are becoming the owners of real estate, and are developing thrift and an ability to provide for the future. A visitor to-day, in the Blackfeet country, unless he should happen to come at a time when they have quit work and have assembled for a few days' recreation in their tribal camp, would not know that he was among Indians. He would now see a marked advance towards civilized conditions, and a striking contrast between the older generations of Indians, who, because of their fixed habits of hereditary savagery, are incapable of work, or a settled occupation, and their children, who are being educated and trained to work and to industrial pursuits.

The Old North Trail contains dozens of photographs taken by the author, and eight full-color illustrations skillfully painted by McClintock. In addition, the first appendix contains sheet music to nine songs: *Love Song, Wolf Song, Sioux Dance, War Song, Sioux Celebration Song, Riding Song, Night Song, Tribal Hymn, "Raising the Pole,"* and *Children's Game Song.* All were copyrighted by McClintock, who pointed out that, "Blackfeet songs are generally sung without words." The final page of the book consists of a fold out map showing "The Country of the Blackfeet Indians."

English reviewers praised the book:

Mr. McClintock gives us a thousand charming pictures—a few reproductions in color of excellent drawings, many more the work of his camera, but most and best of all, prose descriptions

Blackfeet Camp by Moonlight painted by Walter McClintock
in *The Old North Trail*, 1910, BSC

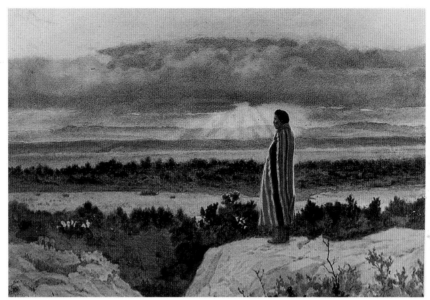

Sunrise from Lookout Butte painted by Walter McClintock
in *The Old North Trail*, 1910, BSC

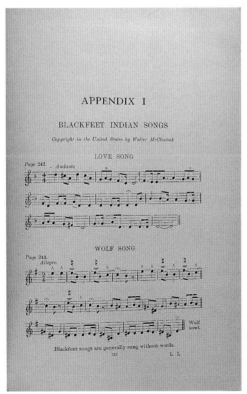

*Blackfeet Indian Songs — Love Song and Wolf
Song* in Appendix 1 of *The Old North Trail*,
1910, BSC

Lodges of Brave Dog Society photographed by Walter McClintock
in *The Old North Trail*, 1910, BSC

irradiated with the joie de vivre of the nomadic life of the foothills…. His book is a mirror, in which the soul of the red man, misunderstood for so many generations of his conquerors, is faithfully reflected, and yet is luminous with light from within. (London Times)

Many have written of what they saw and told us of their sports, the wars, the love and pastimes of these people of the Stone Age, but, since the days of Hunter, only the writer of the present volume has told us of their souls and their interior life. This book and Hunter's are perhaps the best books that have been written on the American Indians. (Nation)

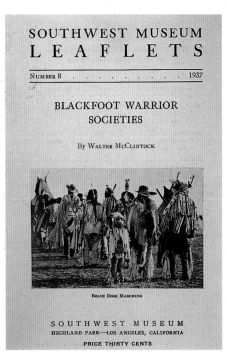

SOUTHWEST MUSEUM
L E A F L E T S

NUMBER 8 1937

BLACKFOOT WARRIOR
SOCIETIES

BY WALTER McCLINTOCK

BRAVE DOGS MARCHING

SOUTHWEST MUSEUM
HIGHLAND PARK—LOS ANGELES, CALIFORNIA
PRICE THIRTY CENTS

The extraordinary interest and value that are attached to this book have their foundation in the fact that no such book can ever be written again. The Blackfeet Indians of Alberta and Northwestern Montana are a dying race…. The book must take its place among the standard works of ethnology. (Standard of London)

Other books on the Blackfeet followed: *Old Indian Trails, The Tragedy of the Blackfeet, Blackfoot Tipi, The Beaver Bundle, Dances of the Blackfeet, The Warrior Societies,* and *Painted Tipis and Picture Writing.* For his outstanding efforts, The United States Geological Survey named the first peak along the continental divide north of Cut Bank Pass, Mount McClintock.

While his residence remained Pittsburgh, McClintock traveled each summer during the 1930s and 1940s to Glacier National Park. During the winter months he was busy lecturing at both Yale and Southwest Museum in Los Angeles. He authored several leaflets on American anthropology, published by Southwest Museum. In addition to his extensive writings on the

"Blackfoot Warrior Societies" by Walter McClintock in *Southwest Museum Leaflets,* 1937, TEC

Blackfeet, McClintock's collection of photographs depicting Blackfeet life is now stored in the two institutions and regarded as one of the most comprehensive records of any Indian people. Sadly, of all the important authors of northwestern Montana, McClintock is least remembered. In the Southwest Museum's *Anthropology Leaflet Number 8,* published in 1937, McClintock reflected:

Forty years ago, when the old generation of primitive Blackfoot Indians was still alive, I had unusual opportunity for study and observation by living in their camps. With horses of my own, an Indian tipi and camp equipment, I took care of myself and was independent. Always I had cameras and note-books, and made records of everything as I went along. I was introduced into the innermost circles of the tribe and became intimately associated with their camp life…. In the spring of 1896, when I first went among them, their country was still in its natural beauty and richness, before devastation by our white civilization.

Frank Bird Linderman (1869-1938)

Frank Bird Linderman grew up in the Midwest, arriving in the Flathead Valley in March 1885 at age sixteen. For seven years he made a living as a trapper and guide in the Flathead and Swan Valleys, before becoming assayer at the Curlew Mine in Victor, south of Missoula. In 1893 he married Minnie Jane Johns in Missoula, and they settled in Sheridan, Montana, where Frank ran an assay office. Six years later, he purchased the *Sheridan Chinook* newspaper and his writing career began.

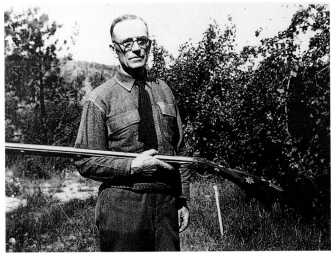

Frank Bird Linderman holding his "Clark" Kentucky rifle previously owned by John Lewis and Edgar Paxson. Linderman believed the rifle originally belonged to William Clark of Lewis and Clark fame, BSC

Linderman had political ambitions and was elected in 1903 and 1905 as a representative to the Montana legislature. After being appointed Assistant Secretary of State in 1905, Linderman moved to Helena where he resided for the next twelve years.

During these years, Linderman became friendly with many of the local Native leaders, including Rocky Boy of the Chippewa, and Little Bear of the Cree. The Chippewa and Cree were summarily left out of the reservation process and many became squatters on any open land they could find. In 1908, Linderman met with an influential group of Montanans — including Senator Paris Gibson, William Bole, editor of the *Great Falls Tribune*, and artist Charlie Russell — who gathered to advocate the idea of creating a reservation for these wandering people. Writing almost five hundred letters and telegrams over a ten-year period, Linderman used his political influence in an attempt to persuade the legislature to support his cause. In 1916, the success of his ceaseless campaign culminated with the creation of the Rocky Boy Indian Reservation near Havre, Montana.

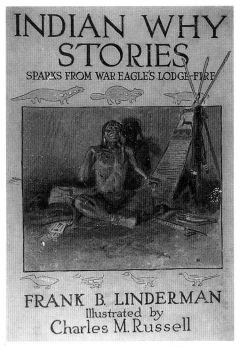

Indian Why Stories: Sparks from War Eagle's Lodge Fire by Frank Bird Linderman, cover, with illustration titled *The Storyteller #2* by Charles M. Russell, 1915, BSC

Linderman had always been intrigued with Indian culture, and now, partly inspired by the successful writings of George Bird Grinnell, he became totally immersed in their legends, customs, and beliefs. In September 1915, Charles Scribner's Sons released Linderman's *Indian Why Stories*, a collection of Blackfeet, Chippewa, and Cree legends retold by War Eagle, a mythical storyteller modeled after Chippewa leader, Chief Penneto. Dedicated to his friends, Grinnell and Russell, *Indian Why Stories* was illustrated by Russell. With delightful stories like "Why the Chipmunk's Back is Striped," "How the Ducks Got Their Fine Feathers," and "How the Otter

Skin Became Great 'Medicine,'" the book was warmly received by the public, and wildly popular with children.

War Eagle describes the main character as:

Napi, Old-Man, is very old indeed. He made this world, and all that is on it…. He was a busy worker, but a great liar and thief…. It was Old-Man who taught the beaver all his cunning. It was Old-Man who told the bear to go to sleep when the snow grew deep in winter…. There was no other man or woman then, and he was chief over all the animal-people and the bird people.

In his preface Linderman gave further explanation:

There is a wide difference between folklore of the so-called Old World and that of America. Transmitted orally through countless generations, the folk-stories of our ancestors show many evidences of distortion and of change in material particulars; but the Indian seems to have been too fond of nature and too proud of tradition to have forgotten or changed the teaching of his forefathers. Childlike in simplicity, beginning with creation itself, and reaching to the whys and wherefores of nature's moods and eccentricities, these tales impress me as well worth saving.

Linderman went on to write numerous volumes on Indian subjects: *Indian Old-Man Stories* (1920), *How It Came About Stories* (1921), *Kootenai Why Stories* (1926), and *Old-Man Coyote Stories* (1931). Through an interpreter, Linderman interviewed Chief Plenty-Coups on the Crow Reservation. In 1931, the John Day Company published Linderman's *American: The Life and Story of a Great Indian, Plenty-Coups, Chief of the Crows,* one of the most powerful and revealing books ever written on the Plains Indians. Plenty-Coups gave Linderman the name "Sign-Talker" and proudly stated in the book:

I am glad I have told you these things, Sign-Talker. You have felt my heart and I have felt yours. I know you will tell only what I have said, that your writing will be straight like your tongue, and I sign your paper with my thumb so that your people and mine will know I told you things I have written down."

For the twenty-fifth anniversary of Glacier National Park, Linderman was chosen by the Great Northern Railway to write the text for a book introducing the magnificent Blackfeet portraits by Winold Reiss. Linderman wrote:

Blackfeet! No tribal name appears oftener in the history of the Northwestern plains; no other is so indelibly written into the meager records of the early fur-trade of the upper Missouri river,

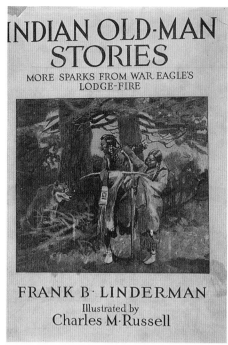

Indian Old-Man Stories by Frank Bird Linderman, dust jacket, with illustration *"Brother," Said Quo-too-Quat to the Wolf* by Charles M. Russell, 1920, BSC

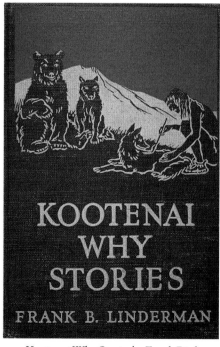

Kootenai Why Stories by Frank Bird Linderman, cover, 1926, BSC

and none ever inspired more dread in white plainsmen…

The tribes of the Blackfeet nation, the Pecunnies (Piegan), Bloods, and Blackfoot, are one people …. Nobody can tell their numbers when they came out of the north. Old Pecunnie warriors have told me that their tribe once counted 750 lodges, probably less than 4000 people; and we know that, of the three tribes of the Blackfeet nation, the Pecunnie was the most numerous.

At the end of the book, Grace Stone Coates profiled Linderman:

The first Indian he ever talked to was Red-Horn, a renowned Flathead. Linderman's account of their meeting, the inception of a lifelong friendship, is moving and beautiful. The boy didn't know a Flathead from a Kootenai….

Linderman's Blackfeet name is Iron-tooth. The Crows call him Sign-talker. The old Kootenais named him Bird-singer and the early Crees and Chippewas called him Sings-like-a-bird. His name is one to conjure with among the Crees and Chippewas. They call themselves Linderman Indians, because—wrung by their pitiable homelessness—he was instrumental in wresting from a dilatory and indifferent Government the Rocky Boy (Stone Child's) reservation near Havre, Montana.

Although historically important, Linderman's books had limited commercial success, prompting him to lament, "The critics all praise my books, but the public won't buy them." Frank Bird Linderman would be pleased to know that many of his books are still in print today, and are enjoyed by western history enthusiasts around the world.

The Promoters

Mary Roberts Rinehart (1876-1958) was already one of the most famous mystery writers in America when she wrote *Through Glacier Park* in 1916. Although not considered classics, her books, *The Man in Lower Ten* (1906) and *The Circular Staircase* (1907) are among the earliest works by any American author still in print.

Through Glacier Park was a departure from her suspenseful style. Sprinkled with photographs, it documented her 300-mile horseback trip across Glacier National Park led by the famous dude rancher, Howard Eaton. At first, Rinehart was somewhat averse to traveling with Eaton and his dudes, but her days in Glacier proved to be a wonderful experience.

In 1918 she penned a sequel, *Tenting To-Night*. It showcased images of the Park by several photographers, including Ted Marble and Fred Kiser. Rinehart's enthusiasm for Glacier was noticed by Louis Hill at the Great Northern Railway, and she was hired to write introductions for brochures:

If you are normal and philosophical, if you love your country, if you are willing to learn how little you count in the eternal scheme of things, go ride in the Rocky Mountains and save your soul.

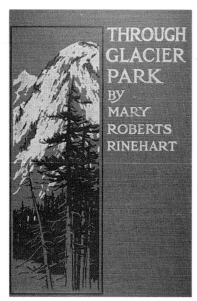

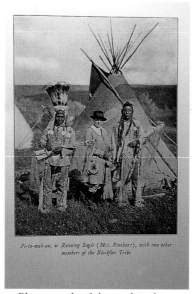

Through Glacier Park by Mary Roberts Rinehart, cover, 1916, BSC

Tenting To-Night by Mary Roberts Rinehart, cover, 1918, TEC

Photograph of the author from *Tenting To-Night*, TEC

There are no *"Keep off the Grass"* signs in *Glacier National Park. It is the wildest part of America…. It is perhaps the most unique of all parks, as it is undoubtedly the most magnificent. Seen from an automobile or a horse, Glacier National Park is a good place to visit….*

The call of the mountains is a real call. Throw off the impediments of civilization. Go out to

The Eaton party in 1915, from *Through Glacier Park* by Mary Roberts Rinehart. Second row, second from left, Charles M. Russell; back row, fourth from left, Mary Roberts Rinehart; fifth from left, Howard Eaton; Nancy Russell is seated in front of them, wearing a hat, BSC

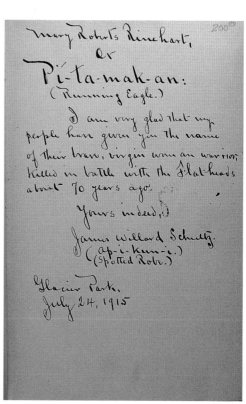

My Life as an Indian by James Willard Schultz, endsheet, signed in 1915 to Mary Roberts Rinehart, TEC

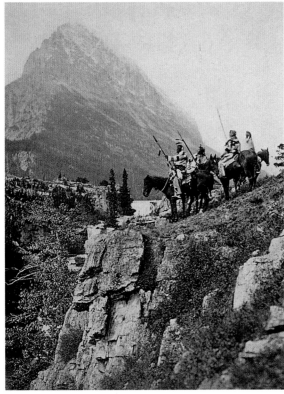

Sighting the Landmark by Roland Reed, 1926
on the frontispiece of *Enchanted Trails of Glacier Park*
by Anges Laut, BSC

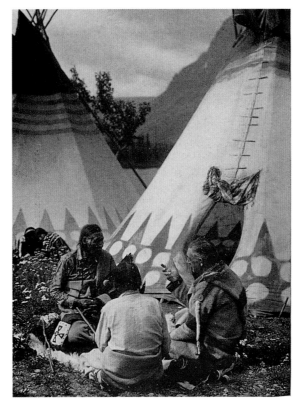

James Willard Schultz with friends, 1926
from *Enchanted Trails of Glacier Park*, BSC

Enchanted Trails of Glacier Park
by Agnes Laut, dust jacket, 1926, JCC

Blazed Trail of the Old Frontier
by Anges Laut, cover, 1926, BSC

the West and ride the mountain trails…. Then the mountains will get you. You will go back. The call is a real call.

I have traveled a great deal of Europe. The Alps have never held this lure for me. Perhaps it is because these mountains are my own—in my own country…. But there is no voice in all the world so insistent to me as the wordless call of these mountains. I shall go back. Those who go once always hope to go back. The lure of the great free spaces is in their blood.

Another of the "celebrity authors" was Canadian Agnes Laut (1871-1936). One of her best-known early works was the historical novel, *Pathfinders of the West: The Thrilling Story Of The Adventures Of The Men Who Discovered The Great Northwest—Radisson, La Verendrye, Lewis and Clark* (1904), featuring illustrations by Philip R.

Goodwin, John Marchand and Frederic Remington.

In 1925, the president of the Great Northern Railway, Ralph Budd, invited Laut and other notables to join the "Upper Missouri Historical Expedition." Beginning in St. Paul, the expedition was a celebration of the railroad's influence on the Northern Plains and Rocky Mountain region. The officials of Fort Union, at the confluence of the Missouri and Yellowstone Rivers, hosted an Indian Congress. As the train moved west, there were festivities and dedications all along the way, until its final stop at the summit of Marias Pass in Glacier. There, a monument was dedicated to explorer John F. Stevens, a Great Northern Railway employee. On July 22, 1925, Charlie and Nancy Russell hosted a banquet at the Lewis Hotel (now Lake McDonald Lodge).

The expedition inspired two books by Laut. *Blazed Trail of the Old Frontier: Being the Log of the Upper Missouri Historical Expedition under the Auspices of the Governors and Historical Associations of Minnesota, North and South Dakota and Montana for 1925,* chronicled the trip and featured forty-seven line engravings by Russell, completed shortly before his death that same year. Promoted as a travelogue, *Enchanted Trails of Glacier Park* also provided human-interest stories featuring James Willard Schultz, and artists Charles M. Russell and John Clarke. The book, illustrated with photographs by Roland Reed of Blackfeet Indians dressed in 19th century buckskins, created the illusion that they could still be found living a romanticized existence in the Park.

As the popularity of Glacier increased, so too did the need for improved transportation and better accommodations. The Great Northern Railway was more than willing to provide both — especially if the result was a tidy profit. Building rail lines that led to the Park remains James J. Hill's legacy, credit for development within the Park belongs to his son Louis. Louis' contribution includes not only the great lodges and chalets, but the impressive body of artwork he commissioned to fill them. Through the Hills' insightful leadership of the Great Northern Railway, these empire builders made Glacier National Park the destination of choice for many Americans.

Cover, *Glacier National Park: Its Trails and Treasures* by Mathilde Edith Holtz and Katherine Isabel Bemis, 1917, TEC

Many Glacier Camp, 1917, TEC

Cover, *Skyline Camps* by Walter Pritchard Eaton, 1923, JCC

Cover, *Girl Scouts in Glacier Park*
by Lillian Elizabeth Roy, 1928, JCC

Dust jacket, *High Trails of Glacier Park*
by Margaret Thompson, 1936, TEC

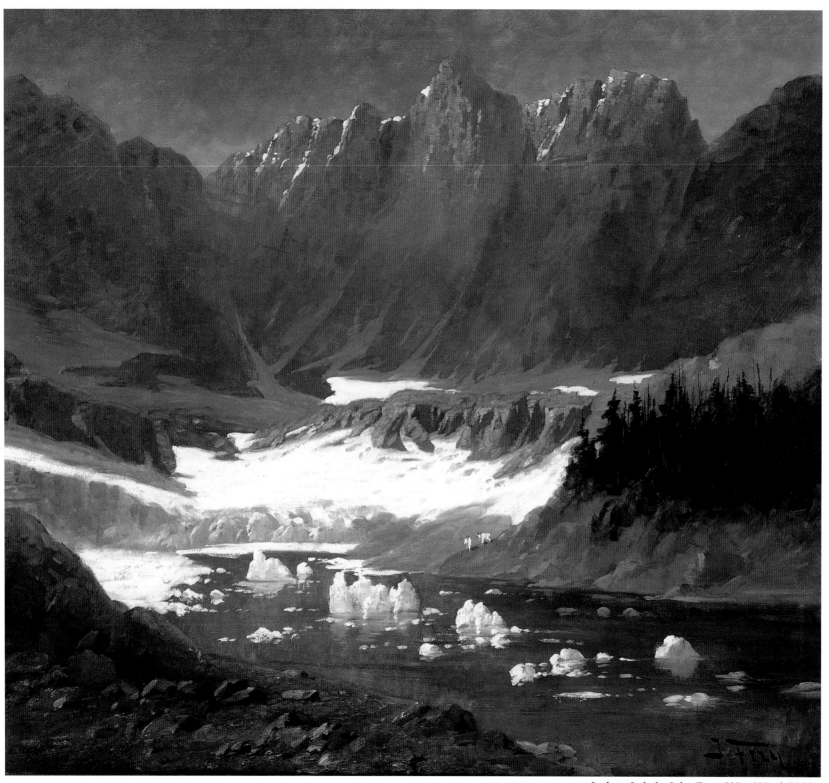

Iceberg Lake by John Fery, 52" x 58" oil, BHC

Empire Builders

The Hills and Their Artists

The conductor shouted his final "All Aboard" as the jewel of the Great Northern Railway slowly pulled out of Chicago's Union Station. The luxury train picked up speed and headed north to Minnesota. Passengers began settling down for the night as the cars turned westward, rushing across North Dakota and eastern Montana, then pushing gently during daylight hours through the scenic Rockies and Cascades en route to Seattle. With initial service in 1929, the Empire Builder was without doubt one of Louis Hill's finest triumphs. It allowed travel across the Northwest in a style and elegance that no other rail service was able to offer. When Louis Hill took over for his father, the Great Northern precedence for excellence did not falter. However, Louis's real interest lay not with arrival and departure times, but with developing the infrastructure necessary to lure rail travelers and other tourists to Glacier National Park. With rail lines in place and passenger trains comfortably transporting sightseers, it was up to him to make certain the Great Northern Railway played a substantial role in making the Park accessible by constructing the

James J. Hill (front left) and Louis Hill (standing next to his father) in Glacier National Park, 1911, JHL

James J. Hill, Vancouver, Washington, 1911, JHL

necessary roads and bridges, horse and hiking trails, chalets and lodges. These improvements came with considerable cost, but it was hoped that in the long run, the company would recoup its expenses and realize financial gain. How, was obvious to Hill — just entice more and more visitors. Aware of the need to increase public recognition of Glacier, he began commissioning artists for advertising campaigns. Although many gifted individuals worked on various projects, four men in particular became forever linked with the Great Northern and Glacier National Park. Painters John Fery and Winold Reiss, and photographers Fred H. Kizer and Tomar Jacob Hileman, were selected for their unique depictions of either the scenic splendor of Glacier or the native Blackfeet who lived nearby. All four came to know Louis Warren Hill.

Louis Warren Hill (1872-1948)

Perhaps to appease his father's concern over the railroad's increasing involvement in Glacier National Park, Louis Warren Hill once stated, "we wish to get out of it and confine ourselves strictly to the business of getting people there." Despite his words, Glacier had already stolen his heart, and Louis was not about to abandon it. Indeed, it was his father's initial influence that prompted legislation finally securing National Park status for Glacier in 1910. Like the Canadian Pacific Railway in Banff and the Northern Pacific in Yellowstone, the Great Northern maintained complete control over Glacier.

Hill was born the second of three sons to one of the richest and most powerful families in America. Educated at Exeter and Yale, he joined the Great Northern Railway in 1893, became its president in 1907, and served as chairman of the board from 1919 to 1930. Hill created the Glacier Park Hotel Company to oversee expanding tourism, and as president of this subsidiary, he began improving the roads, trails, and bridges on the east side of the Park. Taking advantage of the spectacular scenery, Hill chose locations for hotels stating, "The work is so important, I am loath to

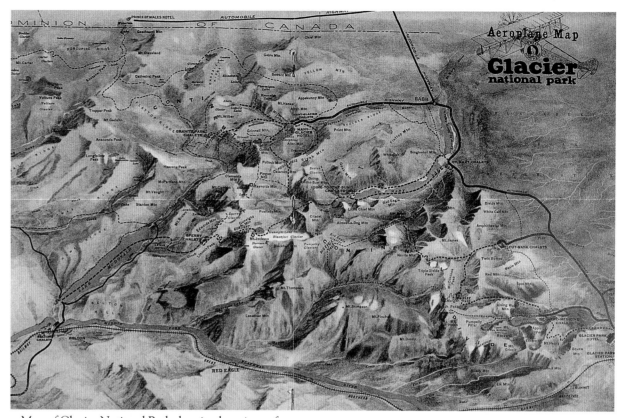

Map of Glacier National Park showing locations of lodges and chalets from the brochure "The Call of the Mountains," 1928, BSC

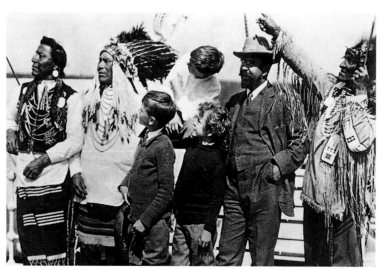

Louis Hill, Sr. and sons with (left to right) White Calf, Medicine Owl, and Many Tail Feathers, April 15, 1915, MHS

Letter on Glacier Park Hotel letterhead, 1921, BSC

entrust the development to anybody but myself." Ten hotels and chalets were planned in and around Glacier; including, Midvale, McDermott Lake (now Swiftcurrent), Belton, Sun Point, Cut Bank Creek, Granite Park, St. Mary Lake, Gunsight Lake, Sperry Glacier, and Two Medicine Lake.

First to be completed was the Glacier Park Hotel in 1913, with easy access to the new Glacier Park railroad station. Located within the Blackfeet Reservation, the 155-room hotel became the starting point for Great Northern tour packages of the Park. The massive structure was modeled after the giant timbered Forestry Center constructed for the 1904-1905 Lewis and Clark Exposition in Portland, Oregon. Elderly Blackfeet marveled at the hotel's giant fir and cedar columns and promptly named it Big Tree Lodge. The hotel was billed as "one of the most novel and interesting institutions of its kind in the country."

The lodge was barely opened to guests before enlargement became necessary. In 1913 and 1914, an annex building, power plant, employee's quarters, laundry, and expanded dining room were constructed. The Lodge facilities were further expanded in 1929 to include tennis courts, croquet grounds, a putting green, and a nine-hole golf course, all costing nearly $100,000.

Fifty miles north of Glacier Park Lodge, the picturesque Many Glacier Hotel rose on the shore of Lake McDermott at a cost of $500,000. Completed in 1915, the new hotel boasted 162 rooms, including eight luxury corner suites, all featuring steam heat and telephones. By the end of its first season, nearly half of Glacier's 13,465 visitors used its accommodations. Even Louis Hill and his family spent most Augusts there hiking, riding horses, fishing, and painting. Its popularity proved so great that in 1917 an 80-room annex was added, making Many Glacier by far the largest hotel in Montana.

With the 1927 completion of the Prince of Wales Hotel in Waterton Lakes National Park, the Glacier Park Hotel Company could provide lodging for 2,061 overnight guests along the Parks' eastern half.

In order to have a greater presence within the Park on the west side, Hill contemplated buying the Lewis Hotel on beautiful Lake McDonald. John

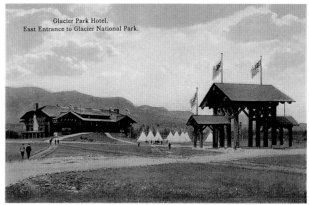

Glacier Park Hotel from "Souvenir Views of Glacier Park, Montana," circa mid-teens, BSC

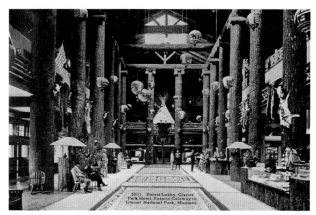

Lobby of Glacier Park Hotel from "Souvenir Views of Glacier Park, Montana," circa mid-teens, BSC

Lewis, a Columbia Falls attorney, purchased the property in 1914, and it was a favorite tourist destination and watering hole for noted westerners including artist Charlie Russell, humorist Irvin S. Cobb, and writer Frank Bird Linderman. In 1930, the railroad negotiated the purchase of the hotel at a price close to $300,000; five times its original cost, and later changed its name to Lake McDonald Hotel.

German-born landscape painter, Adolf Heinz in Glacier National Park, circa mid-1920's, GNP

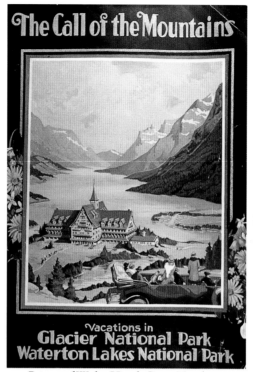

Prince of Wales Hotel, Great Northern Railway brochure cover, 1928, BSC

Painting by Adolf Heinz for Great Northern Railway brochure, circa mid-1920's, BSC

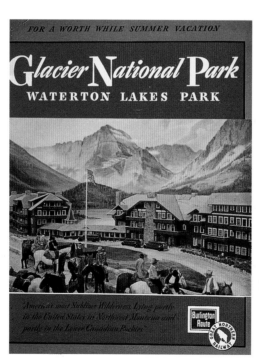

Many Glacier Hotel, Great Northern Railway brochure cover, circa 1930's, BSC

Between 1910 and 1929, the Great Northern Railway spent $2.3 million developing Glacier. With this large investment, Louis Hill naturally took an active role in Park promotion. Painters, photographers and authors were provided free transportation and lodging in the Park while they searched out material for proposed advertising. Some of America's top artists produced paintings to adorn postcards, stamps, playing cards, brochures, luggage stickers, books, coins, maps and guidebooks; virtually anything to promote Glacier. The slogan, "See America First," along with the symbol of the Park, a Rocky Mountain goat, became popularized throughout the nation. Paintings and photographs were hung in every Great Northern Railway facility. With over $300,000 spent annually on tourist promotion, advertisements continually appeared in magazines, and when an important event like the 1915 San Francisco Exhibition took place, the Great Northern was careful to ensure passengers were routed through Glacier National Park. Although some may dispute these numbers, one Park historian calculated that in the early years the Great Northern "spent almost $10 there for every one spent by the government" and Louis Hill "did more than any other to put Glacier National Park on the map."

Despite Louis Hill's dedication to the Park, the Great Northern never realized any profit from

its operations. The Glacier Park Hotel Company showed losses every year from 1914 to 1929. Further complicating its position was the fact that while visitation increased five-fold from 1914 to 1929, tourists increasingly traveled by automobile rather than by train, with yearly traffic increasing from 881 vehicles in 1920 to 49,750 by the end of the decade.

After World War II, Louis Hill's Glacier dream started unraveling. The unprofitable chalets were sold, forced to close, or simply torn down. Even though Louis Hill never anticipated losses from the Glacier Park operations, they were somewhat tolerable for the Great Northern because of the prestige garnered from its association with the National Park. In addition, the enormous body of art commissioned by Hill and purchased by the Great Northern was a tangible asset. When considering his legacy, this great collection of art is often overlooked. In fact, Louis Warren Hill's effort to promote the Park is almost entirely responsible for this outstanding body of work celebrating Glacier National Park.

Portrait of Chief Many Tail Feathers by Elsa Jemne on Great Northern Railway's dining car menu, 1926, courtesy of Adam Granger

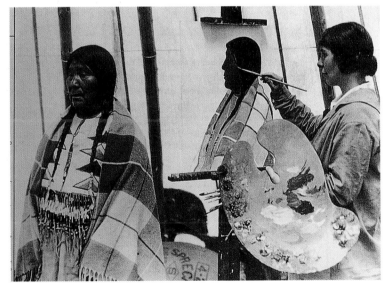

T.J. Hileman photograph of Elsa Jemne painting *Peace Offering* for the Great Northern Railway, 1925, courtesy of Adam Granger

The Lake McDonald Hotel, circa 1930, BSC

Great Northern Railway Glacier Park advertisements

1921, BSC

1921, BSC

BSC

1926, BSC

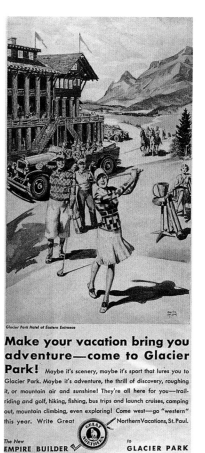

1931, BSC

1912, BSC

1912, JCC

1912, courtesy Ron Lerner

1913, JCC

Great Northern Railway brochure covers

Great Northern Railway brochure covers

1914, JCC

1914, JCC

1913, JCC

1915, JCC

1915, BSC

1915, JCC

1916, BSC

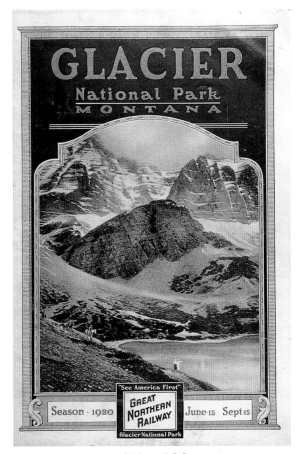

1920, BSC

Great Northern Railway brochure covers

-35-

Great Northern Railway brochure covers

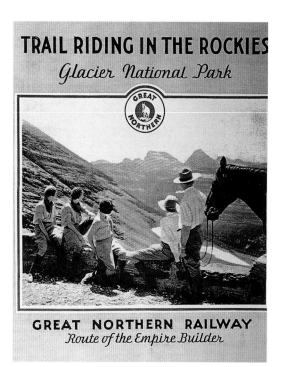

circa early 1930's, JCC

circa late 1920's, MHS

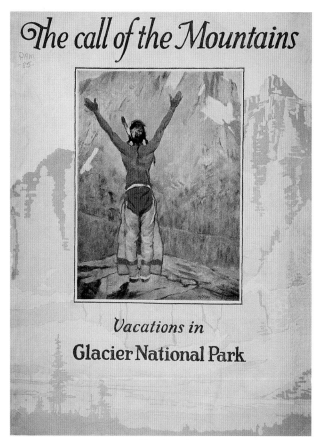

1927, MHS

circa early 1930's, JCC

circa early 1930's, JCC

Great Northern Railway brochure covers

circa early 1930's, JCC

circa mid 1930's. JCC

1936, JCC

Fred H. Kizer (1878-1955)

Fred Kizer, courtesy of the Oregon Historical Society

Fred H. Kizer is acknowledged as one of the most successful commercial photographers between the turn of the century and the First World War. Born in Grand Island, Nebraska, Kizer moved to Portland, Oregon where his parents ran the

Columbia Beach Hotel and Nursery. Fred became interested in photography, and with his brother Oscar, established "Kizer Brothers, Photographers."

A 1903 exhibition of his Crater Lake photographs brought Kizer his first public recognition. A hand-colored-in-oil process that earned him rave reviews imaginatively portrayed Kizer's stunning images. Two years later he was honored as the official photographer of the Lewis and Clark Exhibition in Portland, Oregon. Unfortunately, tragedy struck that same year when his brother and business partner, Oscar, died in a boating accident. Though deeply saddened by his loss, Kizer continued to photograph the Northwest.

He journeyed across Oregon taking photographs for a traveling national exhibition. The September 27, 1907 _Oregonian_ newspaper's review of the exhibition touted Kizer as "one of the best scenic photographic artists in this country." His 200 "exquisitely colored scenes of Oregon scenery" prompted the Mayor of Portland to state:

Cover, Souvenir Views of Glacier National Park,
Kizer postcard portfolio, circa mid-teens, BSC

Cover, Glacier National Park Souvenir Folder
Kizer postcard portfolio, 1918, BSC

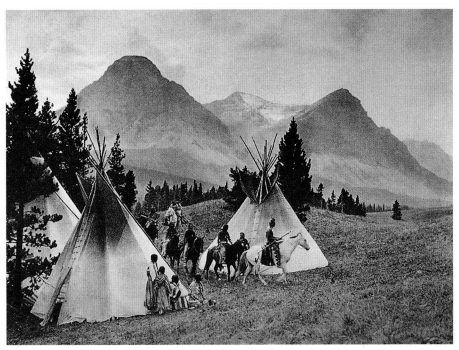

Blackfeet Indians, Glacier National Park, Kizer photograph, 1910, TEC

St. Mary's Camp, Kizer photo, 1912, TEC

Ladies and Gentlemen, I have been called upon to be present at the opening of the Kizer exhibit, a collection of photographs of the mountain scenery of the State of Oregon. It is a pleasure and honor; we owe as a master of justice, many words of thanks to the gentlemen who risked his life and been to great expense and trouble to produce such an elegant collection of views as we see here today; and he has many more which are not on exhibition as this time. In his efforts, as an artist, Mr. Kizer has become, as a matter of fact, a public benefactor to the state. His work will live on after him, and will bring great good to the state; for an exhibit of this kind cannot be made in the Eastern States....

Mr. Kizer is of Portland. His whole ambition is bound up in the wonderful scenery of the great Northwest; and through this exhibition of his work the citizens of Portland are given an opportunity to discover a real and genuine artist in photography. Let us hope they will reserve to themselves the honor of making that discovery before this exhibit goes to Eastern cities, for after that it will be too late....

That same year, Louis Hill became president of the Great Northern Railway and began searching for artwork to promote Glacier. Hill discovered the Kizer exhibition and immediately appreciated Kizer's striking photographs of mountain scenery. Kizer was hired as the official photographer of the Great Northern Railway, and for six years spent his summers in Glacier. Soon, his images were reproduced in brochures, books, periodicals, and as postcards. Some were released in beautiful hand-colored portfolios richly showing scenes from Glacier.

After Kizer's association with the Great Northern ended, he returned to photographing Crater Lake. There, he built his studio in 1921, and became its official photographer. With the onset of the Depression his business took a serious downturn, causing Kizer to seek seclusion in Los Angeles. He died in Newport Beach, California in March of 1955.

Kizer's Glacier Park images provided early visual documentation of the Park. He hoped to inspire Americans to preserve their scenic treasures, optimistic that his photos would:

... forever be considered a reminder to future generations that regardless of the primitive state of any region and ruggedness of industrial and agricultural demands for greater development of that specific region, there must be, always, a certain number of citizens who will exert their strength, their endeavors and their influence exclusively to the conservation of God Given Scenic Beauty for the benefit of posterity.

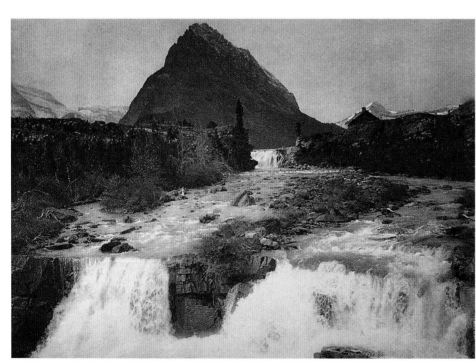

McDermott Falls and Grinnell Mountain, Kizer photo, 1914, BSC

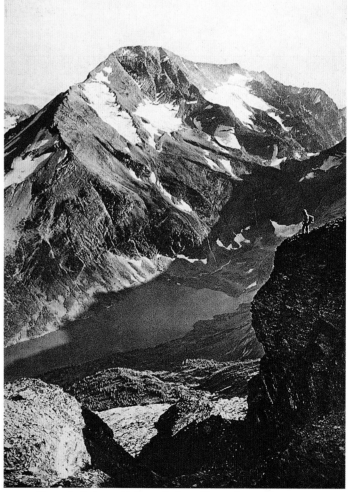

Gunsight Lake and Mount Jackson, Kizer photo, 1914, BSC

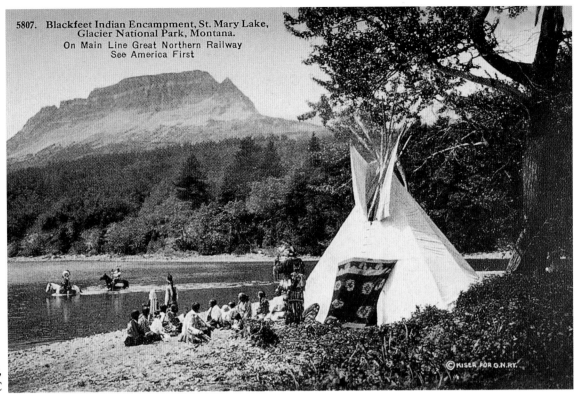

Postcard, *Blackfeet Indian Encampment, St. Mary Lake*, Kizer photo, 1918, BSC

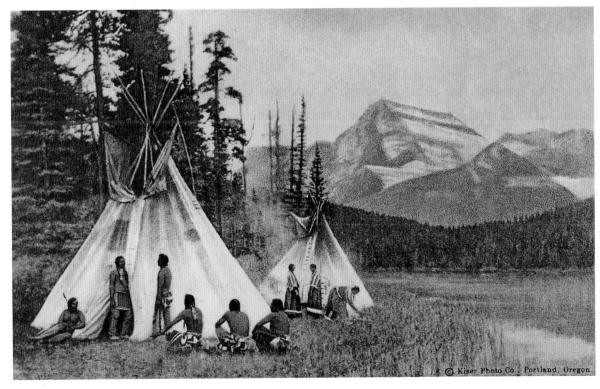

Postcard, *Blackfeet Indian Encampment, Glacier National Park*, Kizer photo, BSC

John Fery (1859-1934)

As the twentieth century dawned, it became very chic for Americans to decorate their homes in an elegant European style. They traveled overseas to collect masterful art and antiques. Everyone's highlight reel showed the Alps. Not surprisingly, the Great Northern coined the popular slogan, "Visit Glacier National Park; the Alps of North America." When preservationist John Muir visited the Flathead Forest Reserve (Glacier) in 1897, he clearly expressed in words what Louis Hill searched for and found in the work of John Fery:

Go to the Flathead Reserve; for it is easily and quickly reached by the Great Northern Railroad … in a few minutes you will find yourself in the midst of what you are sure to say is the best care-killing scenery on the continent — beautiful lakes derived straight from glaciers, lofty mountains steeped in lovely nemophilia-blue skies … mossy, ferny waterfalls … meadowy gardens abounding in the best of everything … the king of larches … Lake McDonald, full of brisk trout … and Avalanche Lake … ten miles above McDonald, at the foot of a group of glacier-laden mountains ….

Give a month at least to this precious reserve. The times will not be taken from the sum of your life. Instead of shortening, it will definitely lengthen it and make you truly immortal.

John Fery was born Johann Nepomuk Levy in Strasswalchen, Austria on March 25, 1859 and grew up in Pressburg. His father urged him to study art and literature, and in 1881, he enrolled at the Vienna Academy of Art. In 1883, a representative of the American Panorama Company recruited Johann. He moved to Milwaukee, Wisconsin where the company specialized in huge murals created to give one the perception of being outdoors. Although Milwaukee had a predominantly German population, Johann Levy legally changed his name to John Fery in order to better adapt to his new country. He returned to Europe where he married Mary Rose Kraemer. After their first child was born in 1885, he went back to Milwaukee with his family. The following years found Fery leaving his wife and children for extended periods to paint in the West, putting a severe strain on his marriage. In an effort to improve his family situation, Fery took his family to live with him in a cabin near

John Fery, BHC

Jackson Lake, Wyoming in 1900; however, the relocation proved unsuccessful. With provisions running low and winter coming on, Fery moved his family back to Milwaukee in the hope of finding a market for his paintings. Recognition came slowly, but his work finally caught the attention of Louis Hill, who immediately hired him for the "See America First" campaign.

From 1910 through 1913, Fery was on the payroll of the Great Northern. He completed an amazing 347 major oil paintings for the astoundingly low average price of $31.70 each. The paintings he created decorated Glacier Park lodges, ticket agent offices, and Great Northern

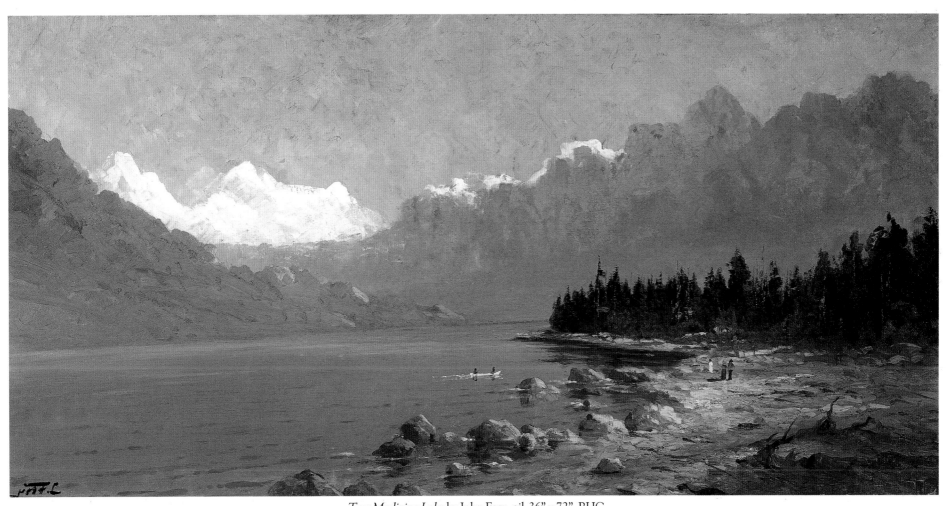

Two Medicine Lake by John Fery, oil 36" x 72", BHC

depots from St. Paul to Seattle. Although dramatically underpaid, Fery had the benefit of a studio and living quarters in St. Paul, a free railroad pass and lodging in Glacier, and a yearly salary of $2,400. Always prolific, he averaged nearly 14 outdoor scenes each month. Louis Hill was a hard taskmaster, apparent in his 1911 letter to Fery:

As I told you what we want is pictures, and since you went west, nearly two months ago, we have not received any. We ought to get out 12 or 15 pictures a month. What we are paying you for is to paint pictures. Later in the season when snow comes and foliage changes we may wish you make some more sketches, but we cannot afford to have you putting in your time making sketches now.

Somewhat begrudgingly, Fery remained in his St. Paul studio during the summer of 1913. By 1914, his relationship with Hill worsened, and he was loaned to the Northern Pacific Railway to paint scenes of Yellowstone National Park. The next year he returned to Glacier to complete paintings for the opening of Many Glacier Hotel. Following the event, Fery found himself off the payroll of the Great Northern. He spent the next few years free-lancing throughout the West, before moving back to Milwaukee in 1923.

In 1925, Louis Hill again called on Fery, offering the same salary paid in 1910, but without

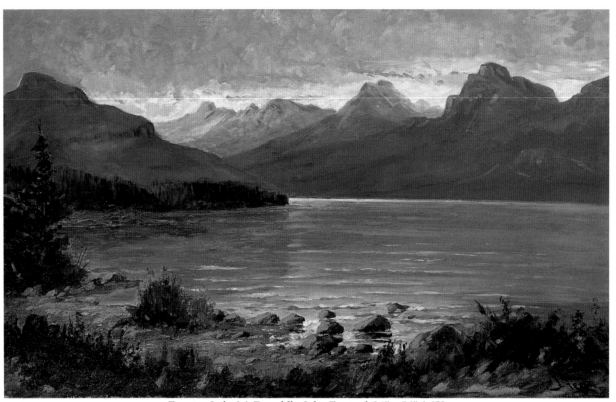

Evening Lake McDonald by John Fery, oil 34" x 56", MSJ

the provision for a studio. The contract required Fery to produce four to six large canvases monthly. Desperate for work, he spent the next four summers painting in Glacier. In 1929, the Ferys moved to Orcas Island, Washington to be closer to their children. A new studio was built, but that fall a fire destroyed all the paintings he had finished for the Great Northern. Fery pleaded with Hill to keep him on salary even at a reduced rate until the paintings could be replaced. Again, little sympathy came his way from the corporate offices:

Mr. Fery is so advanced in years that I doubt he could do more at this time than to produce the pictures he owes us and for which he has received payment, so if we undertake to help him it would simply mean that we were doing it out of sympathy and in order to facilitate the delivery of pictures which we have once paid for.

After months of stalling, the Great Northern agreed to pay Fery $600 for seventeen paintings

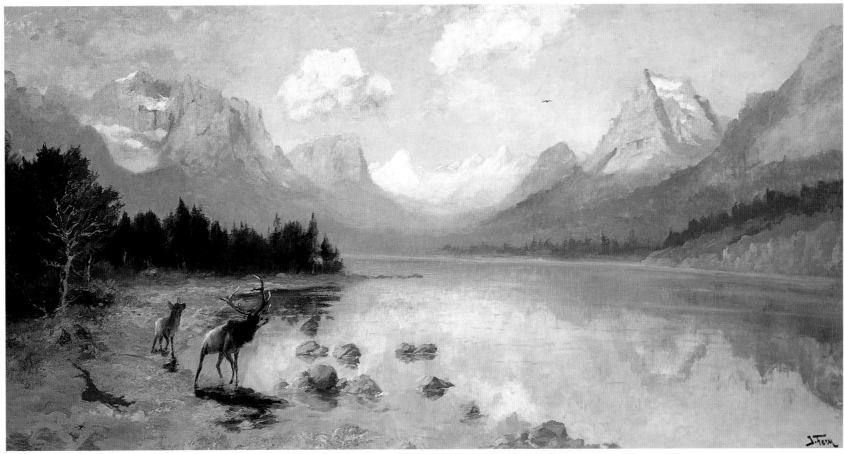

St. Mary Lake—Glacier Park by John Fery, oil 48" x 96", CAG

that were due them. After that, there were no more contracts. Fery's wife died in the spring of 1930, making his final years sad and lonely. On September 10, 1934, Fery died and was buried next to her on Orcas Island.

John Fery was at his best capturing the splendor of Glacier's landscapes. His paintings endure as poignant reminders of the mountains, lakes and streams he painted in the "Alps of North America."

Sunset Over Lake McDonald by John Fery, oil 11" x 21³/₄", JHA

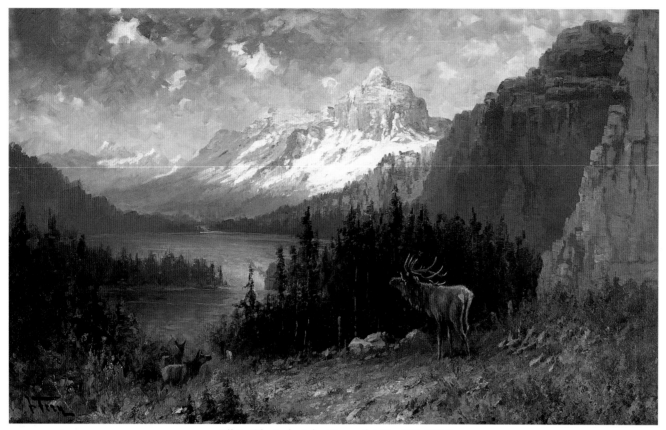

Elk in Glacier by John Fery, oil 36" x 72", BHC

Lake Josephine by John Fery, oil 12" x 16", JHA

Prince of Wales Hotel by John Fery, oil 36" x 62", JHA

Going to the Sun Camp by John Fery, oil 36" x 48",
Courtesy of Beverly and John Dittman, Kalispell, Montana

Elk in the Rockies by John Fery, oil 42" x 60", BHC

Swiftcurrent Falls by John Fery, oil 16" x 10", BHC

National Park Splendor by John Fery, oil 14" x 23", BHC

Clark Fork River Crossing (1930) by John Fery, oil 30" x 40", BHC

T. J. Hileman (1882-1945)

T. J. Hileman is known as the one photographer most closely associated with Glacier National Park. For many years he produced and sold countless photographs from his commercial shop. Not only did he capture impressive scenic images, but he documented the visits of important individuals to the area. Like Kizer, Hileman's photographs were reproduced on countless postcards and in brochures, periodicals and books.

Tomar Jacob Hileman was born on November 6, 1882 in Marienville, Pennsylvania. He graduated from the Effingham School of Photography in Chicago. In 1911, he moved to Kalispell, Montana and opened his own portrait studio in the Alton Pearce Building. He met Alice Georgeson, and in 1913 they were wed in Glacier Park, exchanging vows near Bridal Falls on McDonald Creek. The *Kalispell Bee* wrote that the union was under "decidedly romantic and unusual circumstances ... the first couple to have been married in Glacier Park."

Hileman began his association with the Great Northern shortly after arriving in Montana. During the summers he traveled with a guide,

moving his bulky camera equipment by packhorse over scant trails. An exceptional climber, "Mountain Goat Hileman," as he was called, often perched precariously on narrow ledges to capture just the right moment on film.

In 1925 Hileman signed a contract with the Great Northern for $125 a month. As its official photographer, he was required to take photos of visiting dignitaries and tour groups. Hileman retained the copyright on his scenic photographs, but his employer could purchase copies for 35 cents per print.

The railroad sent him on nationwide promotional tours that included visits with publishers and newspaper editors. Since his images were distributed throughout the country, Hileman soon became quite a celebrity. Enjoying his role as "good-will ambassador," the gregarious Hileman was a guest at such events as baseball games, and automobile and horse races. Back home he wrote:

I've been out all week with Miss Dorothy Pilley, British mountaineer; Hans Reiss, European

Tomar J. Hileman, GNP

guide and artist; and Count Edgar Henckel Domersmaeck of Silesia.... The Count is in this country to study American business conditions, he has been visiting all the national parks during his summers...though he has climbed through the Alps and mountains in Norway, he says he must admit he likes Glacier the best. Miss Pilley, who is a member of the

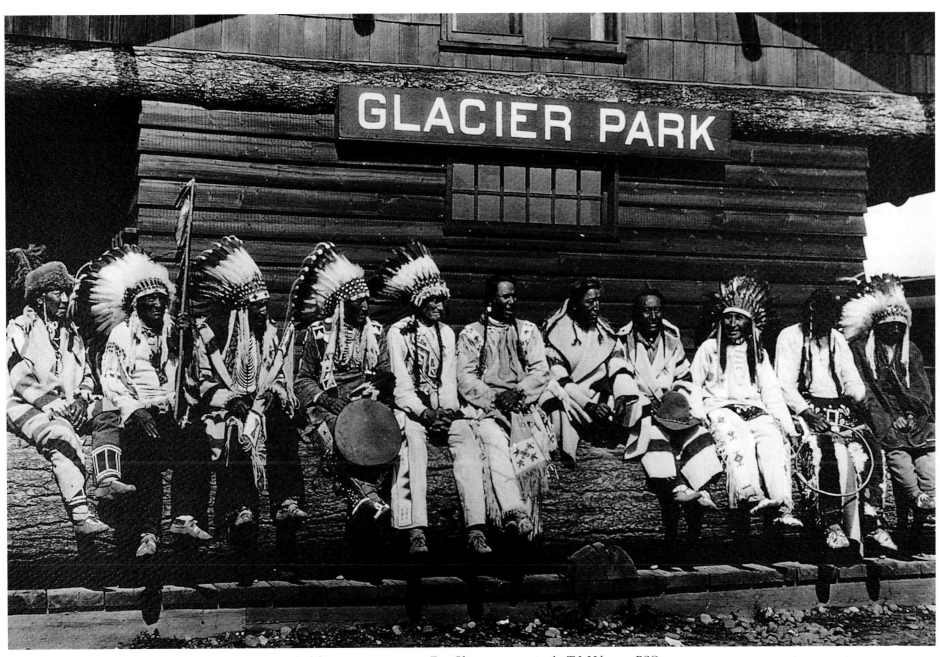

Blackfeet greeting tourists at East Glacier train station by T.J. Hileman, BSC

Climbing Stark Peak with Guide by T.J. Hileman, TEC

Cover, *Glacier National Park: Scenic Marvel of America*, portfolio of hand-colored photos by T.J. Hileman, BSC

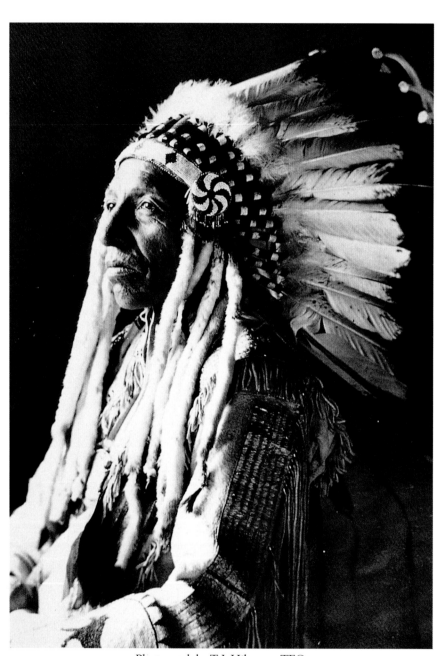

Photograph by T.J. Hileman, TEC

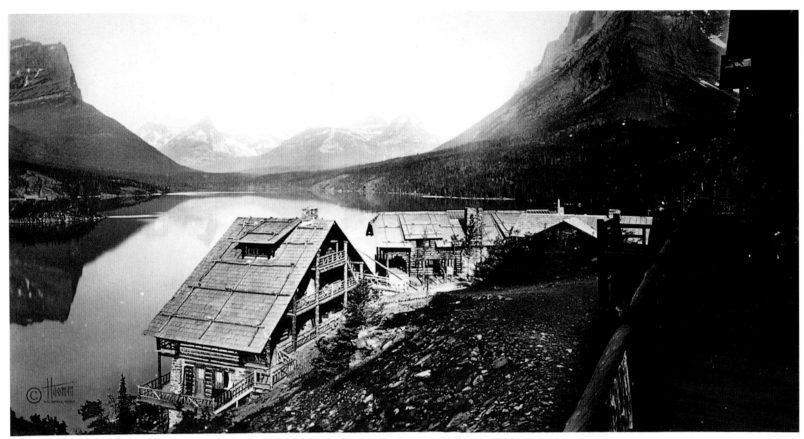

Going to the Sun Chalet by T..J. Hileman, TEC

Ladies' Alpine Club…is spending the summer here to learn whether it might be practical to organize a mountaineer's club.

In 1926, Hileman opened photo finishing labs in Glacier Park Lodge and Many Glacier Hotel. Tourists appreciated being able to drop off film in the evening and pick up their prints the next morning. With all Hileman's film developing experience, he became exceptionally creative when printing his own images. In fact, from one negative alone he sold $4,000 worth of prints, allowing him to build a home on Flathead Lake in 1931. This was accomplished despite the Depresssion and the reduction of his salary to $25 a month during the difficult economic times.

Tourism dropped with the onset of World War II, and with his wife in poor health, Hileman sold his studios in Kalispell and the Park to work out of his home. In June 1943, a stroke paralyzed his entire left side, and his career with the Great Northern was over, although he continued to receive $25 a month in appreciation for all his past fine work. On March 13, 1945 Tomar Hileman died at his home on Flathead Lake. In 1985, the Glacier Natural History Association purchased over one thousand of Hileman's nitrate negatives. The Association also owns 32 of Hileman's photographic albums containing more than 2000 prints. These treasures remain a lasting tribute to Glacier's most prolific photographer.

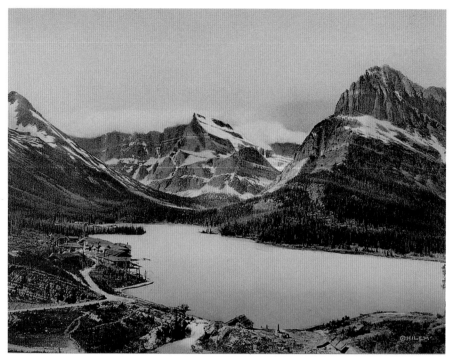

Many Glacier Hotel from Altyn Mountain, hand-colored photograph by T.J. Hileman, BSC

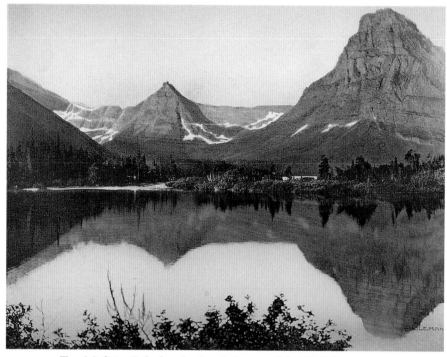

Two Medicine Lake, hand-colored photograph by T.J. Hileman, BSC

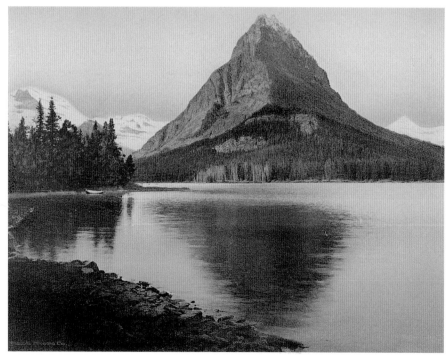

Grinnell Mountain and Lake McDernott, hand-colored photograph by T.J. Hileman, BSC

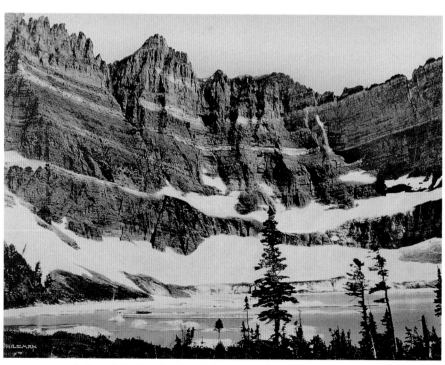

Iceberg Lake, hand-colored photograph by T.J. Hileman, BSC

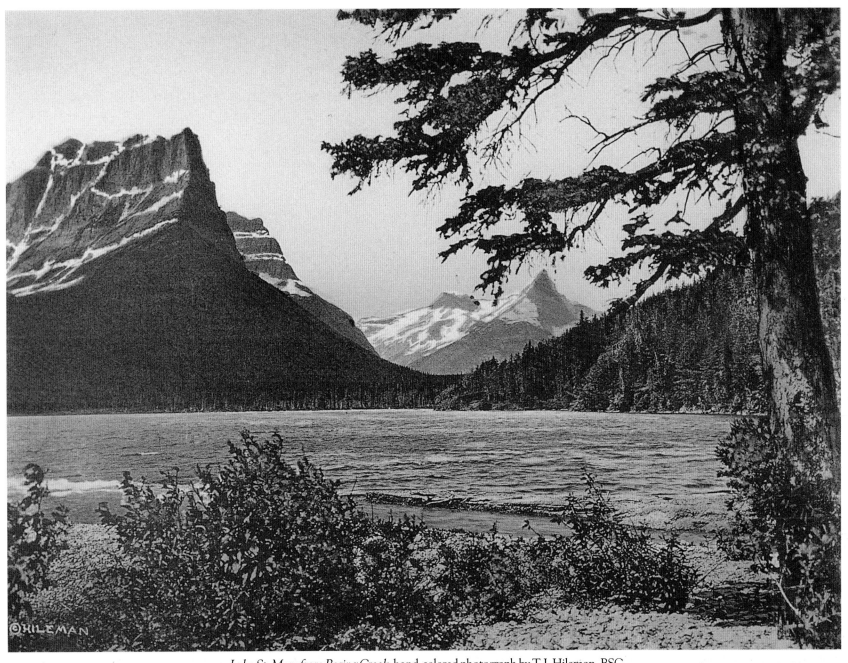

Lake St. Mary from Baring Creek, hand-colored photograph by T.J. Hileman, BSC

Winold Reiss (1888-1953)

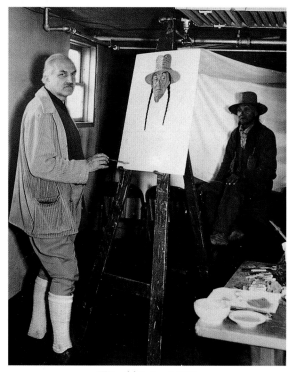

Winold Reiss, MHS

Winold Reiss first learned about the American West reading frontier adventure novels like James Fenimore Cooper's *Leatherstocking Tales* and eyewitness accounts such as Prince Maximillian von Wied's trip up the Missouri River. As a child in Germany, Reiss never dreamed that his own dramatic portraits of Blackfeet Indians would someday impact American art.

Fritz Reiss, Winold's father, was a well-known German landscapist whose paintings depicted the surrounding Black Forest countryside. Fritz realized his son had talent and enrolled him at the Royal Academy of Fine Arts and the School of Applied Arts in Munich. As the world moved perilously toward war, Winold fell in love with a fellow student, Henrietta Luethy, and they married in 1912. Reiss convinced his bride that they should come to America. When they arrived in New York the following year, he naively expected to be greeted by Indians. Settling in New York City and anxious to paint Indians, Reiss eventually found a model, a Blackfoot recently fired from the circus. With his model dressed in a war bonnet and beaded shirt borrowed from the American Museum of Natural History, Reiss completed his first authentic Indian portrait. Success came slowly, as the German artist's modern style was not immediately well received. Fortunately, the H. Hanfstaengl Gallery specialized in modern art and secured several commissions for Reiss, including one for *Modern Art Collector* magazine. In 1916, Reiss opened an art school and three years later completed Art Deco paintings for New York's Crillon Restaurant. By 1918, he

had saved enough money to allow him to chase his dreams of the West in real Indian country.

In the fall of 1919, he traveled alone to Browning, Montana on the Great Northern, unaware he soon would be its most important artist. Eagerly jumping off the train in Browning, Reiss enthusiastically slapped the first Blackfoot he encountered on the back and shouted "How"! Turtle, also known as Angry Bull, didn't take offense, and the two became lifelong friends.

He shared sleeping quarters with a cowboy at the Haggerty Hotel and used one of its public rooms as a makeshift studio. In his distinctive style, Reiss produced 35 portraits of the Blackfeet within the month, using brilliant colors in pastel and tempera, rather than traditional oil. Having gained their trust, the Blackfeet bestowed on him the name Beaver Child. Paul Raczka, owner of a latter-day trading post in Fort Mcleod once said:

I think their respect for him comes from something else. There was absolutely no guile about the man. He wanted to record their greatness, not just for him but, for them—and

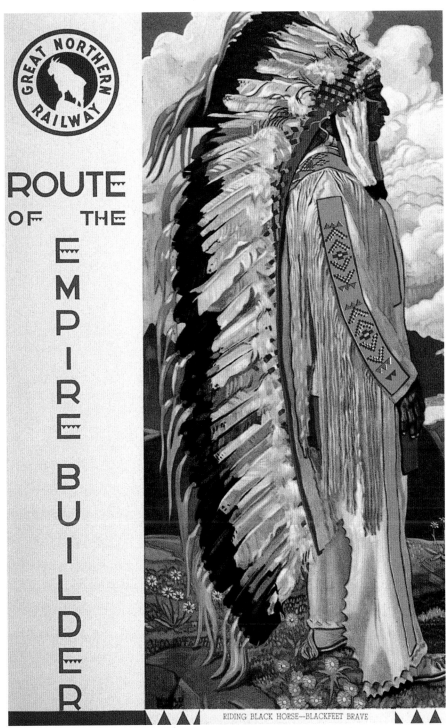

Cover, Great Northern Railway dining menu with
Riding Black Horse — Blackfeet Brave by Winold Reiss,
circa 1930's, BSC

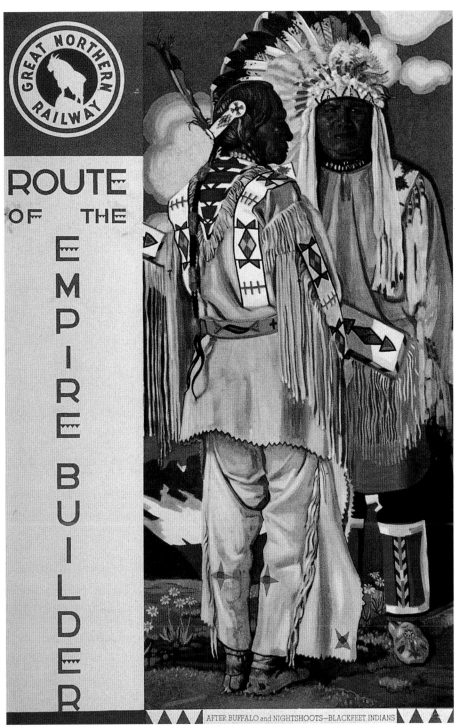

Cover, Great Northern Railway dining menu with
After Buffalo and Nightshoots — Blackfeet Indians by Winold Reiss,
circa 1930's, BSC

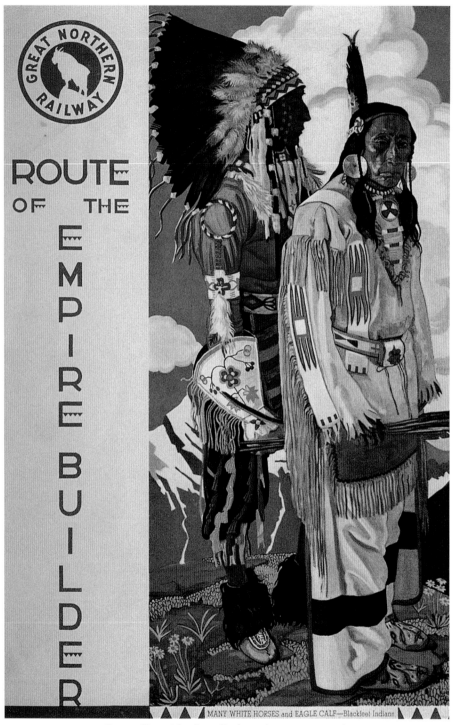

Cover, Great Northern Railway dining menu with
Many White Horses and Eagle Calf — Blackfeet Indians
by Winold Reiss, circa 1930's, BSC

they spotted that immediately. I mean, look at these paintings, of Shot On Both Sides, for instance. He's wearing his yellow-and-red war paint, his red-horned headdress. Blackfeet don't put on finery for anyone. It is their status and, therefore, very private. Winold had, over time, earned their trust. He was, they knew, one white man who wasn't about to rip them off.

Back in New York, he exhibited his new works at the H. Hanfstaengl Gallery, and in January 1920, they caught the eye of one of the most important collectors of western art, Dr. Philip Cole. Cole purchased the entire group of paintings, today exhibited at the Bradford Brinton Memorial in Big Horn, Wyoming. Reiss spent the next eight years teaching at his art school, filling commercial orders, and illustrating for magazines.

Reiss convinced his brother Hans, also an artist, to leave Sweden and join him in operating the art school. Hans suffered asthma attacks in the heavy, humid air of New York, and at his brother's urging, he traveled to Glacier National Park for a change of climate. The area agreed with Hans, so he decided to stay and became a licensed guide in the Park. By chance, one of his clients was Louis Hill.

Their association led to a contract for Winold Reiss. For ten years beginning in 1927, he returned to Browning every summer to paint for

the Great Northern Railway. Accompanying him on his first trip was his 13 year-old son, Tjark, who acted as a helper and crayon sharpener. Reiss asked Tjark to record some of the history of each Indian who posed for him. Years later, his son recalled:

During those years, I can only remember Dad taking one day off and that was to go mountain climbing in Glacier Park with Uncle Hans. Partway up, he found he suffered from vertigo and for five hours was left by the others on a 18-inch-wide ledge, towering over Glacier Park. He disliked that experience so much he never again declared a holiday….

It was an extraordinary life for a boy. At the age of 45, Dad learned to drive and we reached Glacier Park by Hupmobile—long memorable drives when we stopped at as many Indian Reservations as we could …. After he had a few good years, his next car was a Cadillac. He paid $4500 for it; he was so proud of that car.

On April 14, 1928, fifty of Reiss' paintings were exhibited at a one-man show, titled "American Indian Portraits," at the Belmaison Galleries in New York. The Great Northern Railway published a companion book to the exhibition. Many exhibitions followed with venues in America and overseas. Over the years,

Calendar, Great Northern Railway with *Homegun* by Winold Reiss, 1930, BSC

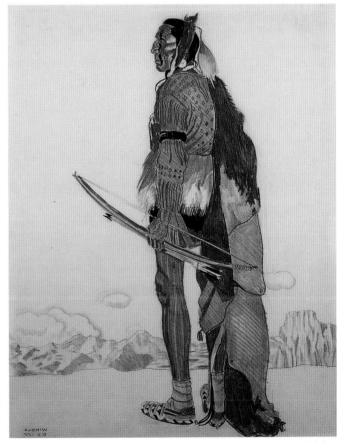

Study for Cincinnati Union terminal mural: *Turtle* by Winold Reiss, conte crayon 24" x 18", TNG

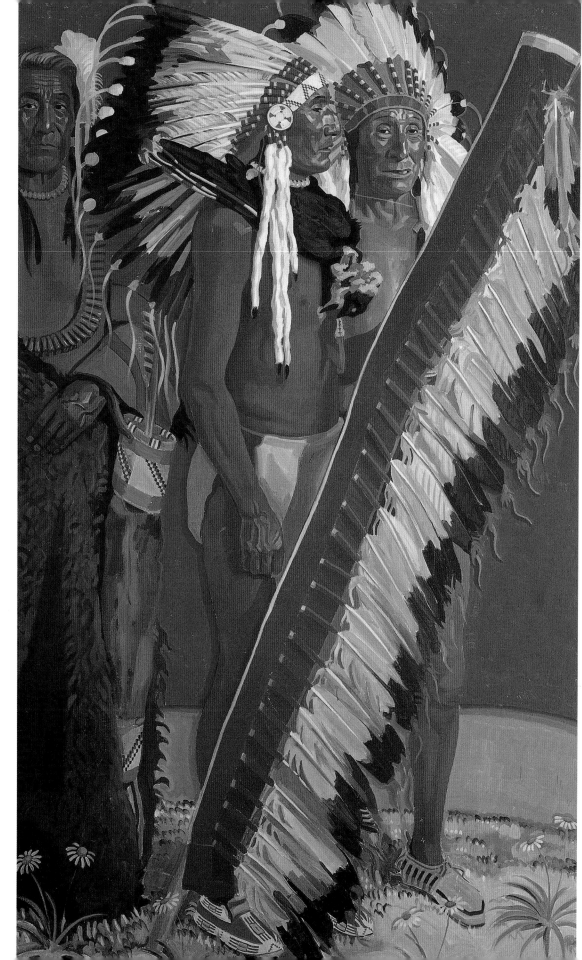

Louis Hill bought at least 80 of these paintings — many of which found their way to the covers of railroad calendars. After seeing his work for the first time, Hill praised Reiss stating, "I think this man is one of the best prospects we have had in the way of artists painting Indian pictures, which are our strongest feature."

Each year Reiss stopped painting in early September to allow Tjark to return to school in New York. Finished portraits were wrapped in wax paper and sent from Browning to the Great Northern Railway headquarters in St. Paul. Upon their arrival, Reiss and the advertising director decided which paintings should be added to the permanent collection and which should be reproduced. Later, only reproduction rights were negotiated. Reiss was paid $500 to $1500 for each image, and for thirty years the images were continually printed on calendars produced by Brown and Bigelow. Railway vice-president, William Kenney stated, "As near as I can find out from all our outside men, this calendar is considered very high class publicity for our line.... So far as the Indian calendars are concerned, no one can do them justice as can Winold Reiss." Today, Reiss' Great Northern portraits can be found at the Burlington Northern Railway in Fort Worth, the Hill Estate in St. Paul, and the Anschutz Collection in Denver.

Three Blackfeet by Winold Reiss, oil 72" x 48", TNG

Cowboy—Nofsinger by Winold Reiss, oil 39" x 26", TNG

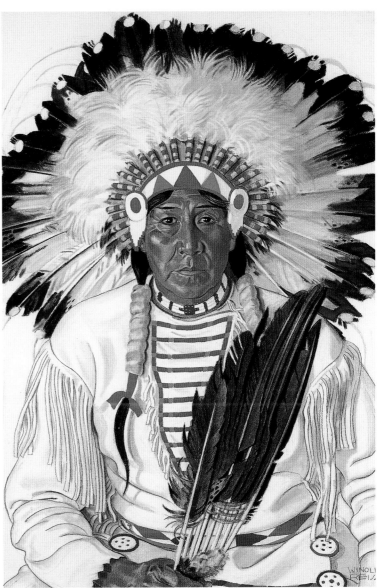

George Bullchild, Blackfoot Indian by Winold Reiss, oil 38½" x 26", CDA

By the early 1930's Reiss was teaching mural painting at New York University's College of Fine Arts. He and Louis Hill continued their friendship, and when Reiss suggested establishing a summer school at the St. Mary Chalets, Hill eagerly agreed. Hard times had closed the chalets in 1934, but an art school was the perfect reason to reopen them, especially with the availability of native models. The students enrolled through New York University for either a $70 two-month course, or a $90 three-month course. Sharing common backgrounds, Reiss was pleased to invite his friend Carl Link to teach summer classes held at St. Mary from 1934 to 1937. Although already recognized as an outstanding painter, Link also gained recognition as an excellent teacher at the Art Student's League, Columbia, and New York University. Frank Linderman's daughter remembered a visit to their home on Flathead Lake by Link and Reiss:

He, Carl Link, came into our lives very briefly one fall day in 1937, driving to Goose Bay, our home, with Winold Reiss and a Miss Erika Lohman. It was shortly before noon, so I prepared lunch for them. Conversation was lively. My father and Mr. Link were instant friends. We had known Mr. Reiss for some time. My father had far too little contact with people of the arts and it was an inspiring several hours for all of us. My father's Indian collection, which is now at the Museum of the Plains

Indians at Browning, Montana hung on the walls of his study and Mr. Link was busy at once sketching the beadwork designs. In the course of conversation, he told us one of his hobbies was going to the theater or a concert or baseball game, where he spent his time sketching the spectators. I recall Daddy asked him how long it took him to get what he wanted and he replied, "Oh, five minutes or so," and as conversation went on, Daddy told him no one had ever been able to sketch or paint him.

Mr. Link's reply was, "Come on, I'll get you in five minutes." He sat him down in the living

room by a window and instructed him to "look into the woods and don't move."

It wasn't five minutes—it stretched into an hour-and-a-half and, he explained, because of the long weather lines (we called them laugh lines) he couldn't move a fraction of an inch or his entire facial expression changed. And that was why no one had ever been able to "catch" him in paint.

The result was indeed superior draughtsmanship None of us had ever seen work like it and my children and I and my mother had the rare

Carl Link, Frank Bird Linderman, and Winold Reiss at Goose Bay, Montana, September 2, 1937, courtesy of the heirs of Frank Bird Linderman

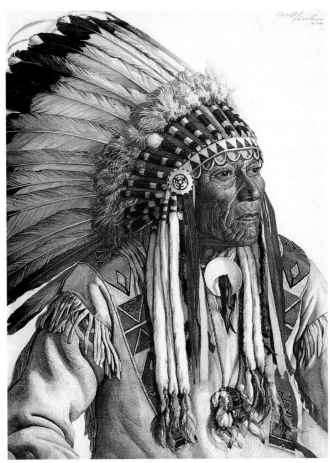

Shorty Young Man by Carl Link, watercolor 30" x 21¾",
courtesy of Tom and Judy Decker

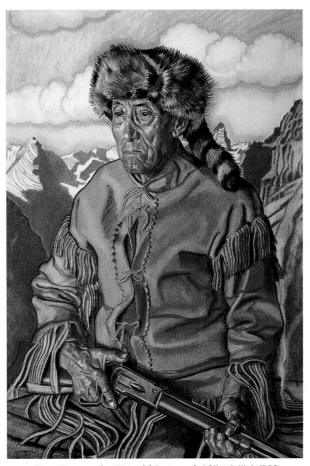

Tom Dawson by Winold Reiss, oil 39" x 26", MHS

privilege of watching every stroke of his pencil. I had watched Charlie Russell paint many times, but this was something special and the result was the only real picture we'd ever had of Daddy.

Reiss played a dual role — as teacher and artist for the Great Northern. His son remembered,

"Classes started at nine each morning. Usually the Indians posed in their own ceremonial robes. However, if they didn't have any, we would borrow a fine one from Margaret Carberry, who ran the trading post in Glacier Park Station."

A noted student, Karoal Miener, praised him. "Winold was a very good teacher. Winold always

found something nice to say about your picture, and then with a slight touch of a finger rubbing out or adding a line, your picture was OK. He also insisted that parts were done again, but seemed to know how far or how much to criticize each picture according to the pupil." While most students paid tuition, exceptions were made for several talented Blackfeet including Albert Racine,

Frank Bird Linderman by Carl Link, pencil 10" x 8", private collection

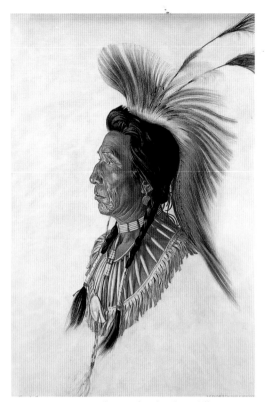

In Dance Headgear, Blood Indian, Alberta, Canada by Carl Link, oil 38¼" x 25", JHA

It is true, of course, that American artists had painted the American Indian before Mr. Reiss dedicated his talents to interpreting their racial characteristics and customs. But in the majority of cases the point of view had been either purely ethnological or sentimentally accurate. Mr. Reiss was the first painter who saw the Indian abstractly as subject for art, who recognized classic monumentality in the manner in which he folded his blanket about him and in the pond carriage of his head. His pictures have helped to restore and give reality to the legend of the noble redman and have made him an epic figure among the lost and vanishing races of mankind. He has been able to achieve this quality of universality without sacrificing his realistic approach. Mr. Reiss believes that the epic of the American Indian should be preserved in murals for future generations on the walls of our public buildings and schools.

Victor Pepion, and Gerald Tailfeathers. Perhaps the summer school's most notable female student was Elizabeth Davey Lochrie who later recalled:

I got acquainted with the Indians. I found them so paintable that I've done them ever since. I've done hundreds, maybe thousands. Every summer after that [1931] I either took the children or left them home with the maid, and I went to Glacier or the Flathead, or somewhere to paint Crow, Nez Perce, *Flathead, Blackfeet, Assiniboine. I spent all summer chasing Indians.*

To commemorate and celebrate the twenty-fifth anniversary of the establishment of Glacier National Park in 1935, the Great Northern Railway published 49 of Reiss' finest works in a book titled, *Blackfeet Indians*. Included was an essay by Frank Bird Linderman titled *Out Of The North*. In a profile of Reiss at the end of the book, Helen Appleton Read communicated Louis Hill's high esteem for his favorite artist:

Feeling the effects of the Depression, the Great Northern Railway closed the school after the summer of 1937. Although disappointed, Reiss stayed in New York throughout the thirties and forties working on commissions. He died on August 29, 1953 from complications following a massive stroke. Reiss' Blackfeet friends, led by Bull Child, ceremonially scattered his ashes on the plains near Browning. No artist since has captured the essence of Montana's native people as did this great painter from Germany.

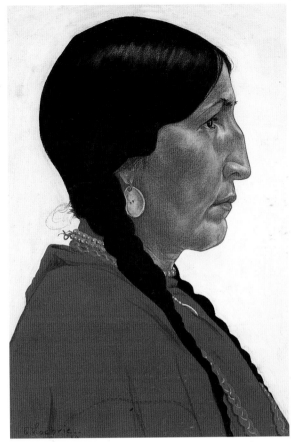

Cecile Boy by Elizabeth Lochrie, pastel and tempera, 17" x 11¼", MHS

Blackfeet Warrior by Gerald Tailfeathers, pen & ink 6" x 8", CAG

Elizabeth Lochrie (center) with her son Arthur (to her left) the day they were initiated into the Blackfeet tribe at Glacier Station, 1931, MHS

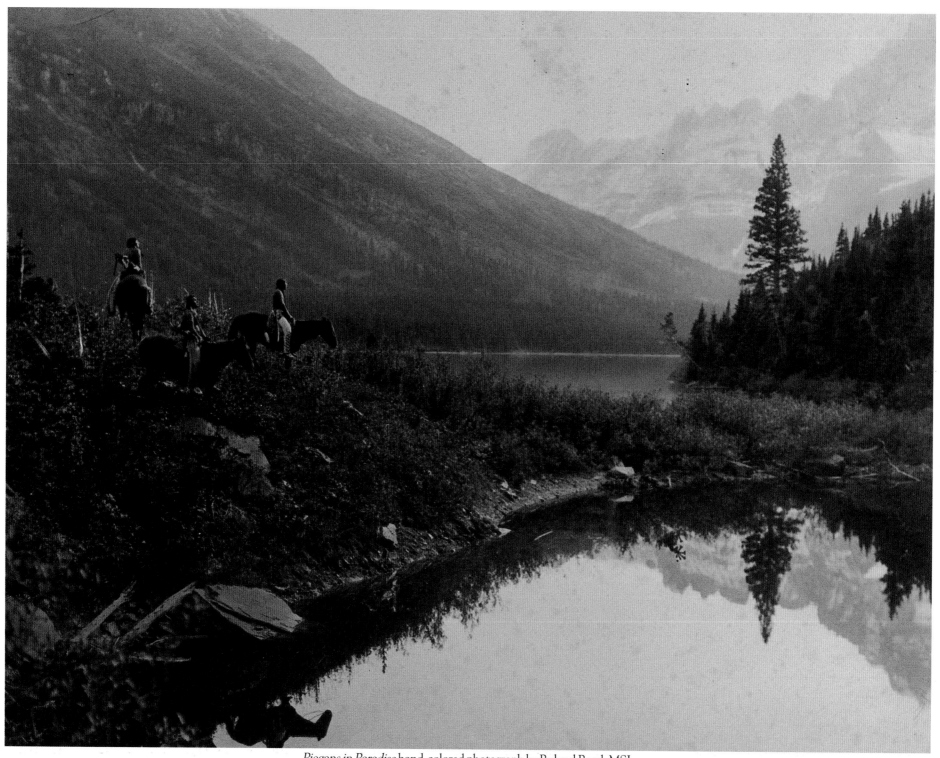

Piegans in Paradise hand-colored photograph by Roland Reed, MSJ

Shadow Catchers

The Photographers

The haunting images captured by early photographers continue to provide us with a glimpse into the spirit that was the American West. Photographs helped create those perceptions that fostered judgment over an entire region and its indigenous people. In 1875 the *New York Times* expressed the reality influencing most Americans, "While only a select few can appreciate the discoveries of the geologists or the exact measurements of the topographers, everyone can understand a picture."

There was continuous debate as to exactly how western lands should be preserved. Hayden Geological Survey photographs taken by W. H. Jackson in 1871 helped sway the Congressional decision to establish Yellowstone National Park. Due to the remote nature of Glacier, most photographers did not arrive in the area until after it was already designated a National Park. Many of them were directed to Glacier on assignment for the Great Northern Railway. Others were simply drawn to the area by its singular beauty or

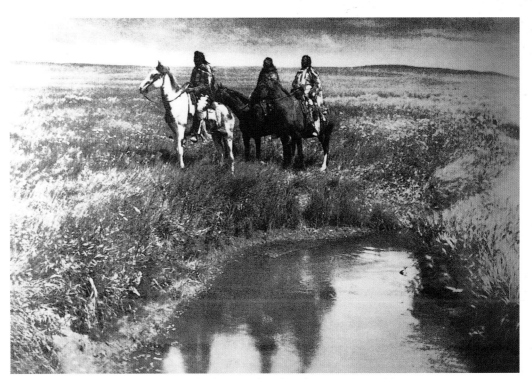

The Three Chiefs, Piegan by Edward Curtis, 1900, BSC

by their desire to document the passing way of life of its Native People.

No doubt thousands of photographs were taken in the early years of Glacier National Park. It was no easy task, for the photographers hiked the Park's backcountry carrying their cumbersome camera equipment and were limited by a medium that was black and white. Today, their photographs give poignant evidence of a time and place that no longer exist, while preserving a golden era in the history of Glacier National Park.

Edward S. Curtis (1868-1952)

Edward S. Curtis, 1899, BSC

Early in the spring of 1898, a prominent group of scientists, officials, and naturalists including George Bird Grinnell; Dr. Clinton Hart Merriam, chief of the U. S. Biological Survey; and Gifford Pinchot, missed the trailhead and became lost hiking on Mount Rainier. Fortunately, Edward

S. Curtis, an experienced climber from Seattle, discovered the cold and hungry party and led them safely back down to shelter. "I managed to get them to camp where I thawed them out," said Curtis, not realizing what profound consequences this chance episode would have on his career.

Once the group was back in Seattle, Curtis showed them photographs he had taken of the Northwest and its native people. Dr. Merriam was so impressed by his work that the following year he invited Curtis to be the official photographer for an Alaskan expedition sponsored by the financier, Edward H. Harriman. While on the 9,000 mile expedition, Curtis took more than 5,000 photographs. In the evenings, he listened intently as many notables lectured on their various fields of expertise. Of particular interest were George Bird Grinnell's reflections on his more than 20 years' experience among Indian people.

Born in 1868, Edward S. Curtis took an early interest in photography. He built his first camera by modifying a slide projector with two wooden boxes, one fitting into the other. At age 19,

Wisconsin-born Edward and his family settled on a claim of land in Sydney, Washington, a small village across from Puget Sound. In 1892 he married Clara Phillips, who as one relative recalled, "shared Edward's love for the great scenic land of the Northwest—but not his interest in photography." That same year, Curtis, outfitted with a 14 x 17 inch view camera, bought an interest in a photo studio.

Seattle was booming. Three years later, the obviously talented Curtis had become the most sought after society photographer in Seattle. Whenever possible, he preferred to spend time out of his studio photographing the nearby Suquamish Indians and came to be known as the "Shadow Catcher." Tourists eagerly bought up every new "Indian view" Curtis printed. One of his favorite subjects was Angeline, daughter of Chief Sealth, after whom Seattle was named. In her old age, she eked out a meager existence gathering firewood and digging clams. Later, Curtis wrote, "I paid the princess a dollar for each picture I made. This seemed to please her greatly and with hands and jargon she indicated that she preferred to spend her time having pictures made

than digging clams." With each photo, Curtis strove to "produce an irrefutable record of a race doomed to extinction — to show this Indian as he was in his normal, noble life so people will know he was no debauched vagabond but a man of proud stature and noble heritage."

Following the Harriman expedition, Curtis remained in contact with Grinnell. In the summer of 1900, Grinnell invited Curtis to witness firsthand the Blackfeet Sun Dance outside Browning, Montana. Looking down from a nearby bluff, the men viewed in amazement the wide circle of tents and tipis. Curtis wrote, "The sight of that great encampment of prairie Indians was unforgettable. Neither house nor fence marred the landscape. The broad, undulating prairie stretching toward the little Rockies, miles to the West, was carpeted with tipis." Intensely affected, he added, "It was the start of my effort to learn about the Plains Indians and to photograph their lives." Realizing the Indian's traditional way of life was soon passing into memory, Curtis wrote, "I don't know how many tribes there are west of the Missouri … maybe a hundred. But I want to make them live forever — in a sort of history by photographs."

By 1904, Curtis expanded his scope to include documenting every Indian tribe in the country by photograph. Curtis raised money for his venture by showing his lantern slides and lecturing

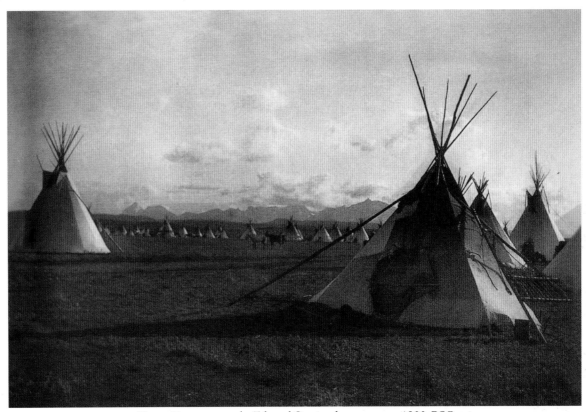

Piegan Encampment by Edward Curtis, photogravure, 1900, BSC
Curtis wrote, "The picture presents a characteristic view of an Indian camp on an uneventful day, but also emphasizes the grand picturesqueness of the environment of the Piegan, living as they do almost under the shadow of the towering Rocky Mountains."

to prominent individuals and groups in the East. Requiring additional funds for the project, Curtis solicited John Pierpont Morgan at the suggestion of his close friend, Theodore Roosevelt. Morgan promised to loan Curtis $15,000 a year for five years. In return, Curtis would author 20 volumes of text, each illustrated with approximately 75 small prints and accompanied by a portfolio of 35 large photogravures. Morgan, anticipating repayment through sales of the series, urged Curtis to market the set himself through advanced subscriptions. Perhaps overly ambitious, Curtis decided on 500 sets of *The North American Indian, Being A Series of Volumes Picturing and Describing the Indians of the United States and Alaska.* Each set would be offered to subscribers at $3,000.

The first two volumes of *The North American Indian* were published in 1907, and showcased seven years of intensive field study. A letter of introduction from President Roosevelt stated, "Mr. Curtis in publishing this book is rendering a

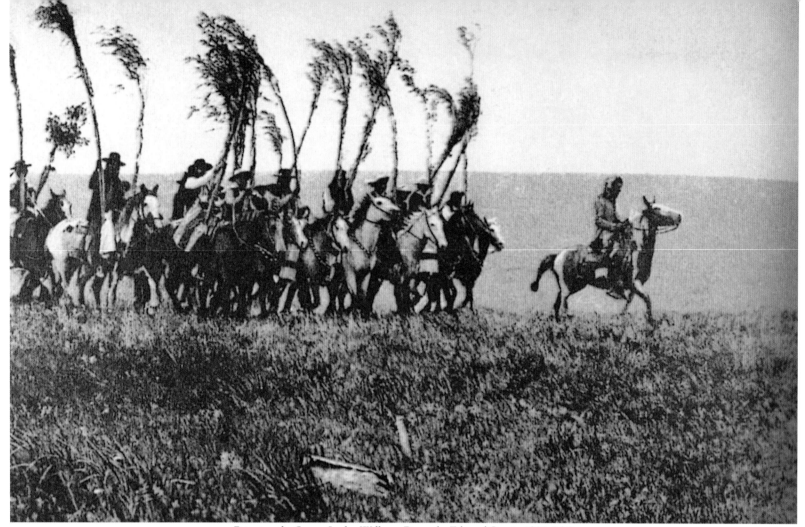

Bringing the Sweat-Lodge Willows, Piegan by Edward Curtis, 1900, BSC

Camp in the Foothills by Edward Curtis, 1905, BSC

real and great service; a service not only to our own people, but to the world of scholarship everywhere."

Among the first subscribers were Andrew Carnegie, S. R. Guggenheim, Alexander Graham Bell, and the kings of Belgium and England. Critics praised the publication, and the *New York Herald* declared it "the most gigantic in the making of books since the King James edition of the Bible…one that can never be repeated. The author of this stupendous work is Mr. Edward S. Curtis who, as an 'Indianologist' and artistic photo-historian of a vanishing race, is unique in ethnology."

Between 1900 and 1927, Curtis made at least seven trips to Montana. His images of Glacier country and its Indians were published in *Volume 6 (Arapaho, Piegan, Cheyenne, 1911), Volume 7 (Interior Salish and Kutenai, 1911),* and *Volume 18 (Chippewa, Assiniboin and the tribes of the Canadian Blackfoot Confederacy, 1928).*

Working long hours and traveling continuously around the country, Curtis estimated it would take 15 years to complete the project. By 1910 he had only 200 committed subscribers, and the money from Morgan was running out. Curtis looked to other means to generate funds, but had little success. Following the sudden death of John Pierpont Morgan in

A Child's Lodge, Piegan by Edward Curtis, 1910, BSC

In a Piegan Lodge by Edward Curtis, 1910, BSC

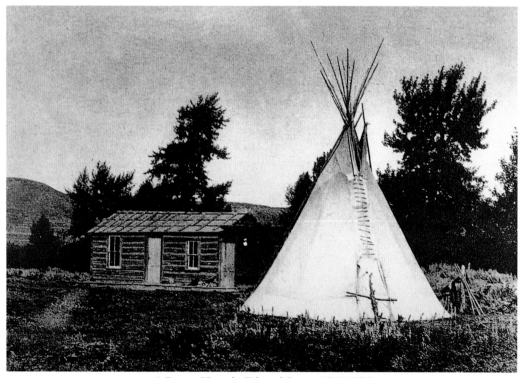

A Piegan Home by Edward Curtis, 1910, BSC

1913, the Morgan family decided to continue funding Curtis' project through the Morgan bank, focusing not on sales, but rather on the completion and publication of the series. The final volume of *The North American Indian* was printed in 1930, by which time the Morgan family had contributed almost $400,000 — one-quarter of the total cost of the entire project. It required 30 years and over 40,000 photographs for Edward Curtis to complete his mission.

Once his ambitious undertaking was finished, Curtis reflected on his life, writing, "I realize that I have rarely taken a Sunday off and but one week's vacation, it's safe to say that in the past sixty years I have averaged sixteen hours a day, seven days a week. Following the Indians' form of naming men I would be termed "The Man Who Never Took Time to Play." On October 19, 1952 Edward S. Curtis died of a heart attack at his daughter's home. Curtis was essentially forgotten until the discovery of his original copper photogravure plates in the basement of a Boston bookstore. Today, his original photos sell for thousands of dollars and are highly sought after by collectors.

Although some critics suggest Curtis held preconceived notions about native culture that biased much of what he photographed, others appreciate his enormous effort to preserve a vanishing way of life.

(opposite) *Flathead Camp on Jocko River* by Edward Curtis, 1905, BSC

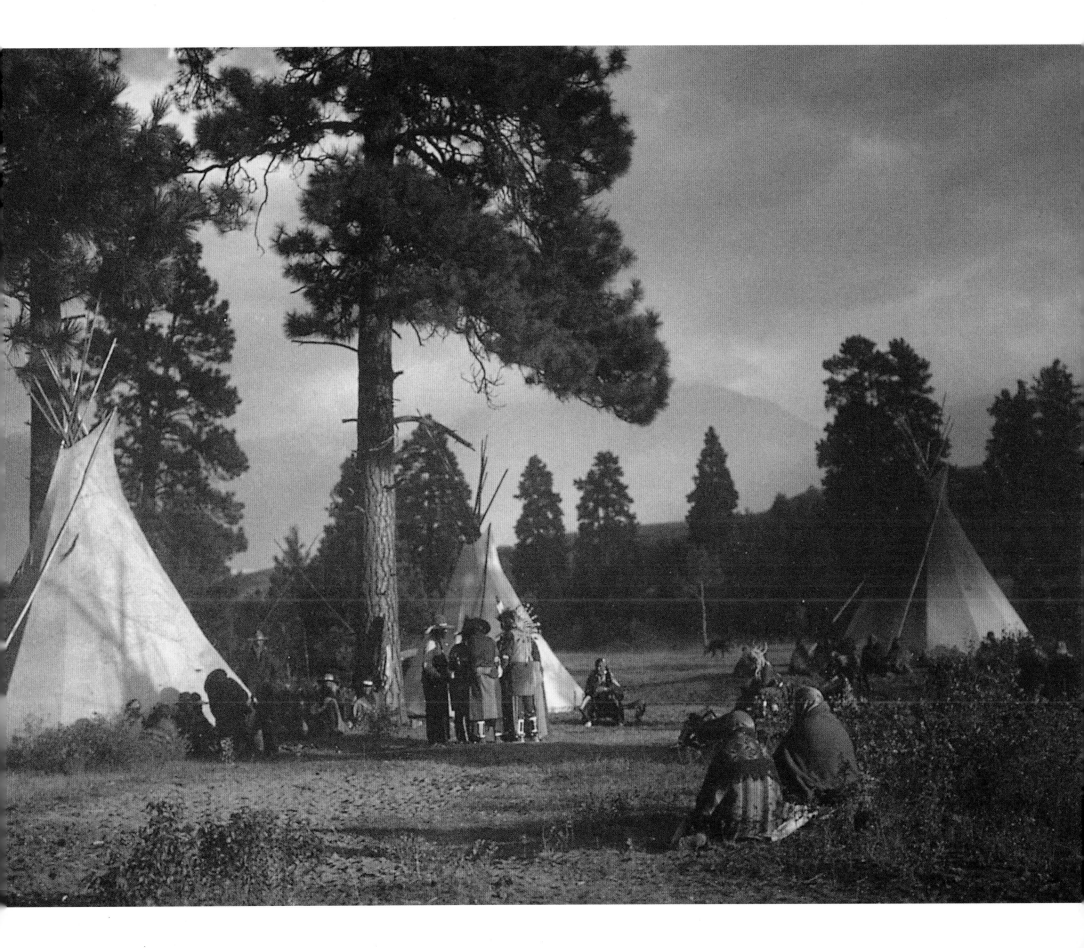

Roland Reed (1864-1934)

Roland Reed once wrote, "I don't know why, but no trip I could plan satisfied me unless it led to Indian country." Reed was born in Omro, Wisconsin, ten miles from the birthplace of Edward Curtis. While still a teenager, he took a job on a railroad crew in Canada. There, he worked alongside native people, and his fascination with them began to blossom. By 1890 he was experimenting with crayon and pencil drawings of Indians and landscapes and thought his career might be one of an artist.

In 1893, Reed met Daniel Dutro, a professional photographer in Havre, Montana. Reed recalled, "I knew that if I could master this seemingly easy way of making pictures, I would have no trouble getting all the Indian pictures I wanted." At the start, he furnished the news department of the Great Northern Railway with publicity photos of Indians, leaving in 1897 to photograph the Alaskan gold rush for the Associated Press. Unsettled, he spent time working in Fort Benton and Great Falls before finally establishing his own successful studio in Minnesota. The studio helped fund his main interest — photographing Indians. It was his "intention to publish a definitive photographic record of the North American Indian."

In a letter Reed described how he gained his subject's trust:

Roland Reed making camp, circa 1915, MHS

In approaching the Indian for the purpose of taking his picture, it is necessary to respect his stoicism and reticence which have so often been the despair of the amateur photographer. A friend once characterized my method of attack as indicative of Chinese patience, book-agent persistence, and Arab subtlety. In going into a new tribe with photographic paraphernalia, although I hire ponies and guides, I never once suggest the object of my visit.

Brochure cover, *Picture Writing by the Blackfeet Indians in Glacier Park Hotels*
photograph by Roland Reed, 1920, BSC

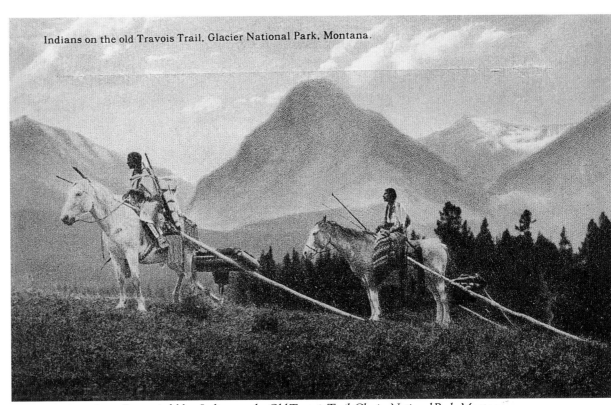

Souvenir folder, *Indians on the Old Travois Trail, Glacier National Park, Montana*
photograph by Roland Reed, circa 1915, BSC

When the Indians, out of curiosity, at last inquire about my work, I reply casually, "Oh, when I'm at home, I'm a picture-taking man." Perhaps within a few days an Indian will ask, "You say you are a picture-taking man. Could you make our pictures?" My reply is noncommittal—"I don't know. Perhaps." "Would you try?" "Sometime, when I feel like making pictures. "Further time elapses; apparently the picture-taking man has forgotten all about making pictures until an Indian friend reminds him of his promise. Then the time for picture-making has arrived.

Reed photographed numerous native people, but his images of the Blackfeet in Glacier National Park — so called "Piegans in Paradise" — are his most memorable. Starting in 1910, Reed kept a studio in Kalispell where his work caught the eye of James Willard Schultz. Sent by Louis Hill, Schultz and several of his Blackfeet friends were gathering Indian legends about Glacier. Reed was invited to come along and photograph the Blackfeet in the National Park. *Blackfeet Tales of Glacier National Park* was published in 1916 and was illustrated with 24 Reed photographs. His imagery instilled the impression that Glacier was home to these proud people. Reed's photos symbolically linked them with Glacier despite the fact that from historic times the Blackfeet preferred

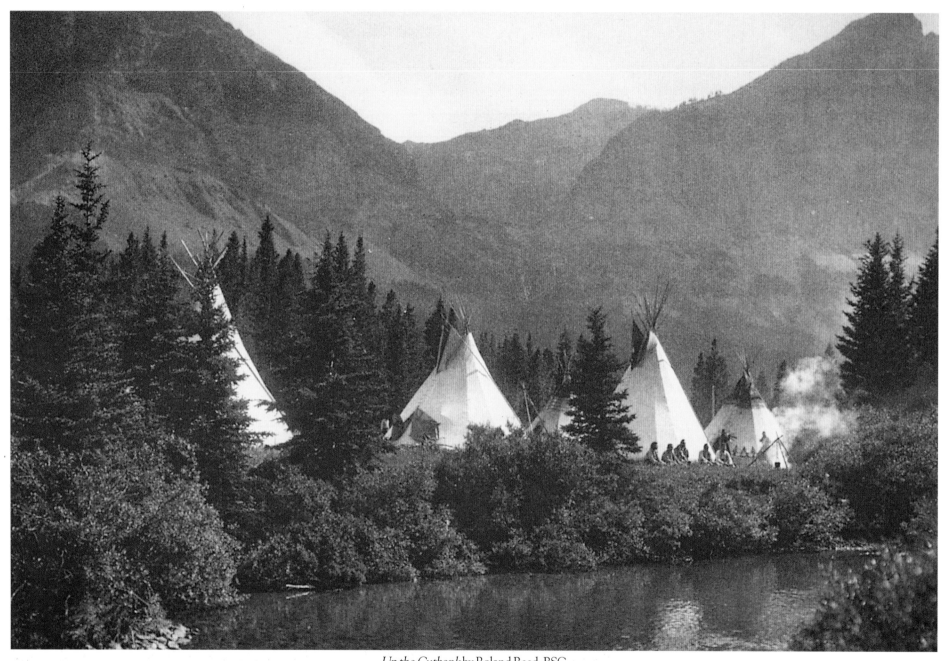

Up the Cutbank by Roland Reed, BSC

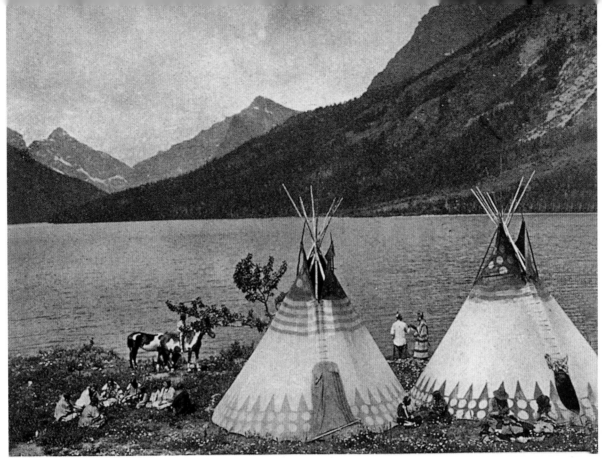

Camp at Lower End of St. Mary's Lake by Roland Reed, BSC

living on the plains. They seldom ventured into the forest except to get lodge poles for their tipis. The false association proved an immediate success with tourists. This pleased Louis Hill, who knew that romanticizing the Park was good for business. Thus, the Blackfeet were encouraged to camp each summer in front of the East Glacier Lodge and were paid to greet visitors arriving on the Great Northern Railway.

Ten years later, Reed's photographs adorned the pages of Agnes Laut's *Enchanted Trails of Glacier Park*, a travelogue promoted by the Great Northern Railway that also carried human interest stories

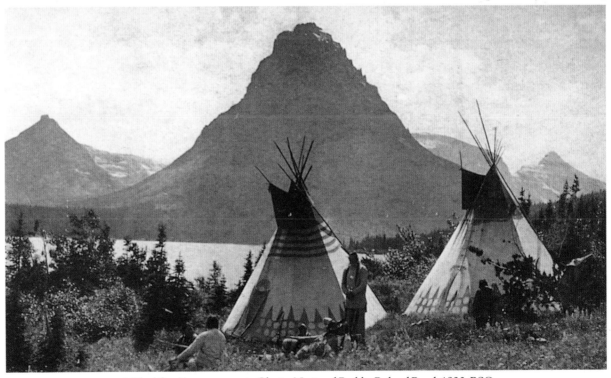

A Blackfeet Encampment in Glacier National Park by Roland Reed, 1920, BSC

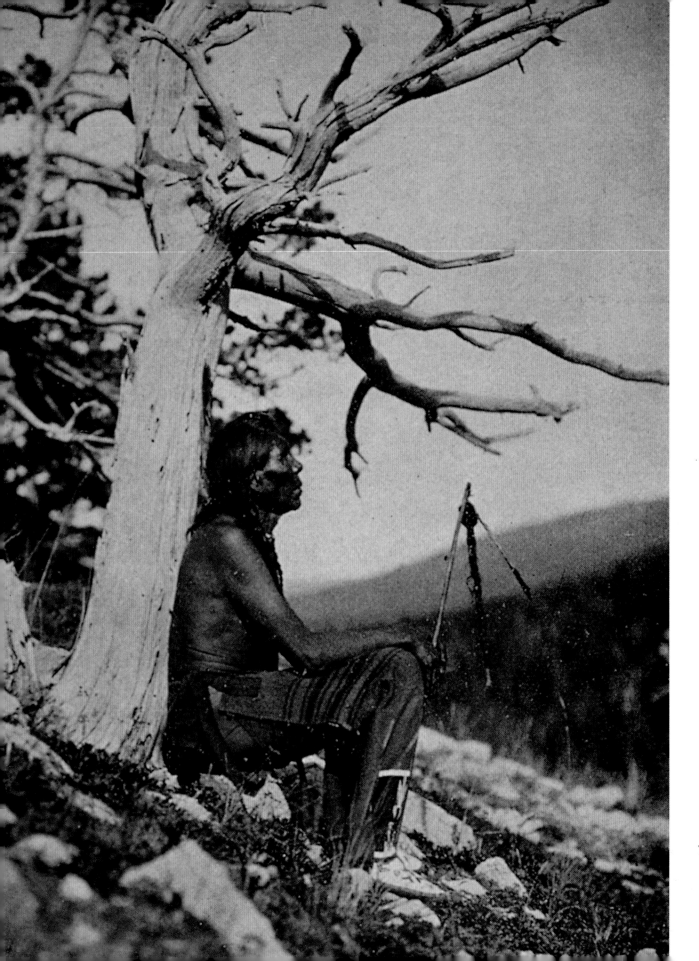

featuring James Willard Schultz, Charles M. Russell and John Clarke. The book proved quite popular and provided Reed with more national exposure.

Reed diligently critiqued every image he took and in a good year might only release twelve photographs. Nonetheless, he made a comfortable living from studio sales and publishers' royalties. Shortly before he died in 1934, Reed lamented "it was no longer possible to obtain authentic Indian pictures because their historic costumes and accouterments had been sold to the tourists."

Contemporaries praised Reed's work for its composition, atmosphere, and authenticity. Although not as well known as Curtis at the time, Reed's photographs earned numerous awards, including a gold medal for "The Pottery Maker" at the 1915 Panama-Pacific Exposition in San Francisco. During Reed's lifetime no comprehensive volume of his photographs was ever published. Only 180 glass negatives were passed on to his heirs, and his diaries, journals, and notes did not survive.

The Last of Their Kind by Roland Reed, 1926, BSC

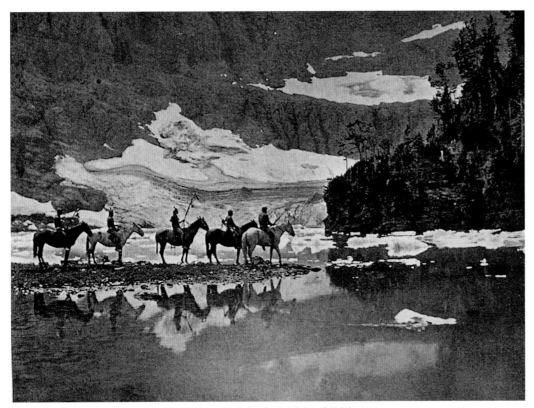

Iceberg Lake by Roland Reed, BSC

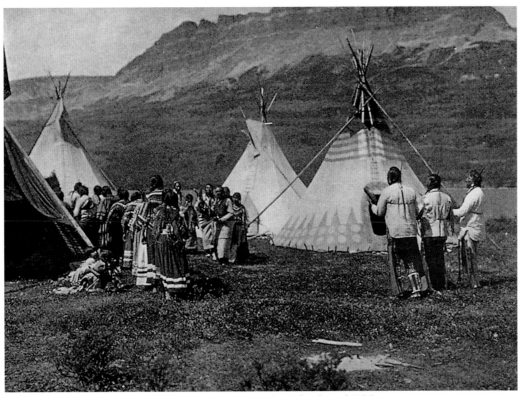

Elk Medicine Pipe Dance by Roland Reed, BSC

INDIAN ART Æ

Photographic
Art Studies
✦ of the ✦
North American Indian

By Roland Reed
Ortonville, Minn.

Roland Reed sales brochure cover
from his Minnesota studio, TMG

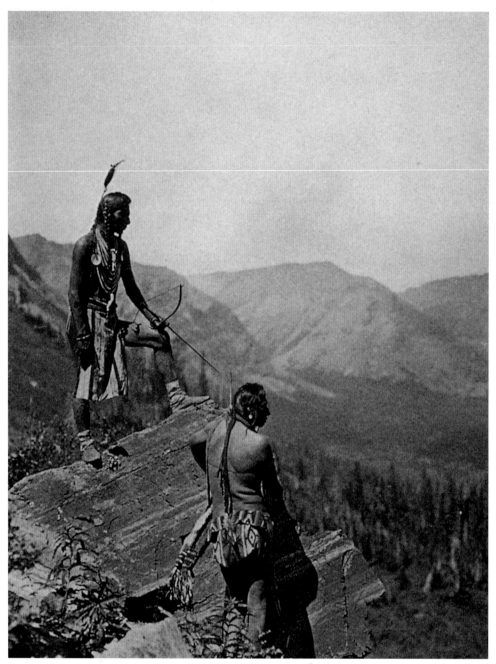

Black Bull and Stabs-By-Mistake (right) Near Lower End of Cutbank Canyon by Roland Reed, BSC

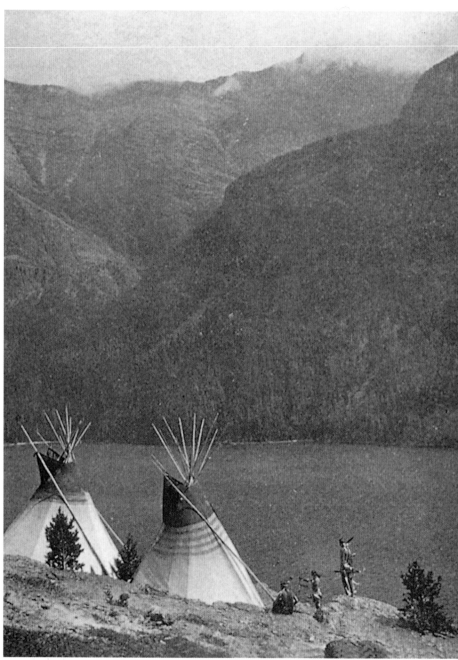

The Narrows, Upper St. Mary's Lake,
With Baring's Basin in the Background
by Roland Reed, 1916, BSC

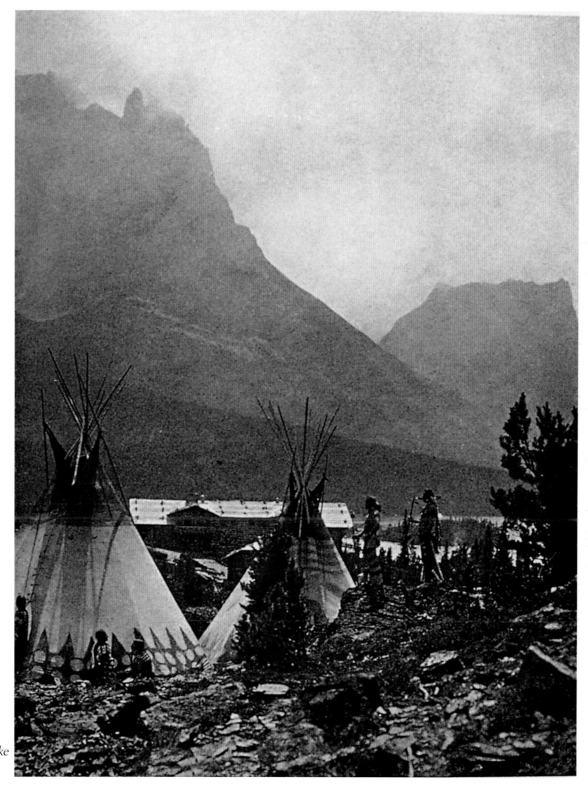

Going-To-The-Sun Chalet, Upper St. Mary's Lake
by Roland Reed, BSC

Ray Elmer "Ted" Marble (1883-1938)

Ted Marble grew up in Big Rapids, Michigan and first passed through Glacier country with his family on their way to Leavenworth, Washington. Captivated by the region, he knew he would someday return. Marble studied the art of photography, and in 1913 was hired by the Great Northern Railway. Marble made his home just outside the west entrance of Glacier. His first studio was a tent, but he was later given a cabin next to the Lewis Hotel at Lake McDonald to use for processing his photographs. Marble, 5'3" and 110 pounds, carried a large format camera weighing over 30 pounds everywhere he went. The intrepid photographer trekked across precipitous mountain trails and through rough terrain in order to capture the essence of the Park. In 1913, he was able to obtain a commercial permit allowing him to "develop and print Kodak films for tourists in Glacier National Park." In a letter dated May 1, 1914 from the Superintendent of Glacier National Park to the Great Northern Railway it is evident the control the company had on Park business:

Mr. R. E. Marble, who has a permit for developing and printing kodak films in Glacier

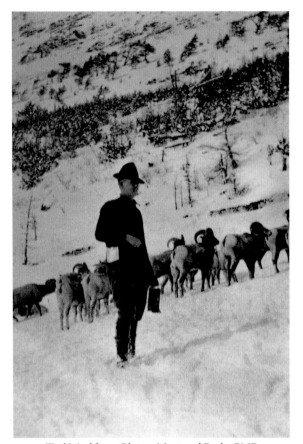

Ted Marble in Glacier National Park, GNP

National Park, with headquarters on Lewis' private holdings at the head of lake McDonald, called on me this morning with reference to the scope of his privilege. I made it plain to him, of course, that he cannot interfere with the

Great Northern Hotel permits or any other permits in the operation of his business. He agrees that this is reasonable but showed me some correspondence with you and with your Mr. W. R. Mills, Advertising Agent, in regard to the possibilities of his getting in some of your hotels on the east side and take care of this developing and printing for you under a satisfactory arrangement with you. I told him that he should take this up immediately with W. R. Mills and state just what he wants. He says that he has prepared to have a man at McDermott and also take care of the work at the head of lake McDonald. By some arrangement with you, films might be collected at St. Marys and other points and forwarded to him at lake McDermott for developing and printing or to Many Glacier camp, if you see fit to make some arrangements with him for a man at that point. He agrees to give prompt and satisfactory service.

Owing to the fact that this young man has a permit for developing and printing, which at the time was issued did not appear to conflict with any other permit in the park, I would

For many years, Marble remained relatively unknown. This was due in part to the fact that the Great Northern Railway would not permit him to sell his own photographs in the Park, and prior to 1919, he received no credit for most of his photographs appearing in its publications. Although Marble's images appeared in Mary Roberts Reinhart's book, *Through Glacier Park*, he was not listed as a contributor.

During World War I, Marble enlisted at Fort Wright, Spokane. He was transferred to Rochester, New York where he spent several months studying at the Eastman Kodak School. In October 1918, he was sent to France to serve in the photographic department of the Army Air Services.

After his discharge the following June, Marble returned to work for the Great Northern Railway, and at last began to receive recognition for his photographs. Marble hoped to increase his visibility by opening his own studio and in 1923

Two Medicine from Mt. Henry by Ted Marble, TEC

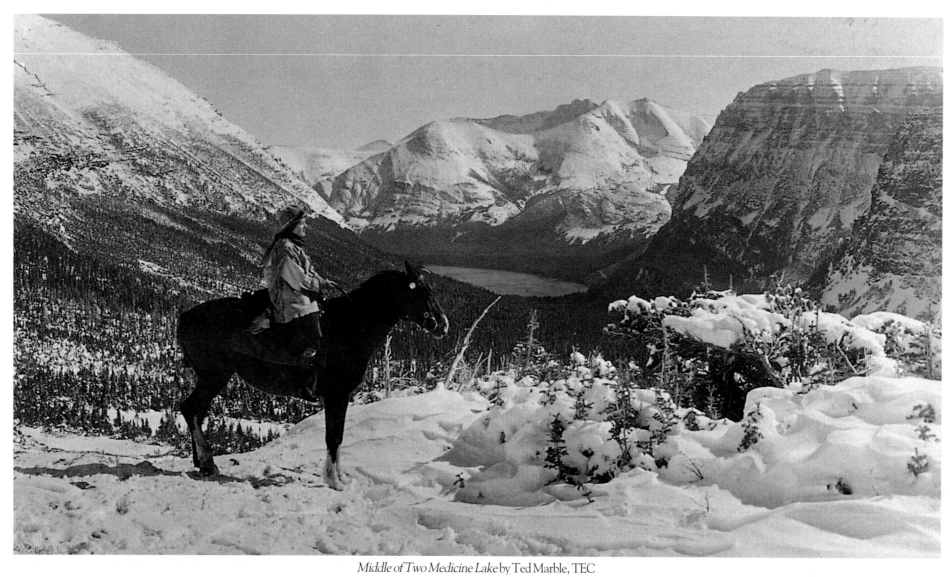

Middle of Two Medicine Lake by Ted Marble, TEC

Postcard, *Howard Eaton's Summer Camp* by Ted Marble, 1916, TEC

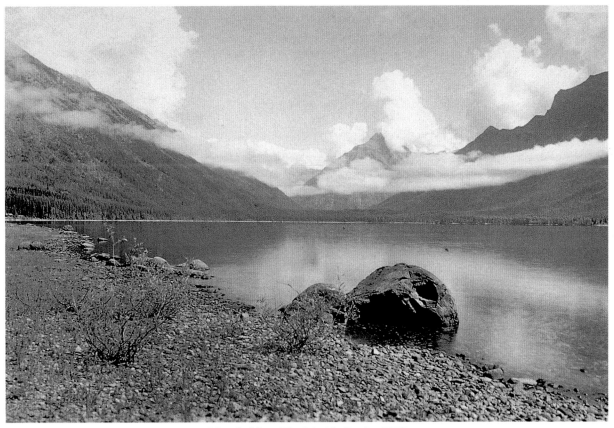

Untitled from The Marble Studio, TEC

began operating out of the old First National Bank building in Whitefish, Montana. There, he sold photographs of regional landscapes and local inhabitants. Returning to West Glacier in 1932, he built a darkroom and studio next to his cabin on the Middle Fork of the Flathead River.

A whimsical legend evolved around one of his postcards as documented by one Park historian:

One of his best selling items was a postcard of the infamous fur-bearing trout. The postcard was still being printed and sold by the thousands after his death. The alleged fish fed on ice worms that lived in icebergs in Iceberg Lake in Glacier National Park. The water in this lake "was so cold that nature has taken care of her own by providing the fish with a thick coat of fur." And to tip it off, fisherman in pursuit of this furry creature had to heat their hooks to keep them from breaking as soon as they hit the water. The hoax, believed to be true by gullible people, actually originated as a gag for a Great Northern convention. Jim Hicken, Great Northern dispatcher in Whitefish came up with the idea and Bob Mills, publicity man for the Railroad, embellished the story with Iceberg Lake being so cold the fish were fur-bearing. A taxidermist fit a trout with a gopher skin and Marble photographed it. It's been a Montana classic ever since.

On July 22, 1938, 55 year-old Ted Marble died from heart complications caused by tuberculosis. In 1963, his estate donated 500 of his negatives to Glacier National Park. A park official praised him stating, "Ted Marble was appreciably instrumental in interpreting and documenting the beauty and splendor of the Crown of the Continent, and these priceless images serve as a pictorial cross-section of life at Glacier during his career."

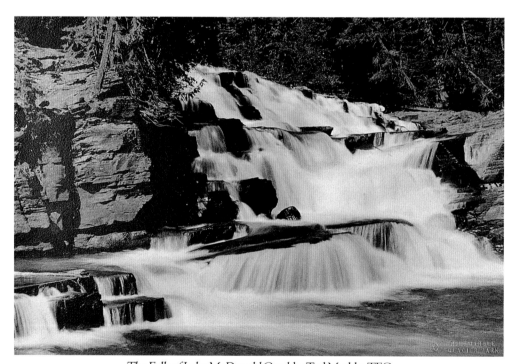

The Falls of Lake McDonald Creek by Ted Marble, TEC

Postcard, *Glacier Park Cub* by Ted Marble, TEC

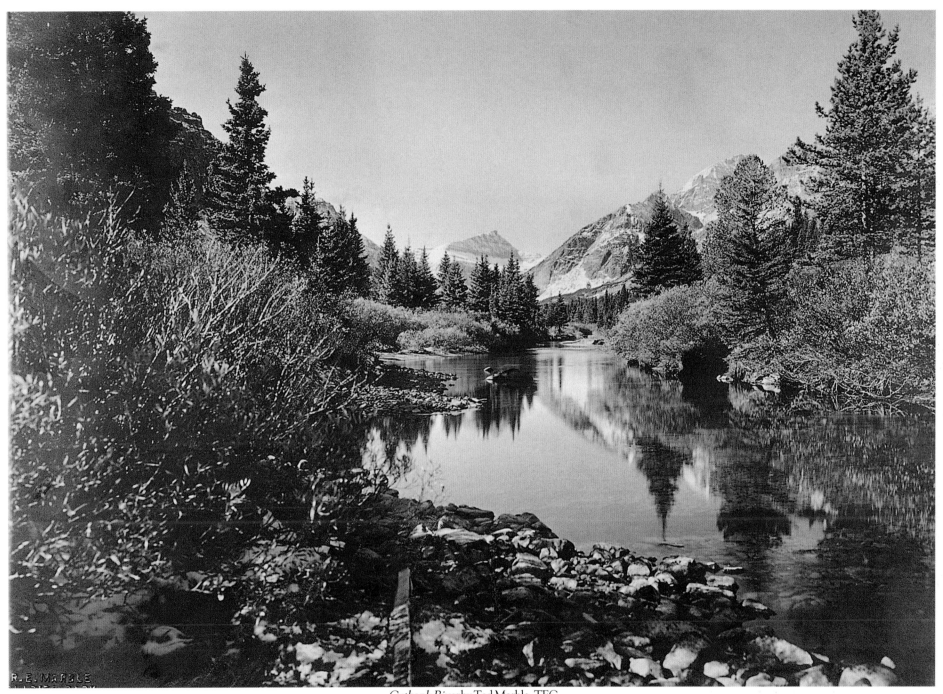

Cutbank River by Ted Marble, TEC

Norman A. Forsyth (1869-1949)

Norman Forsyth's specialty was the stereoscopic photograph, popularized in the early twentieth century. Produced by taking two photos of the same scene from slightly different angles, the resulting stereoscopic photographs are viewed, one by each eye, giving the illusion a single three-dimensional object. Forsyth later recalled his first encounter with stereoscope views:

My introduction to stereoscopic views was when I was about ten years old. I heard people telling about the wonderful things they had seen at the Centennial Exposition at Philadelphia. Their stories did not mean anything to me until a lady let me see her stereoscopic views of the great Exposition through a stereoscope. After that when I heard their stories I felt like I had been there and seen it with my two eyes.

In 1896 Forsyth entered Nebraska Wesleyan University. After receiving a Bachelor of Science Degree in 1901, he spent the next six summers in Yellowstone Park as a stage driver and tourist guide. In his spare time he authored park bulletins and sold his own stereo views. Working as a travel agent and photographer, Forsyth spent his winter

Norman Forsyth and Charlie Russell visiting at Bull Head Lodge, circa 1909, JFC

months in Butte, also arranging summer tours of Yellowstone National Park. His photographs of Butte are a remarkable record of its mining history during the great copper boom. His big break came in 1904 when Underwood & Underwood, manufacturers of stereoscopic views, purchased Forsyth's negatives of Yellowstone National Park. It was then that Forsyth began making trips to

Glacier to photograph its people and scenery. From his studio in Butte he sold his stereoscopic photographs, packaged in sets of 30.

Forsyth will always be remembered for his participation in the famous Pablo buffalo roundup south of Flathead Lake that he attended with his friend, Charlie Russell. In a sad chapter in

American history, the once great herds numbering in the tens of millions had been wantonly slaughtered, leaving only a few hundred remaining. Michel Pablo had tried in vain to sell his herd to the United States government. In 1907, he struck a deal with Canadian officials to buy his 700 animals for $200,000. Russell and Forsyth did not want to miss this momentous event, undoubtedly their last chance to see a large herd of buffalo in America. The resulting stereo views that Forsyth took are highly prized today as a lasting record of this unique event.

During the roundup, Forsyth was almost killed by a charging group of buffalo. He recalled years later:

On Nov. 8, 1908, Charles M. Russell and I were camped with about 30 cowboys 20 miles south of Polson on the Ponderay river.... Russell and I took it all in. Camping with Charlie was the best way to get to know him. Gathered around the campfire at night he would keep us all entertained and those four summers he never ran out of stories.

He was a roughneck. He was the most tender hearted person I ever knew. He liked all kinds of 'humans.' What they did was their business. He saw their good qualities only. From him I learned to see the beauties of the sunsets and the colors in flowers as I had never done before.

A Camp of the Blackfeet by Norman Forsyth, TEC

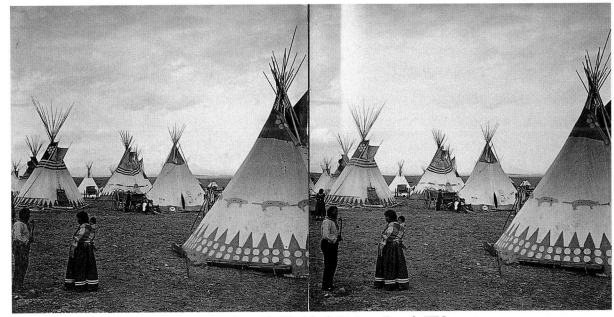

Painted Lodges of the Blackfeet by Norman Forsyth, TEC

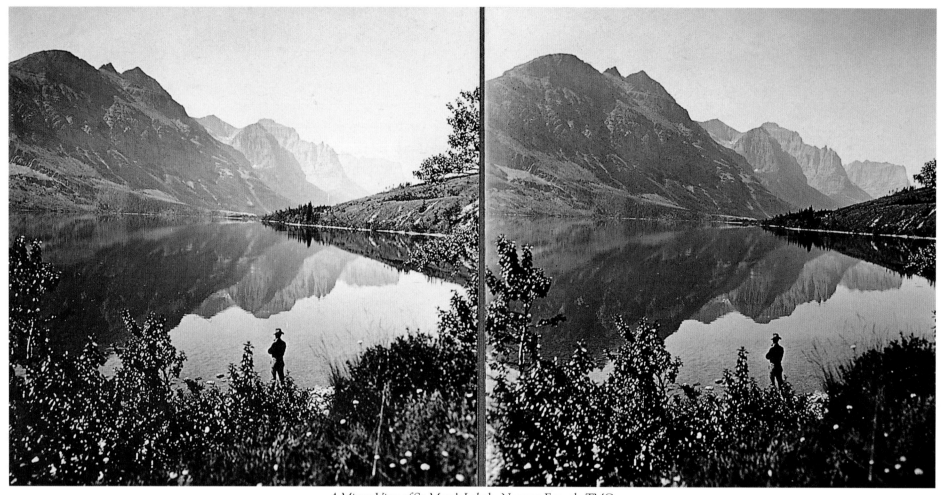

A Mirror View of St. Mary's Lake by Norman Forsyth, TMG

On Nov. 8, 1908, the boys brought in 117 head and I was ready with my camera. The old leader saw me and charged. I had a cedar tree picked out but just as I started up I found myself straddling a mad buffalo bull. I hung to the tree and after what seemed a week the heard was gone and so was my camera and also my hat.

That Christmas Charlie sent me the painting [*A Close Call*] which is perfectly true to life. I wish Charlie could come back so he could see how much we all appreciate him and his wonderful pictures. Perhaps he does know.

Most of Forsyth's Glacier photographs were taken between 1902 and 1912, and roughly 50 stereo views of the area were published. His glass

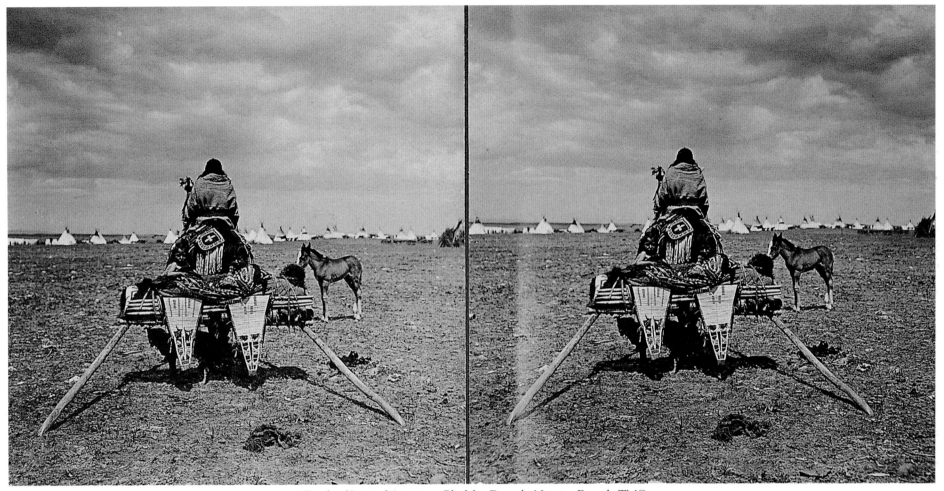

Overland Limited Arriving at Blackfeet Dance by Norman Forsyth, TMG

negatives were later sold to C. Owen Smithers Photography, and at age 61 Forsyth moved to Dillon, Montana. His last photos, including ten spectacular views of Glacier National Park, were published in 1947. That same year he was diagnosed with kidney cancer. Never married,

Forsyth passed away at a rest home in Dillon on December 15, 1949.

Forsyth historian, Robert Greenwood, states: *Norman Forsyth was an accomplished and imaginative stereo photographer. He worked close to his subject … selecting the best camera angle to take advantage of the dimensional effects of stereo photography. Perhaps more important is the historical value of his work, for he has left us a valuable record of life in Montana at the turn of the century.*

Lake McDonald, the Glory of Montana by Norman Forsyth, TMG

A Good Place for Trout, McDonald Falls
by Norman Forsyth, TMG

A View of Lake McDonald from the Outlet by Norman Forsyth, TMG

A Morning Scene at Two Medicine Lake, G.N.P. by Norman Forsyth, TMG

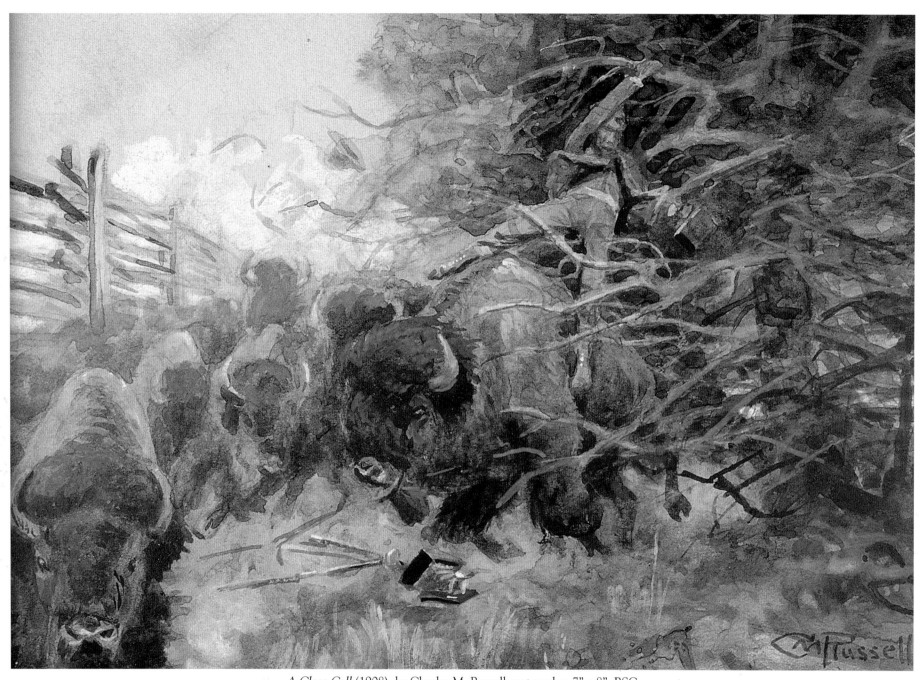

A Close Call (1908) by Charles M. Russell, watercolor 7" x 8", BSC
This painting is Russell's version of Forsyth's ordeal.

Postcard, *Blood Squaws in War Dress*, no credit to artist, 1907, TEC

Postcard, *Scalp Dance, Blackfoot Indians*, no credit to artist, 1907, TEC

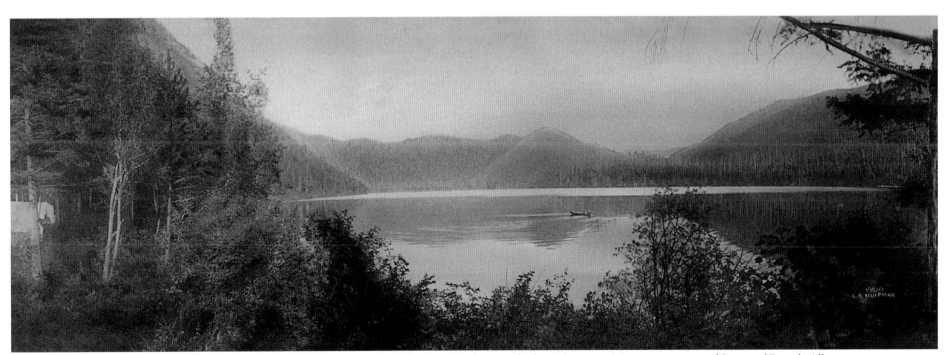

St. Mary's Lake hand-colored by L.A. Huffman, based in Miles City. He photographed mainly eastern Montana, courtesy of Gene and Beverly Allen

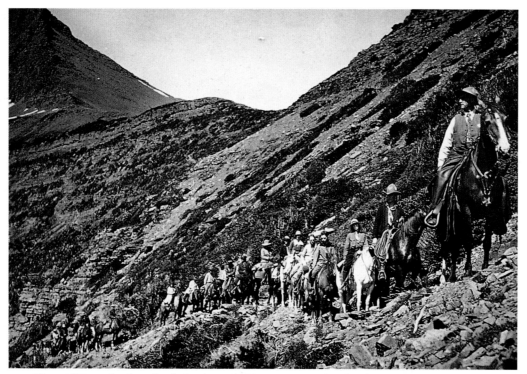

Howard Eaton leading the dudes through Glacier National Park, photo by his nephew, TEC

The End of the Trail by Rollin McKay, based in Missoula. He photographed the
Flathead Indians from 1908 to 1917, TMG

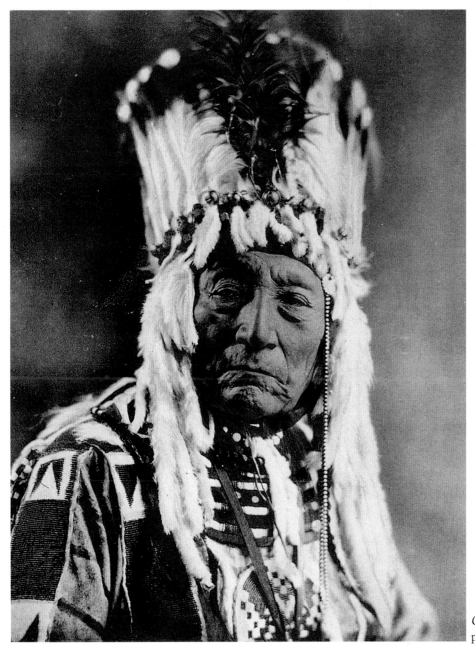

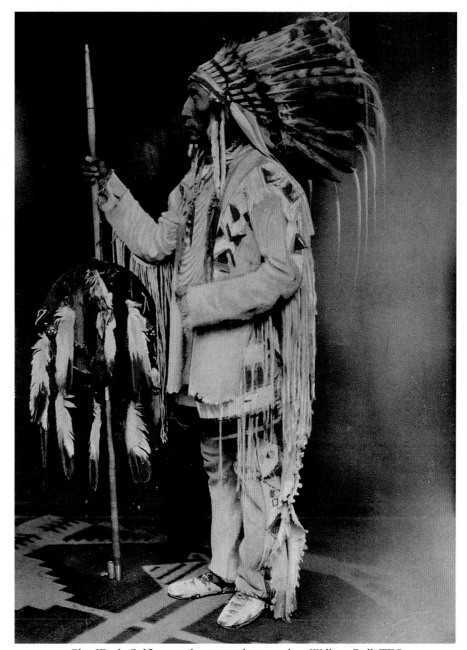

Chief Eagle Calf by noted portrait photographer, William Bull, TEC

Chief Curly Bear by noted portrait
photographer, William Bull, TEC

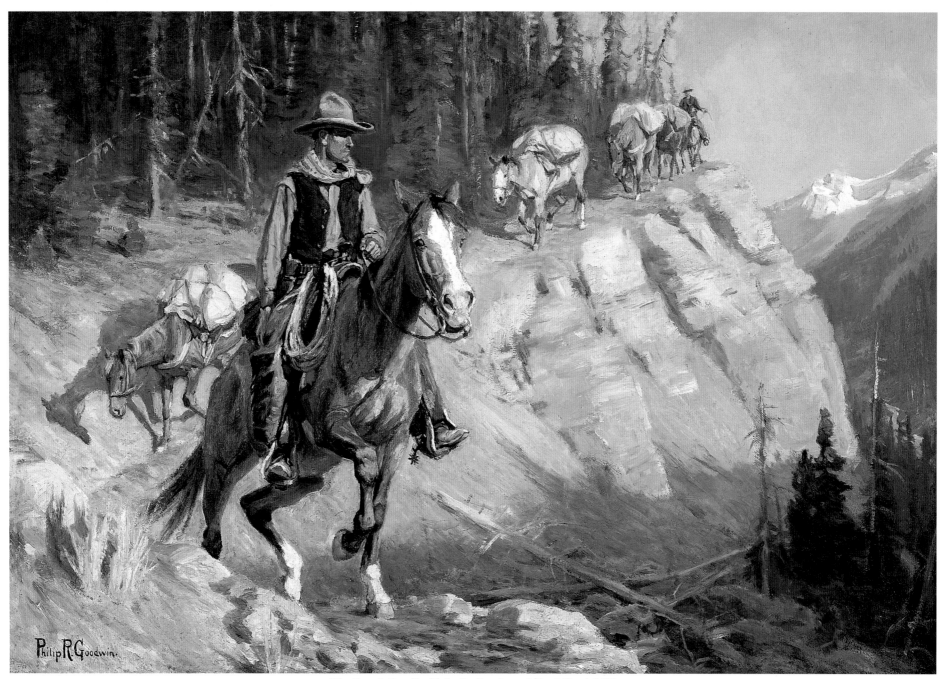

The Sturdy Band by Philip R. Goodwin, 24" x 36", oil, MSJ

Word Painters

Charles M. Russell and Friends

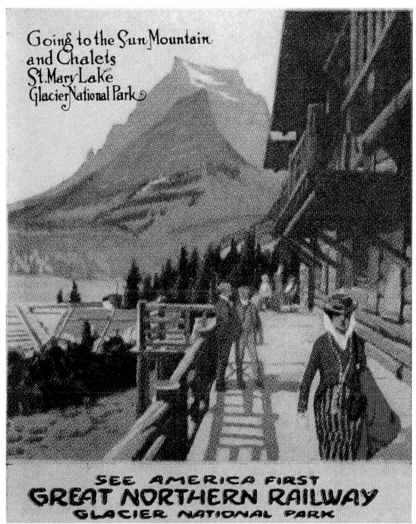

Going to the Sun Mountain and Chalets, St. Mary Lake, Glacier National Park, artist unknown, one of eighteen "See America First" stamps, Series No. 5, courtesy of Parkland Books, Kalispell, Montana

I spend my summers at Lake McDonald on the west side of the mane [sic] range where I have a cabon [sic]. Is about as wild a place as you can find these days and that is what I like.... If its laying down you need Lake McDonald is the best ground in the world and my lodge is open and the pipe lit for you and yours. You know that lake country sings the cradle song to all who lay in her lap.

Thus Charlie wrote a friend in 1915, inviting him to the Bull Head Lodge, a log structure nestled among the cedar, fir, and tamarack trees above the shoreline of beautiful Lake McDonald. Besides Russell and his friends, many artists were attracted by the shear inspiration and beauty offered by Glacier. Together, they completed a lasting tribute to this vast domain.

Charles M. Russell (1864-1926)

Charlie Russell was born in St. Louis in 1864 and by sixteen was living the life of a cowboy in Montana Territory. Always interested in painting, Russell first gained prominence with an image capturing the severe winter of 1886 when thousands of cattle perished on the northern plains. *Waiting for a Chinook* became one of his most important artistic statements. This exquisite little watercolor was shown all around Helena and soon became famous throughout the Territory. Charlie's talents garnered him the nickname "The Word Painter," and Montana newspapers began to note the progress of this local artist. His days as a wrangler ended when Nancy Cooper became his bride in 1896.

Nancy was Russell's business manager, freeing him to concentrate on his art. In 1888, *Harper's Weekly* became the first national publication to use his work with *Recreation, Field and Stream* and *Sports Afield* soon following. Still, Russell remained only a regional celebrity. In 1901 he gave an interview to the *Anaconda Standard*:

There's nothing in the east for me, what do eastern people care about my pictures? Why,

Side view of Bull Head Lodge, with Nancy Russell and Josephine Trigg on the left, and two unidentified people on the right, 1916, CMR

they wouldn't give thirty cents a dozen for them. It is the western people who understand them and the western people are the only ones who will want my pictures. I realize and understand that. It would be useless for me to go East. I am going to stay right here and paint things as I see them in nature.

Russell's success gave him the means to build a new home and studio in Great Falls. He and Nancy began spending part of their summers in Glacier, and in 1905 they bought land across the bay from Apgar Village on the south end of Lake McDonald. The following year Dimon and Milo Apgar built a cabin for the Russells. Originally called Kootenai Lodge, the Russells changed its name to Bull Head Lodge after Charlie's buffalo skull trademark was copyrighted. The cabin was accessible only by boat and was located 100 feet from the water's edge. It was Russell's favorite haunt, and he shared it with his fellow artists and close friends. Only a buffalo skull marked the cabin site from the lake as heavy undergrowth made it undetectable from the shoreline. Filtered light, lush vegetation, and towering evergreens, as well as scattered "little people" crafted by Charlie,

Famous humorist, Irvin S. Cobb; John Lewis, owner of Lake McDonald Lodge;
and Charlie Russell outside the Lodge, 1925, BSC

(from left) Charlie Russell, Austin Russell (Charlie's nephew), Skookum, Marie Sappington (Skookum's mother),
and Nancy Russell, circa 1913, JFC

made the setting magical. Activities included painting, hiking, horseback riding, fishing, playing cards, boating, and lots of socializing.

Since there were no separate bedrooms, 48 by 21 inch muslin privacy screens served as room dividers. They became makeshift guest books as more than 150 guests of Bull Head Lodge signed their names on them. Some visitors, including Joe De Yong, Olaf C. Seltzer, Kathryn Leighton, Philip R. Goodwin, and Maynard Dixon created elaborate paintings on them, all wonderful reminders of happy summer times.

One page of the Bull Head Lodge guest register, kept between 1909 and 1930, BSC

Bold Hunter—Heavens! A Grizzly Bear by Charles M. Russell, on 1907
W.T. Ridgley Calendar Co. postcard, FGR

Best Wishes To Mr. And Mrs. Calvert by Charles M. Russell,
8¼" x 6¼", watercolor on birch bark, 1906, FGR

In 1907 Charlie swore off drinking and never touched anything stronger than Vichy water thereafter. His five-year contract with Brown and Bigelow provided economic security. Now with a steadier hand, Charlie's art took off. *A Disputed Trail, Land of the Kootenai, First Wagon Trail, The Medicine Man, Bronc to Breakfast, Smoke of a .45* and *When Sioux and Blackfeet Meet*, all painted in 1908, were followed by *In Without Knocking* and *Wounded* in 1909.

Russell stormed New York with his first national one-man exhibition. Romantically titled "The West that Has Passed," it ran from April 12 to May 1, 1911 and included most of Russell's great paintings of the past several years. Three new bronzes, inspired by wildlife near Bull Head Lodge — *The Lunch Hour* (a mother bear and two cubs), *Mountain Sheep*, and *Nature's Cattle* (three buffalo) — were introduced. The next five years saw exhibitions of Russell's work open in New York, Chicago, Pittsburgh, and London. He was truly the undisputed king of western art.

Russell's Bull Head Lodge became one of the stopovers for dudes led through the Park by Howard Eaton. Eaton met the tourists at the train station, loaded up their gear, and transported them into the Park on horseback. Russell's charm provided great entertainment for Eaton and his dudes, and Nancy, regarding each tourist as a potential client for future paintings and bronzes, made certain everyone signed the guest book. Russell's art ended up on numerous advertising pieces for dude ranches throughout the area. He began displaying his work in the three-story lobby of the newly-built Lewis Hotel at the northern end of Lake McDonald. Legend has it that Indian

Wrangling the Dudes by Charles M. Russell, on 1926 Park Saddle Horse Company postcard, JFC

scenes on the massive fireplace in the lobby were painted by Charlie, but that remains to be proven.

By 1920, Charlie Russell was one of highest paid artists in the country. He spent his summers in Glacier National Park and his winters in Southern California. One evening in 1923, while walking down a dark path at Bull Head Lodge, he fell and severely injured his back. Weeks of bed rest led to walking with crutches for months. He would never enjoy good health again.

In February 1924, Russell was finally able to travel again and visited the California ranch of actor Harry Carey. His physical appearance was shocking. Lack of iodine in his diet and too much cigarette smoke had taken its toll. In July 1926, Russell had goiter surgery at the Mayo Clinic in Rochester, Minnesota. Although the operation helped Charlie breathe easier, it did nothing to improve his failing heart.

Shortly thereafter, one of the most destructive fires in the history of Glacier swept through the Park. A mile of forest burned along the edge of Lake McDonald but stopped short of Bull Head Lodge where Russell was spending his last summer. In August, the guest panel at Bull Head Lodge registered 21 visitors, including Margaret and Josephine Trigg, close friends from Great Falls, who came to help with Charlie's care.

When Sioux and Blackfeet Meet by Charles M. Russsell, one of ten Russell "See America First" stamps, Series No. 3, circa mid-teens, BSC

On October 24, Charlie Russell died of a heart attack at his home in Great Falls, Montana. The story was carried in newspapers across the nation and condolences arrived from all over America.

Nancy continued to spend her summers at Bull Head Lodge until 1936. Today, the lodge is privately owned, but remains a symbol of Charlie Russell and a golden age in Glacier National Park history.

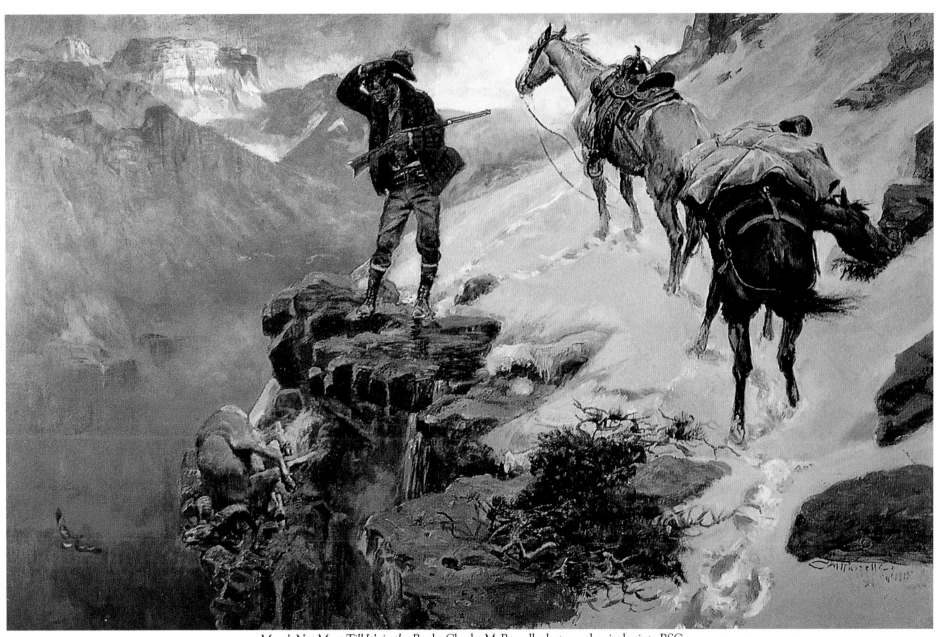

Meat's Not Meat Till It's in the Pan by Charles M. Russell, photomechanical print., BSC
The original 23" x 35" oil is in The Thomas Gilcrease Institute of American History and Art, Tulsa, Oklahoma

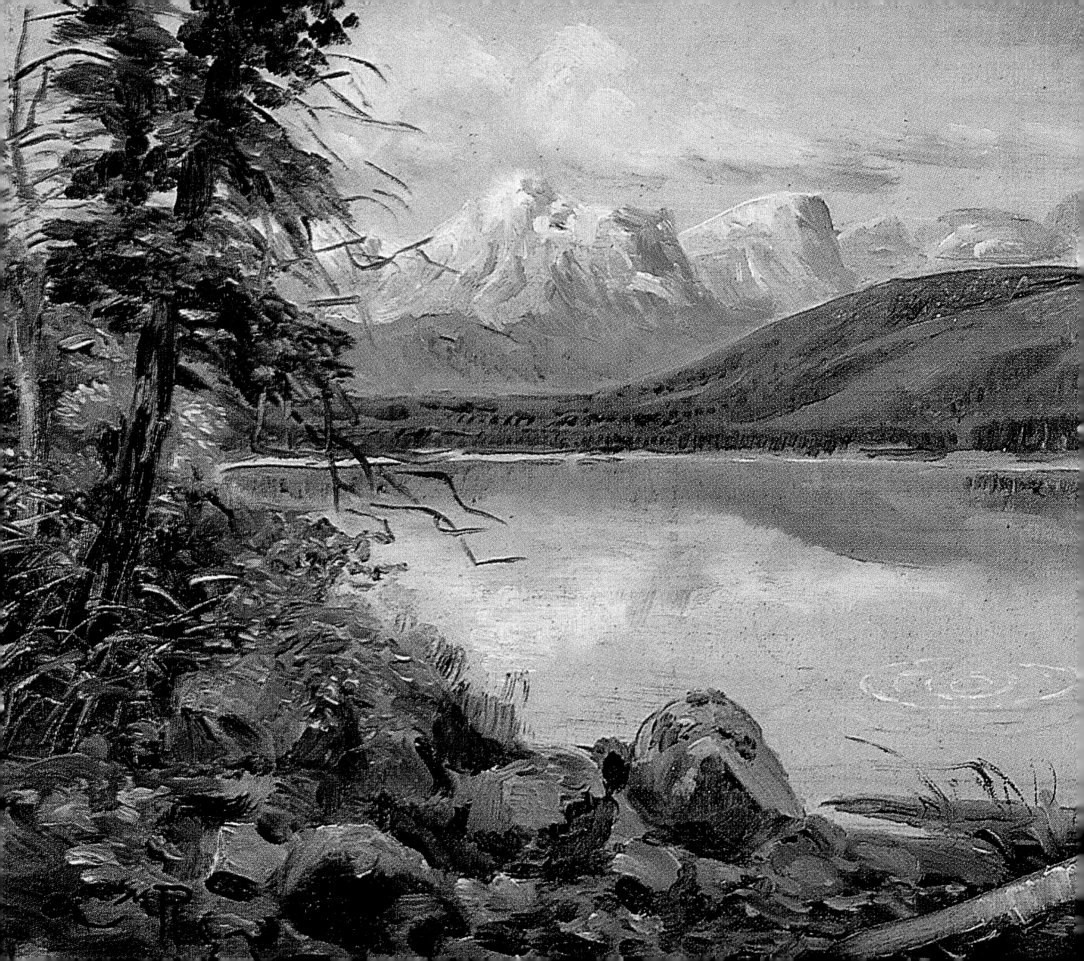

Lake McDonald by Charles M. Russell, 9¾" x 14" oil,
courtesy of the Amon Carter Museum, Ft. Worth

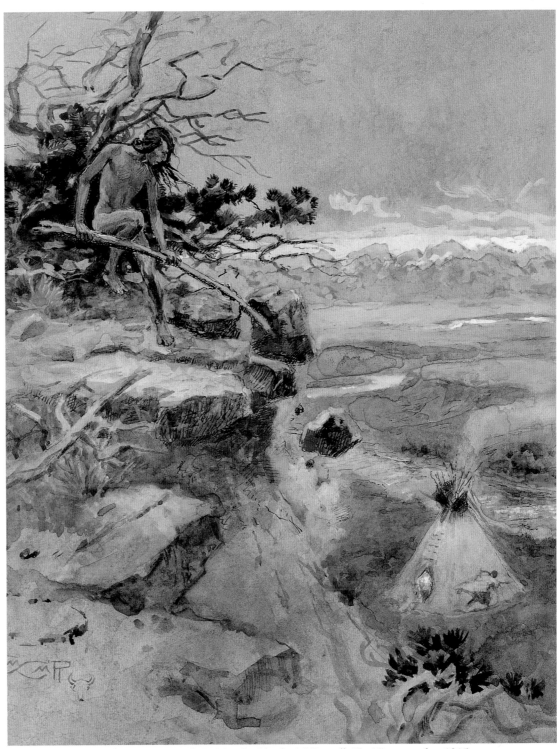

How the Man Found His Mate by Charles M. Russell, 9" x 7" watercolor, 1915,
courtesy of Steve Rose, Biltmore Galleries, Scottsdale, Arizona
This image appeared in Frank Bird Linderman's *Indian Why Stories*

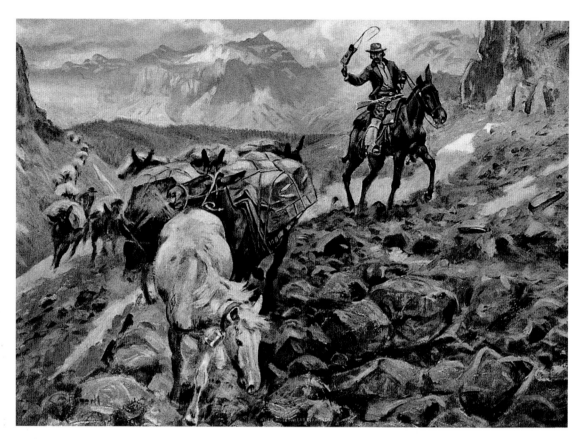

When Mules Wear Diamonds by Charles M. Russell,
on 1949 M & M calendar,
courtesy of the Rudy and Lynette Hass Collection

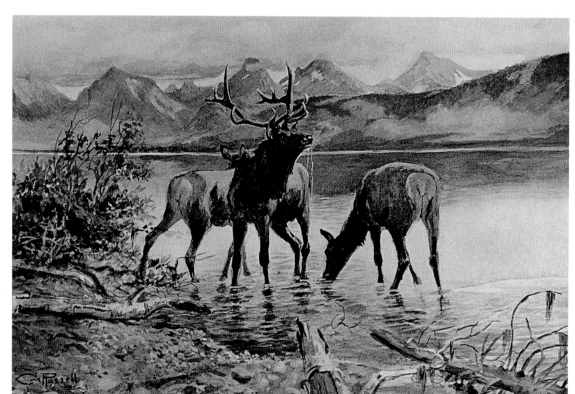

Elk in Lake McDonald by Charles M. Russell,
on 1915 Basin Lumber Co. calendar , JFC

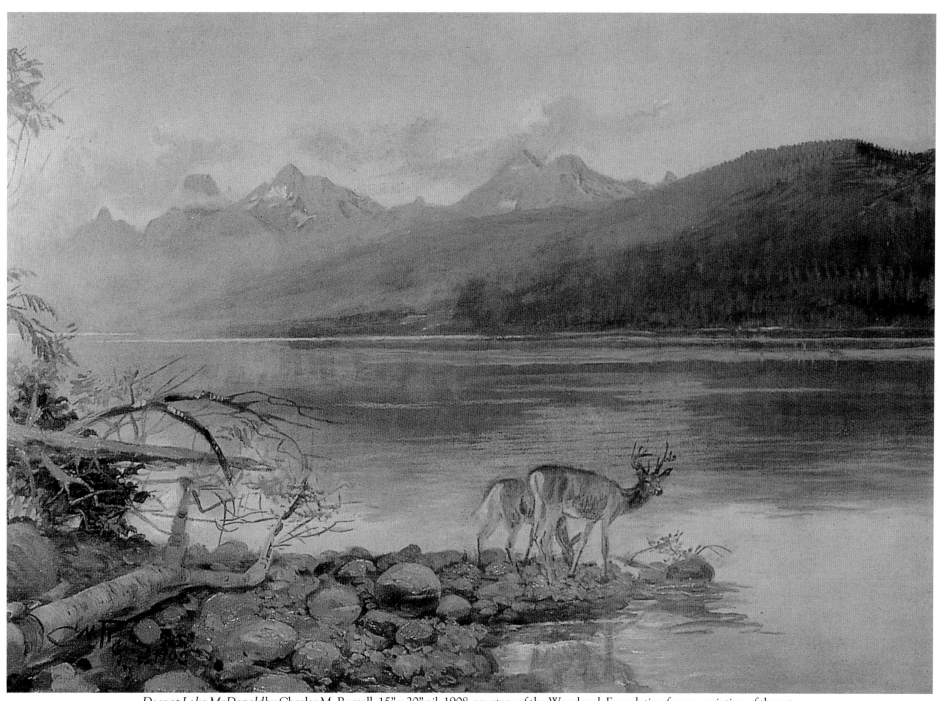

Deer at Lake McDonald by Charles M. Russell, 15" x 20" oil, 1908, courtesy of the Woodcock Foundation for appreciation of the arts
by agreement with St. Louis Mercantile Library at the University of Missouri, St. Louis (Woodcockmuseum.unsl.edu)

Philip R. Goodwin (1881-1935)

Many consider Philip R. Goodwin America's greatest sporting and wildlife artist. Born in 1881 in Norwich, Connecticut, his artistic talents were apparent at a young age. When he won a drawing contest sponsored by *Harper's Round Table*, fourteen-year-old Goodwin became the focus of national attention.

In the fall of 1898, he entered the Drexel Institute of Art and Industry in Philadelphia to study with Howard Pyle. Pyle, considered the country's leading illustrator and teacher, helped his students achieve success, in part through his many contacts with book and magazine publishers. In 1903, he recommended Goodwin to illustrate Jack London's *Call of the Wild*. Released in July, the book was an immediate success, prompting art directors to seek more work from the talented young artist.

Goodwin first met Charlie Russell in 1904 when Russell visited New York. Russell was the center of attention, colorfully dressed in cowboy clothes that were brightened by a prominent red sash always tied around his waist. Goodwin, on the other hand, was unassuming in stature and

Philip R. Goodwin with Charlie Russell and one of Charlie's colonies of gnomes, CMR

dress, quietly unnoticed in a crowd. The friendship was cemented by their shared passion for America's great outdoors.

Russell described the breathtaking scenery of Glacier to Goodwin in great detail. When he invited Goodwin to Bull Head Lodge, Goodwin immediately accepted. Not only would the trip give Goodwin a chance to spend more time with Russell, but would afford him the opportunity to photograph reference material for paintings. After a long car trip, he crossed Montana where

he saw "lots of Indians and their ponies." On August 2, 1907, soon after arriving in Glacier, Goodwin enthusiastically wrote:

It is one of the prettiest spots I have ever seen here on the lake with the Giant Rockies surrounding it...

Belton consists of five houses, a hotel, a saloon and general store, a log cabin and the station, and is about three miles from the lake. The lake has several camps at different

Moose etched into wet plaster above the fireplace at Bull Head Lodge by Russell and Goodwin, 1907, CMR

Privacy screen from Bull Head Lodge 48" x 21",
top illustration by Charles M. Russell, bottom illustration by
Philip R. Goodwin, 1910, MHS

Dear Russell, illustrated letter by Philip R. Goodwin,
March 8, 1907 [actual date 1908], BSC

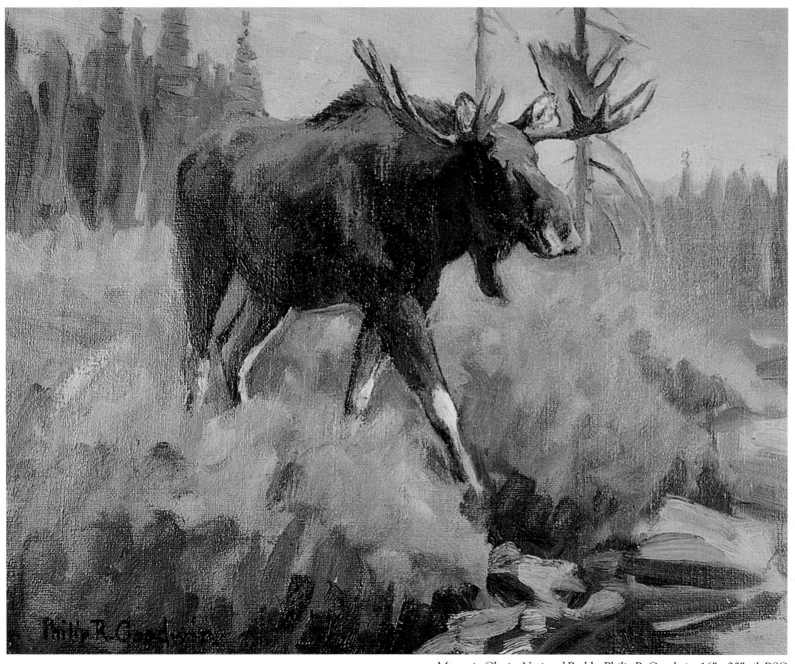

Moose in Glacier National Park by Philip R. Goodwin, 16" x 20" oil, BSC

points and several gasoline launches, but it is wild enough back in the timber.

I sent postal cards to you from Chicago, St. Paul, and Belton and I guess you have got them by this time. I don't believe Dunton would like it here as there are no ranches and cowboys, but there are plenty East of the Rockies.

Goodwin added his personal mark to Bull Head Lodge lore when Russell asked him to help decorate the new fireplace. Since a mason was just finishing, the two artists were able to etch twelve images into the wet cement. Goodwin contributed a standing moose, a wolf, a bear, and a portaging scene, signing them P.R.G.

In his memoirs, Charlie's nephew, Austin Russell recorded the event:

[Goodwin] had been there the year Charlie built the big new hearth and chimney, and the two of them had decorated the fireplace by scratching the wet cement with drawings of moose, deer and so forth.

Outside the cabin, under the bottom log, Apgar put a wide strip of concrete to run off the drip from eaves-it's always the bottom log that rots first-and Charlie marked it with big bear tracks which he knew how to make with the heel and ball of his hand, his thumb and the tip of his fingers. This was years before Hollywood started the fad of recording the stars' footprints; in fact, it was years before Hollywood.

Besides these memorials Nancy had made a set of white cotton screens-intended primarily for dressing rooms when the whole bunch bunked in one cabin-and every guest who stayed overnight had to write his or her name in India ink, and one leaf of the screen for each summer.

The chimney of brick and stone and cement caused a catastrophe, Apgar had built it around a wooden form, and when it had set and Charlie and Goodwin took over, some bright person suggested that the quickest way to get the form out was to burn it. It was quick all right.

But when Charlie and Goodwin started to burn the chimney they almost burnt out Montana, within three minutes it was roaring like a blast furnace with a flame forty feet high shooting out the top. They were scared sick, afraid of starting a forest fire. When they tried to cut off the draft with a wet tarp across the fireplace the suction pulled it right up the chimney. They stayed up almost all night before the damn thing burned out. The chimney was cracked from bottom to top and had to be pointed up. The moral is-before you start something you can't stop, consult an engineer. But you can't expect an artist to know everything.

During the following weeks so much rain fell that it was impossible to sketch or take photographs. However, this did not stop Goodwin, Russell, and Henry Pike Webster, the son of an old friend of Russell's, from camping across the lake and racing model sailboats.

Despite the bad weather, the two artists were able to paint together for the first time that summer. Goodwin's more vibrant palette directly influenced Russell, encouraging him to use brighter colors. Russell's hilarious scenes depicting bears, skunks, porcupines, and horses in conflict with humans intrigued Goodwin and became the inspiration for Goodwin's predicament paintings. By September 10, Bull Head Lodge was locked up for the long winter, and everyone headed back to Great Falls.

For Goodwin, the trip out West was the "treat of a lifetime." Business contacts were made and friendships strengthened. Despite only ten days of sunshine, Goodwin enthusiastically wrote his mother that "it is the most beautiful scenery here of any place I have ever been, the big back bone of the Rockies just towers at the foot of the lake which is 11 miles across."

Goodwin thought Russell "more than a genius. His work is a great asset to the country and a monument to the Old West." Goodwin soon received the first of several beautifully

illustrated letters from Russell. He mailed back a reply, nostalgically illustrated with images of experiences they shared in Glacier.

In 1910, Goodwin illustrated a book chronicling Teddy Roosevelt's hunting tales. *African Game Trails* was a triumph for both author and artist. In a time when few Americans visited Africa, *African Game Trails* transported the reader to a land of adventure thousands of miles away. For twenty-nine year old Goodwin, it solidified his position at the forefront of wildlife illustrators.

Having received $800 for his *African Game Trails* illustrations, Goodwin looked forward to another summer trip. Russell convinced him to visit Bull Head Lodge for a second time. While rain dampened his 1907 visit, it was a lack of moisture that created problems in 1910. Forest fires raged throughout Montana from spring until early autumn. Merciless fires burned almost three million acres of virgin forest and killed nearly 100 people. Bull Head Lodge was spared, but much of the forest on the other side of the lake was destroyed.

Austin Russell recalled:
Forest fire is an ever present danger in the mountains. Even the ground, the floor of pine needles, will burn. Started by vandals, by careless campers, by locomotives, by

lightning, it goes with the wind; it burns uphill quickly and downhill slowly; it will jump fire-guards and rivers and even lakes. More than once we went up to Belton with fire burning on either side of the right of way and railroad guards every few hundred feet.

The summer Goodwin was out there, the sky was hidden for weeks. You could look straight at the weird red sun; soot fell in a black snow storm day and night; the lake was covered with scum.

The wind was blowing our way and one evening, just at sunset, the fire came up over the crest of the foothills across the lake. We went down to the shore to watch. It was a solemn, terrifying business. We'd see the flame reach a pine tree a hundred feet high and run right up it to the top. We thought the whole country was going to be ruined and Charlie talked about breaking camp and getting out before the fire reached Apgar and cut us off from Belton. But that night the wind changed. The fire went back over the hill and the lake was saved. Finally it rained; the lake and the river cleaned themselves and danger was gone for that summer.

The pine woods are a great place to fall in love, and Goodwin, as was inevitable, went

suddenly soft at the top about kid sister. Big brother was dum, as big brothers are, and it wasn't till I was out in the canoe with Aunt Nancy and remarked on Goodwin's queer clumsiness-as if he was mentally slipping off the perch-that she explained what was happening. I began to laugh in a nasty way and would certainly have made trouble, but the steerslady forestalled me, "One snicker out of you-just one-and you go back to town on the evening train!"

I knew my Aunt Nancy and there were no snickers.

Kid sister was too young and Goodwin too unenterprising for anything to come of it, but no doubt it enchanted the whole summer for both of them. El Encantando the enchanted man-and the enchanting maiden.

Goodwin was bashful; he couldn't sing in the daylight, but one night, just after Nancy blew out the light, he surprised us all by suddenly piping up in a high-pitched, unnatural, embarrassed but resolute voice, and sang an ancient ditty from his childhood. I remember it now: I was lying on my back looking up at a star through a crack in the shakes, and suddenly out of the dark, like a thin fountain of light-thin but with a crystal clearness to it-that jet of song.

Untitled by Philip R. Goodwin, on 1916 calendar for Winchester Guns
and Cartridges, courtesy of Neil and Sharon Snyder.
The original painting is at the Buffalo Bill Historical Center, Cody, WY

Untitled by Philip R. Goodwin, on 1918 Bristol Steel Fishing Rods
calendar, BSC

Bighorn Sheep in Glacier National Park by
Philip R. Goodwin, 30" x 20" oil, BSC

Not a very romantic song, you will say, but artists in love express themselves in queer ways,

> *"My father had an old black horse*
> *With a pain down in the thorax,*
> *So he took a great long rubber tube*
> *And filled it full of borax.*
> *He put one end in the horse's mouth,*
> *In his he took the other;*
> *When he blew in that horse blew out*
> *And the blow almost killed the father."*

I suppose it stemmed from New England; we had none of us heard it before and it made a great impression. Especially on Nancy, who sang it next day and not knowing what thorax means she transposed the syllables so that it came out-with a pain down in his throw-ax. Depth-psychology being then unheard of, we just thought it funny.

While Goodwin was visiting, Russell was working on illustrations for *Fifteen Thousand Miles by Stage* by Carrie Adell Strahorn. To supervise, the author rented one of Apgar's cabins at the foot of the Lake and while there met Philip R. Goodwin as he was working on a model yacht. She thought Goodwin a mere child. Later, when she saw him sketching she expressed admiration, referring to his sketches as "pretties." Goodwin as a practicing artist was indignant.

Charlie never forgot it. Every few mornings he'd ask, "Well Philip, going to make any pretties today?"

Besides painting, the two artists also enjoyed modeling with clay and wax and building sailboats as noted by early Russell biographers, Homer Britzman and Ramon Adams:

> *To the day of his (Charlie Russell's) death, he still played with little bits of modeling material. It was one of his marked characteristics, as all his friends know. Philip R. Goodwin tells of colonies of odd little Russell gnomes, whittled out of tree branches and fitted with long gray whiskers made of moss, at Russell's summer lodge. He was always making something interesting, either modeled out of wax or whittled from wood.*

> *Once the artist whittled out and fitted up a model of a full-rigged ship, while Goodwin, also given to modeling and whittling, spent his time in the small likeness of a racing yacht. Together they went down to the shore of Lake McDonald in front of Bull Head lodge to sail their craft. While they were thus busily engaged, along came a certain matter-of-fact and elderly army officer whom Charlie had great respect. Consternation reigned in the breast of the skipper of the full-rigged ship and the smart craft was thrust under the boat-landing. When these two overgrown boys realized that the General had*

not discovered what they had been up to there was a breath of relief. But after the visitor had departed the whole ship's crew were found to have gone to Davy's locker.

Unfortunately, after this second trip Goodwin never returned to Glacier National Park. Nevertheless, many of his paintings were inspired by its beauty, and contributed to his distinguished success in sporting and wildlife art. His famous *Horse and Rider* (1919) for Winchester became the most enduring product logo in American history. Goodwin lived alone in Mamaroneck, New York until his death in 1935 of pneumonia.

Joe De Yong (1894-1975)

Joe De Yong was born in Webster Groves, Missouri in 1894, and raised in Dewey, Oklahoma near present-day Bartlesville. De Yong was always a cowboy at heart and when he was old enough, sought work at local ranches. In 1911 he met Tom Mix, a Western movie star who was filming *Life on the Diamond "S" Ranch*. They struck up a friendship and in 1913, De Yong moved to Prescott, Arizona to work as a technical adviser on Tom Mix films, including *The Law and the Outlaw* and *The Life Timer*. While there, De Yong contracted spinal meningitis, resulting in permanent hearing loss. During his convalescence, De Yong mustered the courage to write to Charlie Russell asking for advice on an art career.

Joe De Yong painting Joe De Yong, JFC

Encouraged by Russell's response, De Yong left for Montana in the spring of 1914. That summer he met Russell, and by January 1916, De Yong was living with the Russell family. The relationship was mutually beneficial. When the Russells were away, De Yong watched the house and fed the animals. In turn, Russell became De Yong's mentor, teaching all he knew about painting and sculpture to the eager protégé. De Yong spent more time with Russell at the Bull Head Lodge than any other artist. The two communicated through Indian sign language or by exchanging notes. Many of these messages were saved, providing valuable insight on their everyday activities, working techniques, and philosophy on life.

Through his association with Russell, De Yong met a number of important individuals. He became good friends with Edward Borein, William Gollings, Maynard Dixon, Irvin Cobb, and Will James. Philip R. Goodwin corresponded and shared the same painting techniques with him that proved so beneficial to Russell. With Nancy Russell's help, De Yong submitted illustrations that were published in *Literary Digest* and *World Illustrated*, and also illustrated Frank Linderman's first novel, *Lige Mounts: Free Trapper*. Nicknamed "Kid Currycomb," De Yong accompanied Howard Eaton and his parties through Glacier selling art. After one such trip, he wrote home, "I can imagine coming to this

Sunrise in Glacier National Park by Joe De Yong,
10" x 14" oil, 1922, BTG

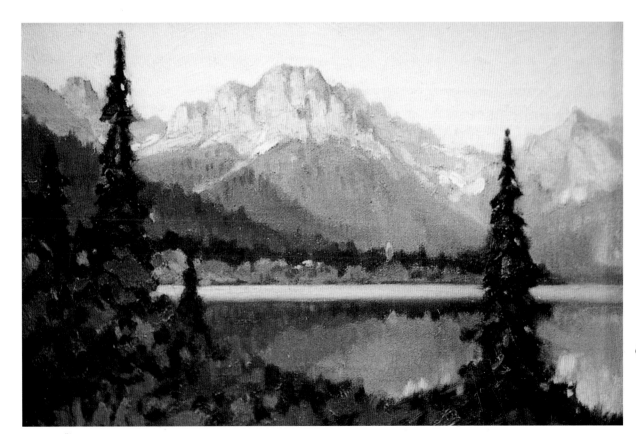

Grizzly Mt.—Two Medicine Lake by Joe De Yong,
9" x 13" oil, 1931, BTG

country years ago and taking up the Indian ways all right. I would have been plum Piegan in 6 months."

In 1924, De Yong accompanied the Russells to California and was introduced to Will Rogers, Charles Lummis, Harey Carey, and William S. Hart. Two years later, De Yong moved to Santa Barbara to study with Edward Borein. It was there that he received the sad news that Russell had passed away. De Yong wrote, "When the sun sets, and the clouds in the East are lighted yet; You'll see the smoke where the Spirit Bands are camped in the hills of the Shadow Land." De Yong remained steadfast in his loyalty to Nancy Russell. He helped repair several of Russell's plasters before they were cast and always championed Charlie's art. Before the city of Great Falls opened Russell's studio for public viewing, Nancy and De Yong arranged the objects there as Charlie would have wanted. With her approval, he set the studio clock to permanently show the time of Russell's death.

Over the next ten years, De Yong earned a living illustrating pulp western magazines. His break came in 1936 when Paramount Studios hired him as historical advisor and costume artist for *The Plainsmen*, directed by Cecil B. De Mille. De Yong designed the headdresses, moccasins, and other Native clothing for the film in the style of the Montana Blackfeet. Next, was De Mille's *Union Pacific*. In what has become a classic scene in the genre of Western filmdom, Sioux warriors derailed a Union Pacific train. Inspired by George Bird Grinnell's *The Fighting Cheyennes*, it was De Yong who fashioned the storyboards for that scene.

De Yong patterned several scenes in De Mille's 1940 film, *Northwest Mounted Police*, after Russell paintings set in the high country of Glacier. He suggested De Mille use local native people stating, "Charlie Russell said to me once that he believed the Flatheads were the nearest to old time Indians of any left in Montana."

Joe De Yong worked on 21 major motion pictures. Such classics as *The Virginian* (1946), *Red River*, (1948), *The Big Sky* (1952), *Shane* (1953), and *El Dorado* (1967) carry his mark. A dramatically changed West saddened De Yong, causing him to reflect:

Will the colors of that far-country be as bright? Will the range still be unfenced, and none of the old trails plowed under? Will the same old friends gather-together, at night-to share the warmth of the campfire's light. Sometimes I can't help but wonder.

St. Mary Lake by Joe De Yong, 7" x 11" oil, CAG

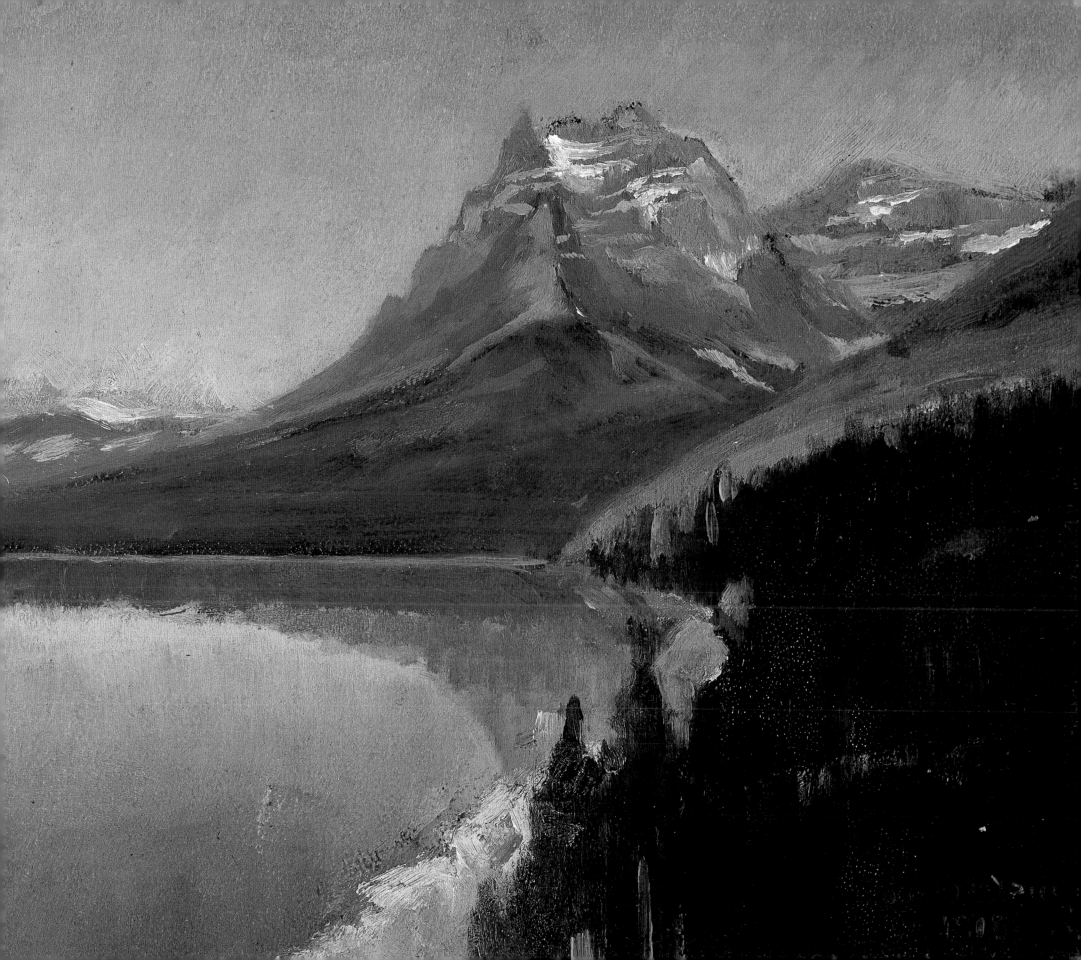

Joseph Henry Sharp (1859-1953)

Born in Bridgeport, Ohio, Joseph Sharp lost his hearing due to infection at the age of 12. In 1874 he was accepted at the McMicken School of Design at the University of Cincinnati even though he was only 14 years old. During his eight years of study there, he became acquainted with Henry Farny, a successful easel painter who specialized in scenes of Indian life. Through Farny, Sharp's interest in the West was kindled, and in 1883 he made his first trip west visiting New Mexico, Arizona, and Oregon.

Sharp first went to Montana in 1899. Asked why he went there rather than stay in the Southwest, Sharp explained, "I went north because I realized that Taos would last longer. I found this northern prototype would soon be extinct and I decided to put into my canvases representations of their present day and time."

He spent the following summer traveling between the Crow Agency in southern Montana and Glacier country. In his outstanding book, *The Beat Of The Drum And The Whoop Of The Dance* (1983), Forrest Fenn chronicled an unfortunate incident:

Joseph Sharp working on his studio at Crow Agency, MT 1903, MHS

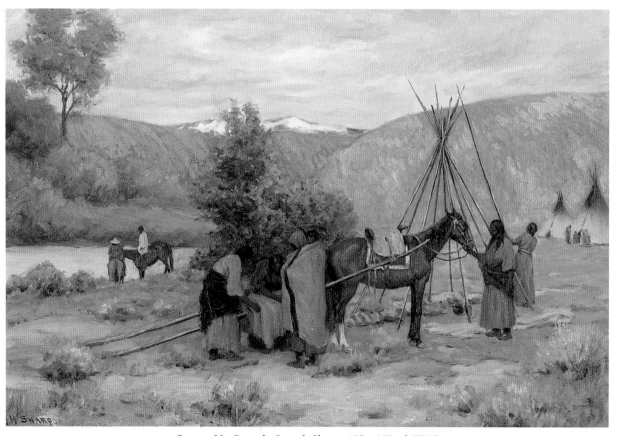

Setting Up Camp by Joseph Sharp, 12" x 18" oil, TNG

- 122 -

Sharp was an avid fisherman and one morning near summer's end while staying near the Blackfeet reservation, he decided to go fishing about ten miles from the hotel where he and Addie [his wife] were staying. During his absence the hotel burned, destroying much of his summer's work. That evening Addie and Francie Leupp, the Blackfeet Indian agent, reluctantly told Sharp what had happened. For a moment he looked down, scraping the ground with his toe, then said simply that the trout he caught that day were the best he had ever eaten.

While at the Crow Agency, Sharp finished 93 paintings for the *Special Exhibition of Indian Portraits Painted from Life by Mr. J. H. Sharp* exhibited in Cincinnati, Detroit, and Washington. The Smithsonian purchased 11 paintings, and a critic praised his work stating, "ethnologically this collection was of the greatest interest…. Sharp's pictures form the most intensely human collection of ethnological studies I have ever seen." In 1901, Sharp exhibited at the Pan-American Exposition in Buffalo, New York, selling every painting to Phoebe Hearst. Hearst also purchased all the paintings in Sharp's Cincinnati studio, financially enabling him to divide his time between Taos and Montana where he wintered from 1902 to 1910.

Sharp and Samuel Reynolds, the superintendent of the Crow Agency, became close

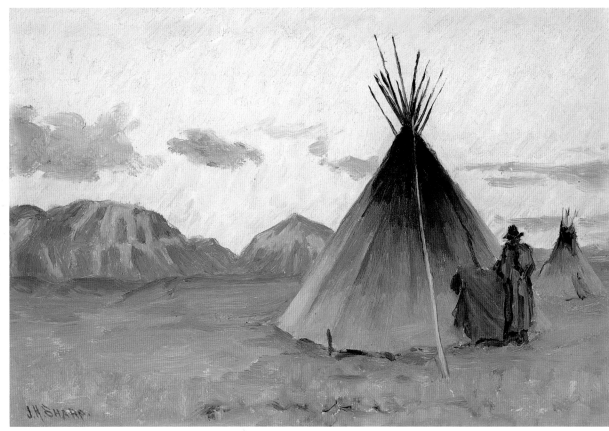

Montana—Blackfoot Reservation by Joseph Sharp, 6" x 9" oil, courtesy of Paul and Doris Masa Collection, Kalispell, MT

friends. Reynolds helped Sharp build a studio and home on the reservation. Late in 1905, Sharp wrote enthusiastically, "We are going to move into our little log 'hut' in a day or two. I've been tinkering around on the interior for three weeks, and have only painted twice, but hope to get at it again soon. We have had such a jolly delightful time fooling around with it, and it will be simply stunning."

By 1906, Sharp was totally immersed in Crow life on the reservation. He traveled throughout the area, painting from a makeshift studio fashioned out of a sheepherder's wagon. Rather than focus on portraiture, he turned his attention to the surrounding scenery, painting the countryside and often incorporating native teepees. His patrons were hesitant to buy pure landscapes prompting Sharp to lament, "The only

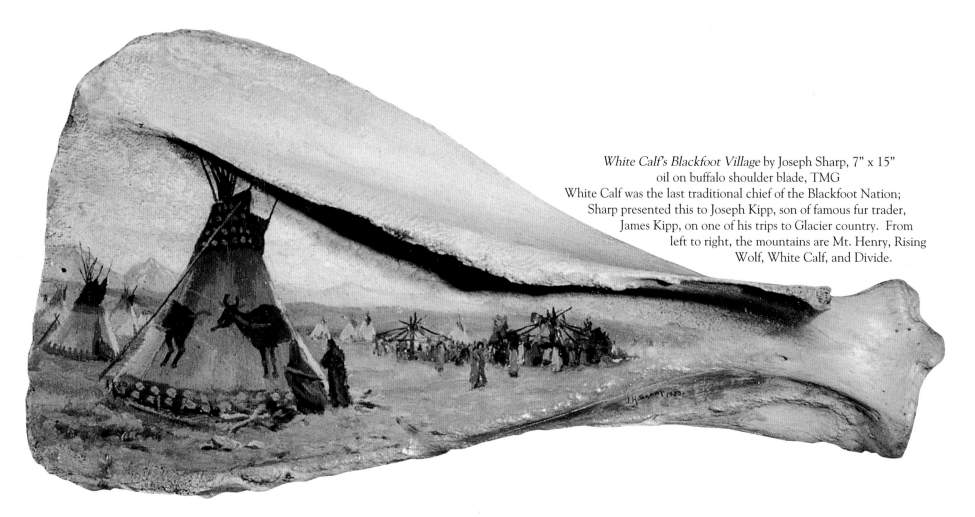

thing, people won't buy my landscapes unless I put those darn teepees in, and some of my best things don't need them; I won't do it, so I lose sales."

One of Sharp's most unique paintings from this period is White Calf's Blackfoot Village painted on a buffalo bone. Antiquarian, Thomas Minckler, described the piece:

The Blackfoot village with its two Sun Dance arbors was painted by J.H. Sharp in 1903 on the shoulder blade of a buffalo. C.M. Russell was known to have painted on a shoulder blade, however, according to Sharp's biographer Forrest Fenn this is unique. It is signed and dated 1903 on the lower right and the name Kip is written on the lower left. Joseph Kipp (1849-1913) was the son of the prominent fur trader James Kipp (1788-1880) and Earth Woman the daughter of Mato-Tope (Four Bears) a prominent Mandan chief whom Karl Bodmer and George Catlin both painted. Two Bodmer portraits of him appear in the aquatint atlas as Tableaus 13 and 14. The father James Kipp built the first trading post Ft. Kipp for the Blackfeet in 1831. Joseph the son was an Indian scout and frontiersman. Both father and son were highly respected and influential with the Blackfoot Indians. Sharp undoubtedly befriended Joe Kipp and apparently presented this marvelous piece of work to him while on one of his frequent painting sojourns to the Blackfoot country.

The prominent teepee in the foreground is the Yellow Buffalo Teepee of White Calf, the last traditional chief of the Blackfoot Nation. The old buffalo hide teepees were much smaller

because of their weight than their modern canvas counterparts. Even in the old days there were only about four dozen painted lodges among all three tribes of the Blackfoot Confederacy. The painted lodges were primarily inspired by a sacred vision. This camp along with the striking Yellow Buffalo Teepee must have greatly influenced Sharp enough to produce one of the finest oil paintings he ever rendered of a Blackfoot village.

Reynolds resigned in 1910, and Sharp had confrontations with each new Indian Agent. As a result, less time was spent in Montana each year. By 1920 Sharp nostalgically commented, "I must go to Montana this Fall for a month or so. There is not much for me to paint up there (Indians scattered and can't get the models) but I get some winter pieces, sell a few, see old friends, and by making the trip hold on to my cabin and studio."

Sharp ended his trips to Montana in the twenties and sold the cabin in 1935. He never forgot his days in Montana, keeping many of the objects he collected there, and often posed his Southwestern Indian models in northern plains garb.

He died in 1953, just prior to his 94th birthday. His paintings of Glacier country span from 1898's *Big Beaver* to 1932's *Blackfeet Camp*. Certainly Sharp's images of Glacier country solidified his reputation as one of the West's greatest artists. One reviewer summarized his importance stating, "He is always our beloved Indian painter and in the benevolent way is bound in the romance and the folklore of the Indian."

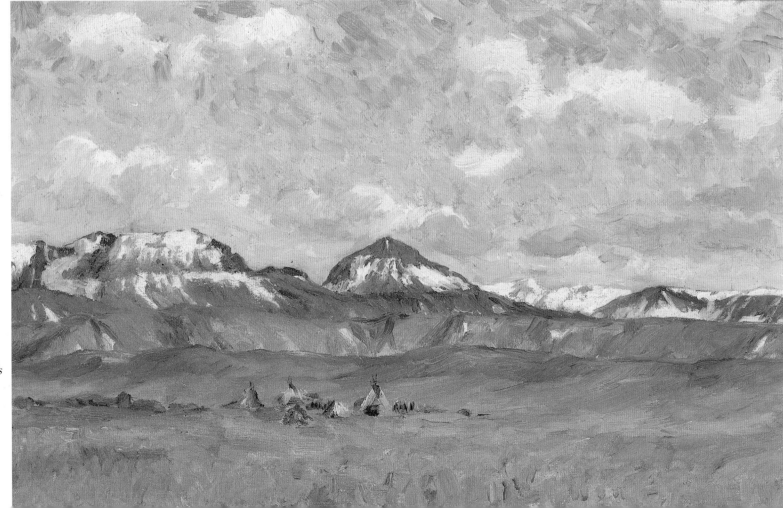

Encampment in the Foothills
by Joseph Sharp,
12" x 18" oil, CAA

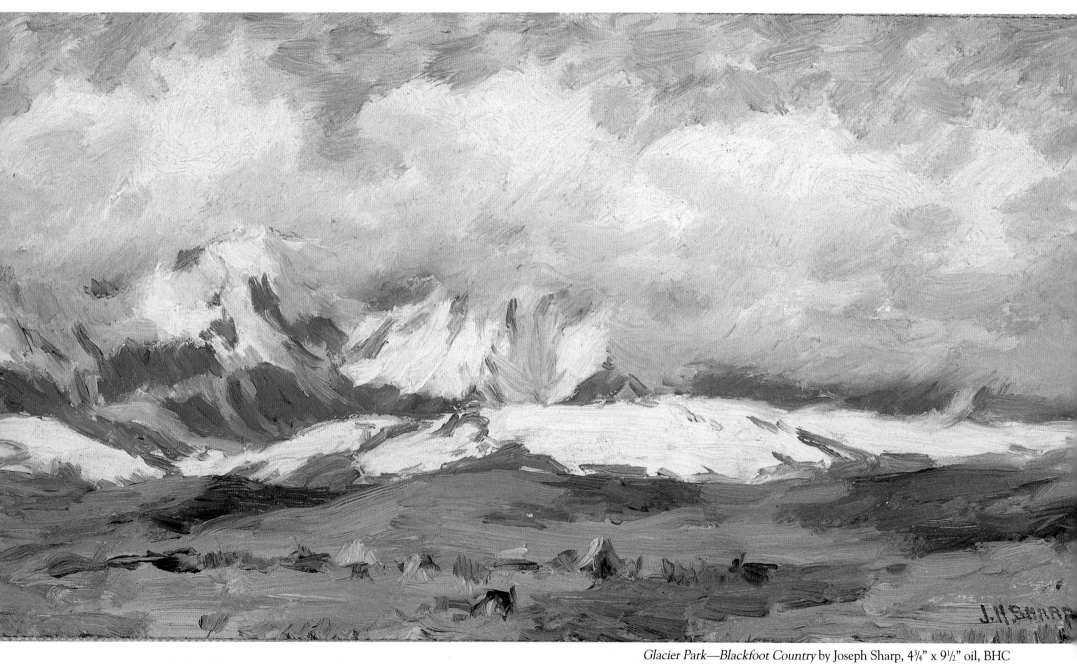

Glacier Park—Blackfoot Country by Joseph Sharp, 4¾" x 9½" oil, BHC

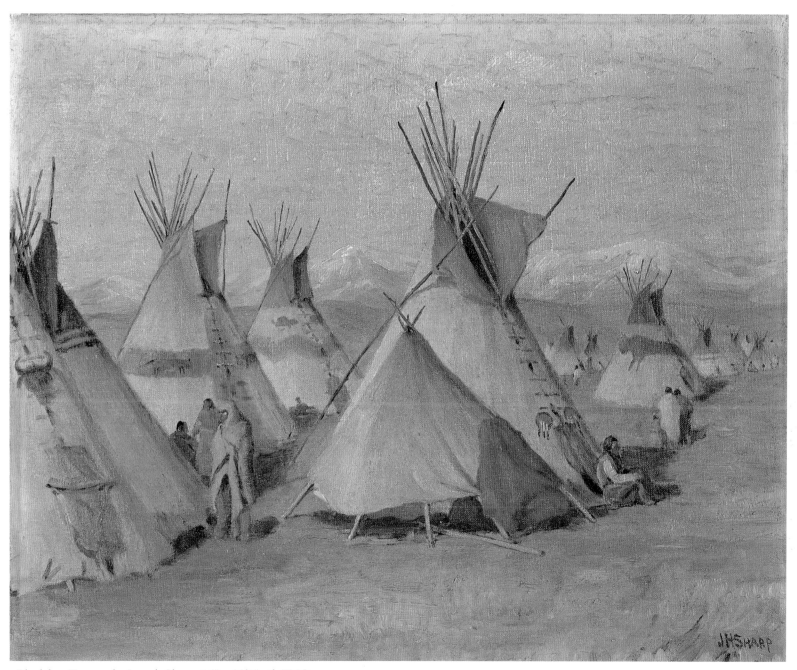

Blackfeet Teepees by Joseph Sharp, 16" x 20¼" oil, TNG

Maynard Dixon (1875-1946)

Maynard Dixon, MHS

When the Great Northern Railway offered Maynard Dixon a commission to come to Glacier National Park to paint, he jumped at the opportunity. Although this 1917 trip proved to be his last visit to Glacier country, Dixon continued to paint memorable scenes of the area for the rest of his life. Recently, his 1938 masterpiece, *Home of the Blackfeet*, was chosen by University of Montana historian, Dan Flores, as one of the top five nominees for "best historic painting of the Northern Rockies." In describing the masterpiece, Flores states:

Like the outlines of a dream, visions of the Blackfeet and Montana lingered on in Maynard

Dixon's mind for the rest of his life. Mostly known for his paintings of the Southwest, Dixon painted his greatest Montana work, the green and blue wonder he called Home of the Blackfeet, *in 1938, when he was at the height of his powers as a modernist. Even twenty-one years after the fact, its hues perfectly capture the color saturation of late summer in Montana. And in anti-nostalgic honesty,* Home of the Blackfeet *doesn't pretend; it evokes the reality of a twentieth century Between-Two-Times world, for the Blackfeet and all western Indians.*

Dixon was born in Fresno, California in 1875, and showed exceptional artistic talent as a youth. When his family moved to Coronado he began painting scenes of the surrounding southern California landscape, especially the old missions. When he was 16 he wrote, "I am determined to devote my life to illustrating the Old West," and sent two sketch books to Frederic Remington, his childhood hero. Remington replied, "…You draw better at your age than I did at the same age…if you imitate any other man ever so little you are 'gone'…above all draw-draw-draw-draw-and always from nature."

Picture Writing by Maynard Dixon, 8½" x 5" oil, 1917, MHS

Dixon briefly attended Mark Hopkins Institute in San Francisco, but left to produce illustrations for the *Overland Monthly*, whose art director touted him as Remington's equal. By the turn of the century, other magazines such as *Sunset* and *Harper's Monthly* also featured his work.

On April 18, 1906, the devastating San Francisco earthquake destroyed much of the city, including Dixon's studio. The following year he moved to New York city. Edward Borein also relocated there, and his studio

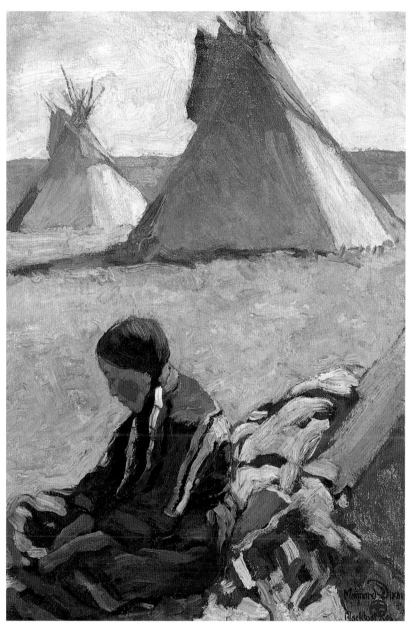

Little Sister by Maynard Dixon, 18" x 12"oil, 1917, TEC

Northern Forest by Maynard Dixon, 29½" x 19½" oil, 1917, MBA

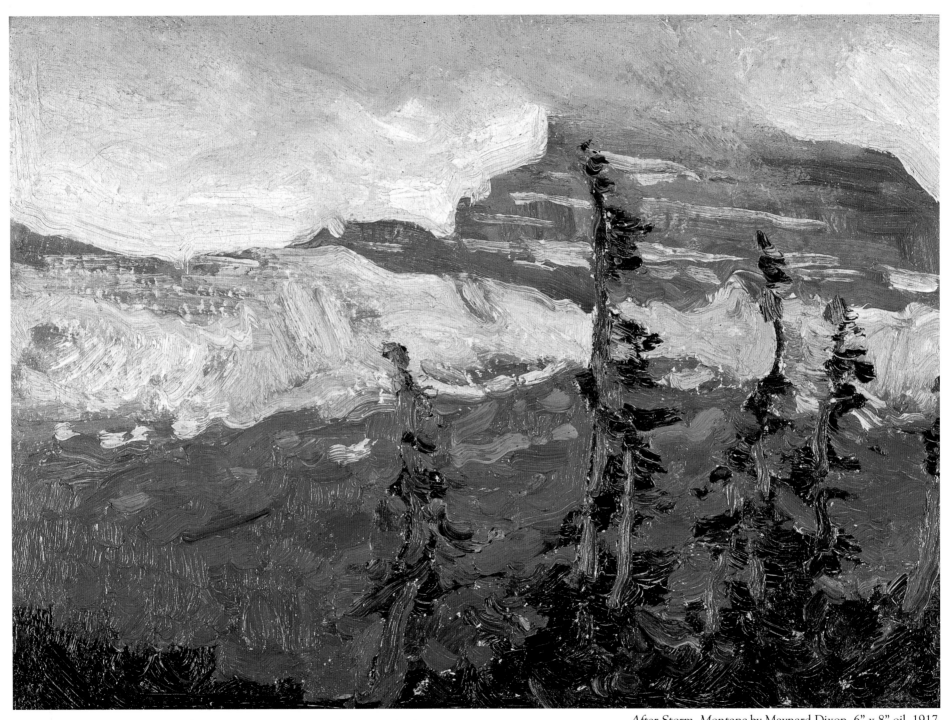

After Storm, Montana by Maynard Dixon, 6" x 8" oil, 1917
MBA

became the gathering place for Philip R. Goodwin, John Marchand, Will Crawford, and Dixon. The "Golden Age" of illustration was in full swing, and Dixon soon completed illustrations for *Century, Colliers, Saturday Evening Post,* and *McClures.* When Charlie Russell arrived, he too joined the artists at Borein's studio. Dixon met Russell in 1907, and later recalled his first impression:

His fame was greatest, of course among cattlemen and old-timers…. Natural fact and historical accuracy were his aims; imagination, interpretation-a recreation of the subject matter-to him were non-sense…. In appearance he was all an old timer… slow of smile…like an Indian, his face was immobile. The gray eyes were kindly.

In 1909, Dixon accepted an invitation to tour the Northern Rockies with his friend Charles Moody, a physician at the Sand Point Agency. He traveled by rail to Coeur d'Alene, Idaho, and then by horseback to the Saint Ignatius Mission on the Flathead Reservation north of Missoula. Several paintings, including *Flathead Indian & Pony* and *Flathead Brave,* resulted from this visit. Dixon returned to San Francisco, and in 1912 met James Willard Schultz. From Schultz, Dixon learned much about Native Americans, and his paintings began to depict "the old life of the Indian who inhabited the prairie lands of northern Montana, Dakota, and Wyoming." His new emphasis prompted Russell to write, "[I]

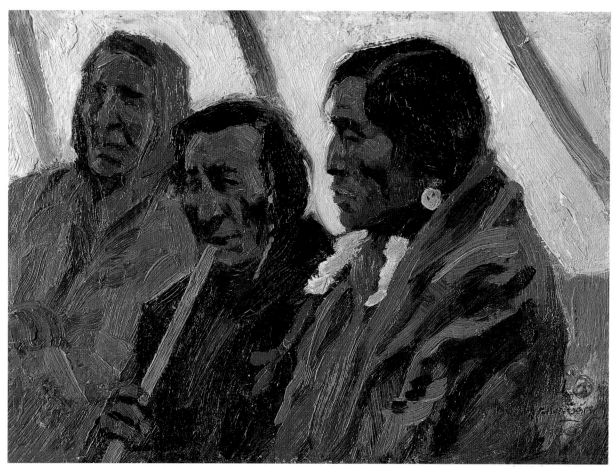

The Conversation by Maynard Dixon, 5" x 8¼" oil, 1917, MHS

think your pictures were fine. They looked mighty real to me. Your Indians ponies and lodges were all mighty skookum…. I am glad of your success…. Now Dixon don't forget if you cut my range don't pass my camp."

In 1917, Louis Hill asked Dixon to paint the Blackfeet Indians for his Glacier Hotel and advertising promotions. Although Dixon had planned a sketching trip to the area with Edward Borein in 1901, they had been forced to turn back before reaching Montana. Dixon conveyed his enthusiasm to Russell who replied on August 21, "I received your letter and will be glad to see you over here and when you come the robe will be shared and the pipe lit. There are no injuns here but there is lots of good picture country and I think we can have a good time."

Dixon arrived in Glacier with his young daughter, Constance, and Frank Hoffman, an artist who worked for the National Park Service. After a two-week tour of Glacier, Dixon arrived at Bull Head Lodge. As Dixon biographer, Donald J. Hagerty, noted:

Russell and Dixon talked into the early morning hours at the lodge, Dixon absorbing Russell's insight into mood, costume details, and everything western. Glacier's silent mountains, blue-green forests of pine and cedar, and the sound of mountain water were glorious…

Dixon left Lake McDonald and continued east where he camped at Cutbank Creek with Curly Bear, Owen Heavy Breast, Two Guns White Calf, Old Beaver Woman, and Lazy Bear. He thought they were "the best Indians I have seen yet." The crisp September days were appealing, and he watched the "smoke-tanned cones of teepees stand sharp in the sun, sending their blue-white breath into the breathless morning." Going on to Browning, he saw Grass and Scalp Dances and the opening of a sacred Beaver Medicine Bundle. While there, Dixon painted several quick oils in his classic style using vigorous, bold, and commanding brushstrokes. Years later, his daughter Constance reminisced that leaving Glacier saddened her, "I wanted to stay and become an Indian."

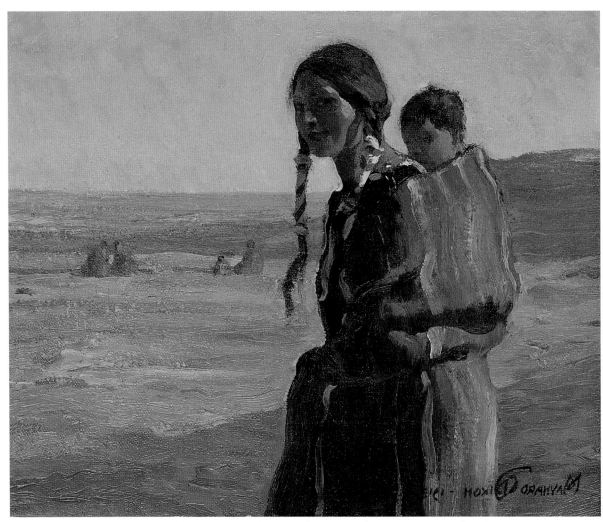

Young Blackfoot Woman with Papoose by Maymard Dixon, 10" x 14" oil, JHA

Back in San Francisco, Dixon finished twelve paintings featuring Glacier National Park and Blackfeet subjects. He sent them to Louis Hill who decided not to purchase the paintings in part due to World War I and the resulting drop in tourism. Hill offered to sell them for Dixon at the hotel during the summer season. Since only two of the paintings have surfaced (*Northern Forest* being one

of them) it is unknown if Dixon accepted Hill's offer.

Although he never returned to Montana, Dixon continued painting the Blackfeet. In 1921, Dixon stopped doing magazine illustrations in order to concentrate on becoming a studio painter. Throughout the 1920's, Dixon held major exhibitions featuring paintings of Native Americans, and completed several murals for public buildings. From 1930 on, Dixon focused on painting the western landscape. Ten years later he left San Francisco and built a home and studio in Tucson. There, Dixon died of a heart attack on November 13, 1946.

Fellow artist, Dorothy Puccinelli wrote:
Of course more than most people he will keep his place in people's ideas-his paintings are almost a pattern for the West, and the Southwest landscapes will continue to look like "Maynard Dixon's" as long probably as they last.

Thomas McGuane extended the praise:
To me, no painter has ever quite understood the light, the distances, the aboriginal ghostliness of the American West as well as Maynard Dixon.

Mountain & Meadow, Glacier National Park by Maynard Dixon, 6" x 8½" oil, 1917, TNG

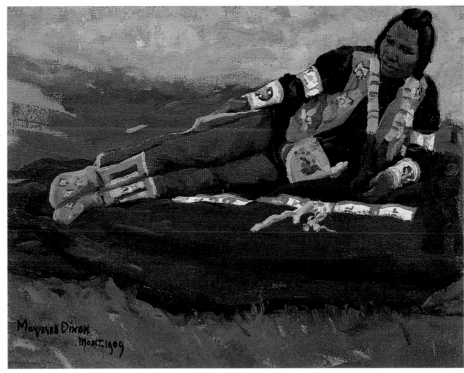

Flathead Brave by Maynard Dixon, 10" x 13½" oil, CAA

Lone Wolf (1882-1970)

Perhaps the most important Native American painter associated with Glacier National Park is Hart Merriam Schultz, more commonly known as Lone Wolf. Born in 1882 in Birch Creek, Montana, Lone Wolf was the only child of James Willard Schultz and his Blackfoot wife, Fine Shield Woman. Red Eagle, a Blackfoot medicine man named him Lone Wolf, but his father christened him after his boyhood friend, C. Hart Merriam, a distinguished physician and anthropologist.

Lone Wolf was raised as a traditional Blackfoot on the family ranch near Fort Conrad. Since his father was often away guiding tourists through Glacier Park, Lone Wolf and his uncle, Last Rider, were responsible for running the ranch. Despite having little free time, Lone Wolf dabbled in watercolor, making his first sale to a clerk at Joe Kipp's Trading Post in Browning.

When Lone Wolf came down with tuberculosis, his doctor advised him to spend time in the drier climate of the Southwest with the hope of improving his lung condition. He found work as a cowboy, and in 1906 guided tourists in the Grand Canyon. In his off hours he painted.

Lone Wolf, GNP

By chance he met Thomas Moran, a popular landscape painter, who thought highly of Lone Wolf's art and recommended he attend the Art Student's League in Los Angeles. In 1909 he studied art at the League, continuing his instruction at the Chicago Art Institute. However, academic life did not really appeal to Lone Wolf, and before long he returned to Montana.

Lone Wolf worked at the Galbaith ranch near the Canadian border, where he met Naoma Tracy,

the daughter of the camp foreman. After a one day courtship, they rode by horseback to Cut Bank where they were married by the Justice of the Peace. Naoma brought a sense of stability to Lone Wolf that lasted throughout their 54-year marriage. In 1917 Lone Wolf had his first one-man-show in California. *The Los Angeles Times* carried the headline "Vance Thompson Discovers Wonderful Indian Artist, An Artist With a Vision." Thompson, the *Times* art critic, praised Lone Wolf:

It is a rare thing to discover an artist. I have seen the young painters pass in droves through the schools and salons of Paris, and in 20 years I can claim to have been the discoverer of only one great artist. Now I like to think that I have, at last, discovered another and he is an artist who has authentic vision, sincerity and a brush which is already capable of doing precisely the thing he wants it to….

Lone Wolf has courage…artistic courage which is the rarest of all. His strength as an artist is in his uncompromising realism… in his sincere treatment of the human form… in

Herding Steer by Lone Wolf, 20" x 24" oil, CAG

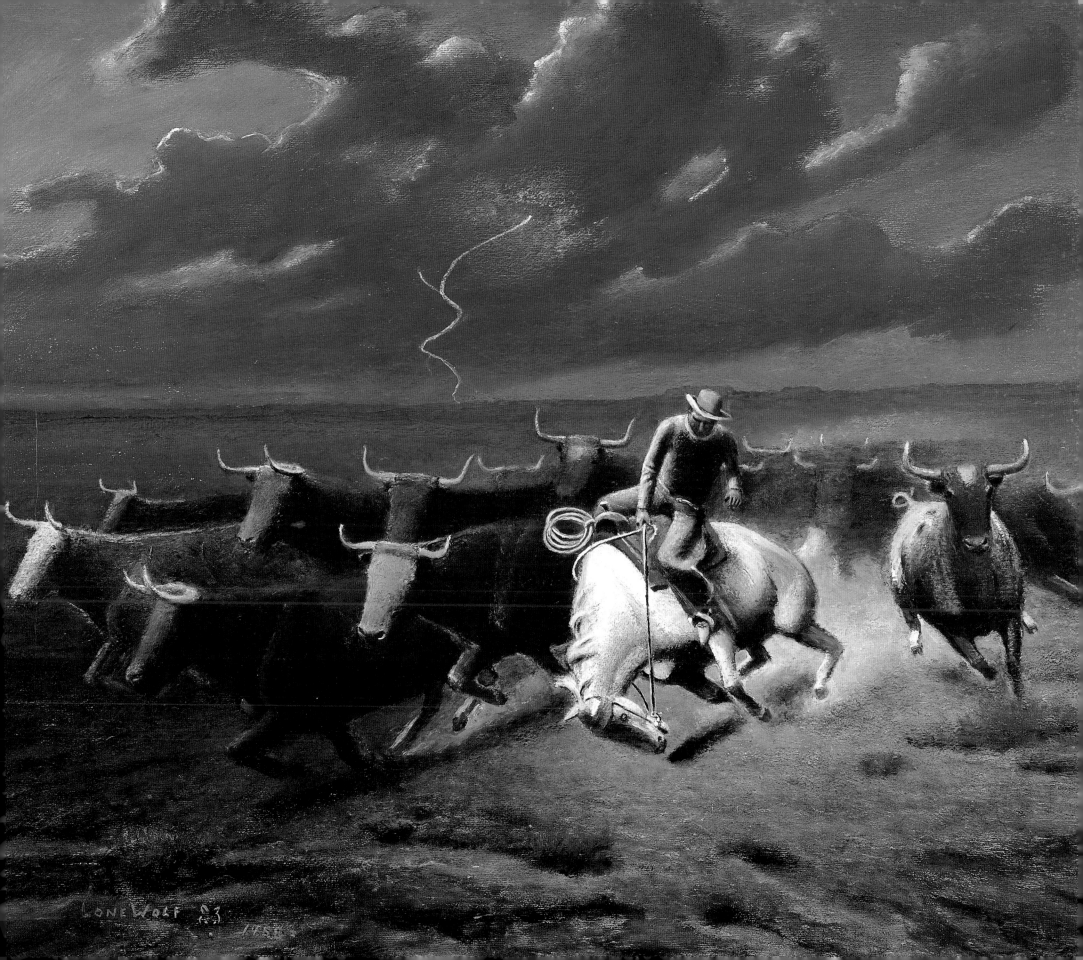

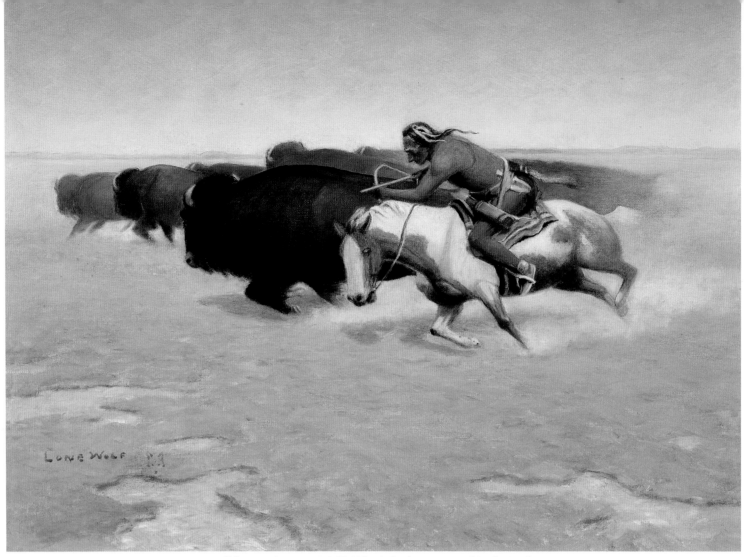

Buffalo Hunt by Lone Wolf, 20" x 24" oil, courtesy of Andy Apple

his intimate knowledge of the life he paints. You might call it quality, but whatever you call it, it is the one thing that keeps art alive, this man of the Blackfeet tribe has got it. He has got it. And to art lovers and painter folk I want to say one thing, there is a new artist coming up the trail and the name of him is Lone Wolf. His pictures are signed with a wolf's head.

Lone Wolf spent the summers painting at his studio near St. Mary Lake. Luck came his way in 1920 when August Hecksher, an avid art collector, arranged for Lone Wolf's first show in New York. He also introduced the artist to the owner of Babcock Galleries thus beginning an association that lasted for years. Soon Mrs. Calvin Coolidge, Herbert Hoover, Owen Wister, and others began collecting his work.

Lone Wolf died February 9, 1970, in Tucson, a few days short of his 88th birthday. On July 16, 1971, a Give-Away Feast was held in Browning to honor Lone Wolf's life. There, along with hundreds of Blackfeet, Naoma viewed the photographs, paintings and other memorabilia on display in tribute to Glacier's most famous Native painter.

John L. Clarke (1881-1970)

John L. Clarke was born on May 10, 1881 to Horace and First Kills, the daughter of Blackfeet Chief Stands Alone. He was raised in the Highwood area, near Great Falls where smallpox and scarlet fever were endemic, taking the lives of five of John's brothers. John contracted scarlet fever when he was two years old, leaving him deaf and unable to speak.

As a teen, John attended the Montana School for the Deaf in Boulder where he took his first carving class. Years later he recalled;

When I was a boy I first used mud that was solid or sticky enough from any place I could find it. While I attended Boulder School for the Deaf, there was a carving class. This was my first experience in carving…I carve because I take great pleasure in making what I see that is beautiful. When I see an animal I feel the wish to create it in wood as near as possible.

Clarke finished his formal education at St. John's School for the Deaf in Wisconsin. Its director praised him years later:

John had great talent for drawing and was the most wonderful penman. Anxious to have him learn a trade that would help him earn a livelihood, we advised him to take up woodcarving. He remained at St. John's two or three years, long enough to acquire a good religious training and firmer character. We found him a job in the city, where he worked at his trade for a few years.

In 1913, John returned to live with his father on the east side of Glacier. With its impressive library, their home attracted artists, writers, and musicians including Mary Roberts Rinehart and Joseph Sharp. Four years later, Clarke exhibited a

John Clarke sculpting in front of Tom Dawson's home for a Pathe movie, 1914, TEC

carving at the Pennsylvania Academy of Fine Arts in Philadelphia. Bolstered by its reception, Clarke began working in a small studio near Swiftcurrent Falls. Louis Hill was so impressed with Clarke's talent that he commissioned wooden bears for the bases of the table lamps used in his lodges. He also purchased 100 small carvings of goats to sell in hotel gift shops.

In 1918, Clarke married Mary "Mamie" Peters Simon who became an invaluable business manager, acting as his interpreter, press secretary, and correspondent. One of their friends once said, "She was very lovely, and patient. Not that John was demanding, oh, he was a nice man. She'd stand at his side, you know, with her hand on his shoulder. And she could sign so fast, you couldn't keep up with her."

Shortly after he married, John received a letter from Charlie Russell responding to his letter about how to sell his carvings:

> ...there is only one art store here and I know they would be glad to handle your work but whether they could sell it I couldn't say. Your work is like mine, many people like to look at it but there are few buyers.... If you send any here I will boost for you.... If you have an Indian name I think it would be good to use it.... Wishing you good luck, C. M. Russell

John Clarke at the Glacier Park Hotel, 1915, TEC

John Clarke at his chalet studio at Many Glacier Hotel, 1918, JCT

John Clarke at the Glacier Park Hotel, 1913, JCT

Years later Mamie discussed their friendship:

His visits were of greatest possible moments to John. Although at first greeting John invariably told Mr. Russell (Indian sign language-of which he too was very good), "Let us exchange heads, yours is fine." Then (Mr. Russell) would laugh and tell John, "Yours too is good." Mr. Russell would then look at all of my husband's work, sculpture and landscape (oil) and praise it, encouraging just enough and not too much. He was so understanding, deeply sympathetic and in all wholly lovable.

Galleries in New York, Boston, London, and Paris exhibited Clarke's woodcarvings. Collectors included Warren G. Harding, John D. Rockefeller Jr., Louis Hill, and Charlie Russell. Clarke won a gold medal from the American Art Academy in 1918, and exhibited at the 1934 Chicago World's Fair.

Untitled by John Clarke, 9" x 11" watercolor, JCT

Bear by John Clarke, bronze cast from woodcarving, 2¾" h x 3½" l x 1¾" w, BSC

Clarke's reputation as a wood carver drew artists from across the country and Europe to his modest studio. Students watched with great interest as he expertly carved mountain goats, bears, big horn sheep, and grizzlies from blocks of wood. During a 1994 Clarke exhibition, Kirby Lambert, curator at the Montana Historical Society, commented, "I've been surprised at how many people told me they always stopped in at Glacier Park to see John, and the fondness with which people recall him." One person more than any other has kept John Clarke's life and works from being forgotten. Clarke's adopted daughter, Joyce Marie, turned his studio into the John L. Clarke Western Art Gallery and Memorial Museum near Glacier Park Lodge. Today it remains a fitting tribute to this master carver.

Other Friends

Charlie Russell and William Krieghoff
at Bull Head Lodge, 1912. BSC
Krieghoff was a popular Philadelphia portrait
painter.

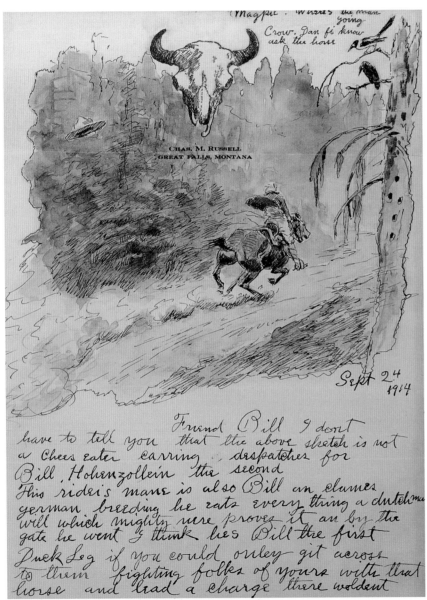

Friend Bill [William Krieghoff], first page of illustrated letter by Charlie Russell, BSC

Little Bear, Cree Chief by William G. Krieghoff,
19" x 13½" oil, BSC
Inscribed on the lower right, "To Frank B. Linderman,
W.G. Krieghoff, Browning, Mont., July 4, 1912"

Ralph E. DeCamp and Charlie Russell at Bull Head Lodge, 1910, MHS
Russell said DeCamp could paint "the wettest water of anybody I know."
DeCamp was a landscape painter from Helena.

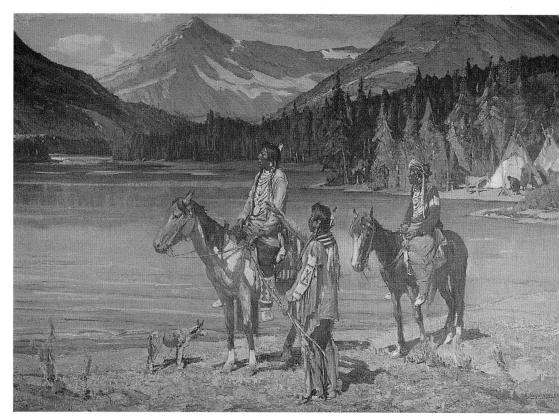

Blackfeet in Glacier National Park by Oscar Berninghaus, 15" x 23" photomechanical print, BSC
Berninghaus was a famed Taos, New Mexico artist who was believed to have painted this scene
from a Roland Reed photograph.

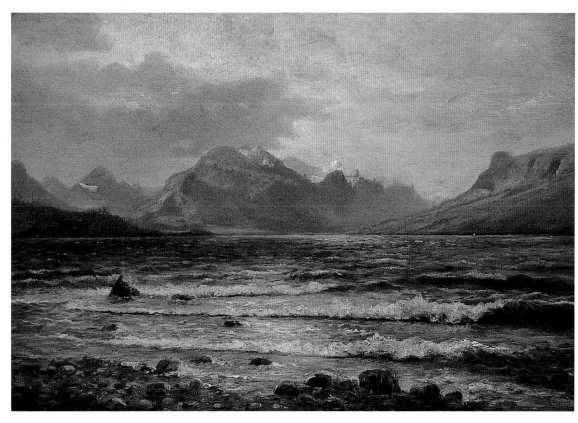

Storm on St. Mary by Ralph DeCamp, oil, MHS

A gathering at Bull Head Lodge, 1915, BSC
Carolyn and Joe Scheuerle and Nancy Russell are seated immediately behind a squatting
Charlie. On the right are English artist John Young-Hunter (standing) and Charlie's
nephew Austin. Scheuerle was a Chicago-based artst.

Long buried are Knife and hatchet.
His warhoop silent today —
"Injun him packin' "Good Medicine"
Ridin' Xmas Trail - headed your way!"

from Joe Scheuerle

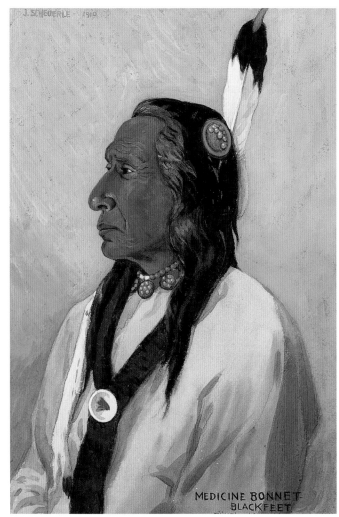

Medicine Bonnet by Joe Scheuerle, 13" x 9" watercolor, CAA

Christmas postcard to Frank Bird Linderman
from Joe Scheuerle, 1932, BSC
Scheuerle was employed for a time by the Great Northern
Railway and painted its famous mountain goat logo.

Grinnell Lake by Kathryn Leighton, 24" x 18" oil, CAG

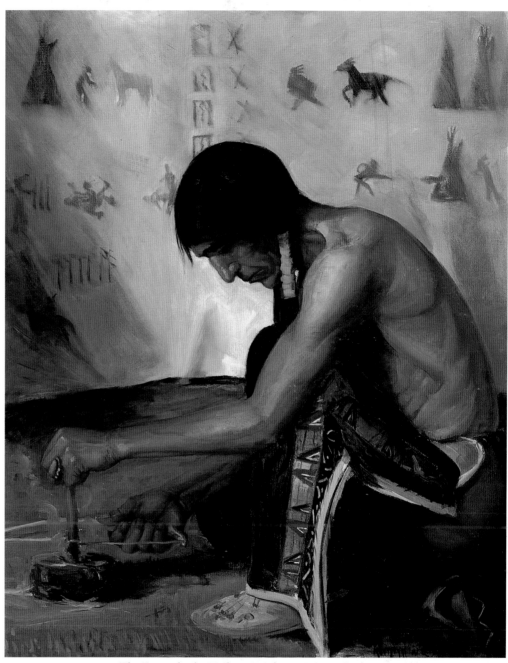

The Firemaker by Kathryn Leighton, 24" x 18" oil, BSC
Leighton was employed for a time by the Great Northern Railway,
and visited Charlie Russell at Bull Head Lodge in 1925.